The Best in Contemporary Fantastic Art **SPECTRUM 9**

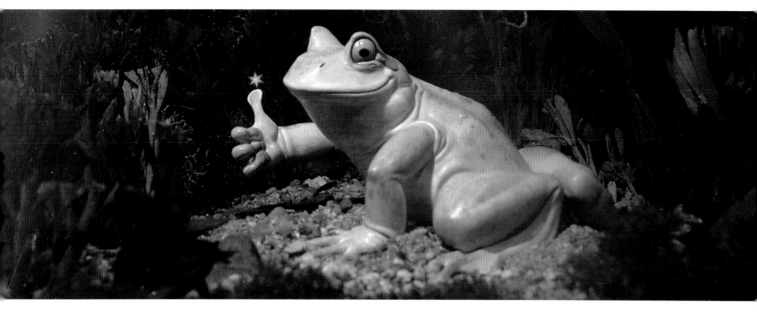

Edited by Cathy & Arnie Fenner

UNDER WOOD BOOKS

UNDERWOOD BOOKS
Nevada City, CA · 2002

Chairmen's Message

Welcome to the ninth edition of *Spectrum*, the annual celebration of the best fantasy, science fiction and otherwise fantastic-themed art produced in the previous year. Works included in this volume are the result of a juried competition and as such the final content of the book is as subject to the art submitted for consideration as it is to the tastes of the judges doing the selecting. It's important to realize (for those not selected for inclusion in the annual as well as for those who were) that regardless of guidelines and procedures established prior to the beginning of the selection process, once the engine starts running the outcome is ultimately determined by the dynamics of the jury as well as by the members' individual standards for excellence. Over an incredibly short period of time, the judges convene, view several thousand works of art, and come to a consensus that results in the book you're now holding. It is, to put it mildly, a Herculean effort and this and every previous jury deserves all of our appreciation for their willingness to devote their time and energies in making *Spectrum* the success that it has been these past nine years.

After the events of September 11th and the downward spiral of the economy, we weren't quite sure how this year's competition would turn out. We were gratified that the creative community once again showed its support for the annual and submitted a mind-numbing selection of quality works. The jury met in Kansas City the final week of February, 2002: not only was the weather unusually clear and mild, but everyone's flights arrived on time (and in most cases, early). An unexpected deadline crush prevented one jurist from participating and artist Bob Haas graciously agreed to step in at the eleventh hour to round out the panel. Once introductions were made and instructions given, the jury plunged into the arduous task of making their selections in a hotel ballroom lined with tables full of art: the room was switched out five times in the course of the day, replacing voted-on art with new works for consideration. The atmosphere was hectic, rambunctious, and fun. At the end of the afternoon, those pieces that had been marked by judges for consideration for awards were brought back out and the merits of each were debated (not without some heat) before Gold and Silver awards were ultimately presented in each category.

Assisting Arnie and I this year in tabulating votes, setting the room, and keeping the proceedings moving along were Arlo Burnett, Armen Davis and Jennifer Zarrelli.

As with every previous *Spectrum*, this book is only made possible by the active participation of the artists, both those selected for the book and of those that unfortunately were not, and to the readers that regularly buy each edition as it's released. This is their book, your book, and to one and all we again extend our warmest thanks for allowing us to be a part of this community.

—Cathy Fenner/Show Co-Chairman

Trade Softcover Edition ISBN 1-887424-66-0
Hardcover Edition ISBN 1-887424-65-2
10 9 8 7 6 5 4 3 2 1

Special thanks to Brom, Tim Hoter Bruckner, Joseph DeVito, and Bud Plant for their continued help and enthusiasm.

Advisory Board: Rick Berry, Brom, Leo & Diane Dillon, Harlan Ellison, Bud Plant, Don Ivan Punchatz, Tim Underwood, Michael Whelan

A limited edition print of the cover by Daniel R. Horne is available from: www.geocities.com/danielrhorne 11"x14" @ $20: 13"x19" @ $28 + postage.

Artists, art directors, and publishers interested in receiving entry information for the next Spectrum competition should send their name and address to:
Spectrum Design, P.O. Box 4422, Overland Park, KS 66204
Call For Entries posters (which contain complete rules, list of fees, and forms for participation) are mailed out in October each year.

Spectrum 9 is dedicated to:
BOB HAAS
As fine an artist as he is (and we can't honestly think of one more gifted), Bob's true talent has always been in being a steadfast friend. If there were more like him, the world would be a better place.

Published by **UNDERWOOD BOOKS**, P.O. BOX 1919, NEVADA CITY, CA 95959
www.underwoodbooks.com
Tim Underwood/Publisher

The JURY

Rick Berry *artist*

Terese Nielsen *artist*

Bob Haas *artist*

Phil Hale *artist*

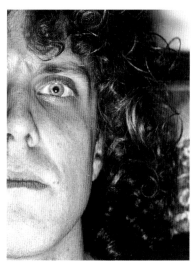

David DeVries *artist*

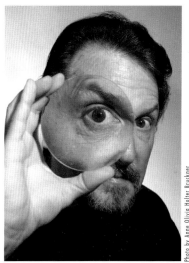

Tim Holter Bruckner *sculptor*

Photo by Anne Olivia Holter Bruckner

Rick Berry Terese Nielsen Bob Haas Phil Hale David DeVries Tim Holter Bruckner

© Hallmark Cards, Inc.

Batman TM & © 2002 DC Comics.

Kinuko Y. CRAFT

"Kinuko Craft is an artist for all seasons, for all kinds of subjects, and all kinds of styles. She fits herself to her subject with charming ease and yet leaves herself free to remain herself...One cannot help but think how delightful it would be to walk into a gallery full of the fruits of her kaleidoscopic talents."

—Ray Bradbury

Her grandfather named her "Silk-child."

Kinuko Yamabe Craft grew up in a small Japanese village and received her first art education in her maternal grandfather's library. "My grandfather was an art collector," she explains, "and my nursery books were art books of the collections of the world's museums. I told myself stories about the pictures. Grandfather had a Maxfield Parrish print, a painting of dreams and the romantic. I think I am a romantic."

Kinuko's pursuit of the artistic muse began in early childhood; constantly drawing, constantly painting, her career was almost pre-ordained. Upon obtaining a B.F.A. from the Kanazawa Municipal College of Fine and Industrial art, she began exploring the possibility of moving to the United States. After a number of inquiries she received sponsorship from a Chicago design studio and, without knowing any English, moved to America in 1964. After a year and a half of attending the Art Institute of Chicago, Kinuko had become "sick of school" and made the plunge into the world of commercial illustration. At first working on staff at several studios for the experience, she eventually hired a representative and launched her freelance career.

Her big break came from *Playboy* and she quickly became a regular contributor to the magazine: her classic approach to a disparate range of subjects made her a favorite among readers and prompted other art directors to seek her out. *National Geographic*, *Forbes*, *Newsweek*, *Time*, and *Cosmopolitan* are only a fraction of the magazines that have featured her art; advertising clients came courting, too, and Kinuko has painted for everyone from AT&T to Clairol to Seagram's. She has created numerous

Kinuko Y. Craft & Wolfgang.

book covers and has illustrated an impressive list of titles for juveniles (including several in collaboration with her daughter, Marie). "For me, picture books are not children's books," she reveals. "Though they are called 'children's books,' I create the images mainly for me, both the mature woman and the child within myself. I believe we are always young inside and psychologically never grow old and worn out, from birth to death. My paintings let me live in a world of my own imagination and fantasy." A series of posters commissioned by both the Washington Opera and the Dallas Opera have added to her renown. Kinuko has received numerous honors throughout the course of her career, including the prestigious Hamilton King Award, medals from the Society of Illustrators, and Gold Awards from *Spectrum*. Popular both as a lecturer and as a teacher, she is constantly on the go: she exhibits her work widely and regularly serves on the juries of various art competitions. Twelve-hour work days are the standard and often include weekends. Her husband Mahlon (a gifted designer) runs her official website [www.kycraft.com], manages the growing archive of her art, and is perhaps the only person that can keep up with the hectic pace Kinuko sets.

"I think you're born a dreamer, born an artist," Kinuko says.

And perhaps she's right. As a dreamer, as a romantic, it was probably inevitable that Kinuko Y. Craft would become an artist. And, if such is the case, it was most certainly inevitable, given the timeless, ethereal quality of her paintings, that she would be honored with the title of Grand Master.

You can't fight fate.

b o r n 1 9 4 0 / K a n a z a w a , J a p a n

S P E C T R U M G R A N D M A S T E R S

1995	1996	1997	1998	1999	2000	2001	2002
Frank Frazetta	Don Ivan Punchatz	Leo & Diane Dillon	James Bama	John C. Berkey	Alan Lee	Jean Giraud	Kiunuko Y. Craft
b. 1928	b. 1936	b. 1933	b. 1926	b. 1932	b. 1947	b. 1938	b. 1940

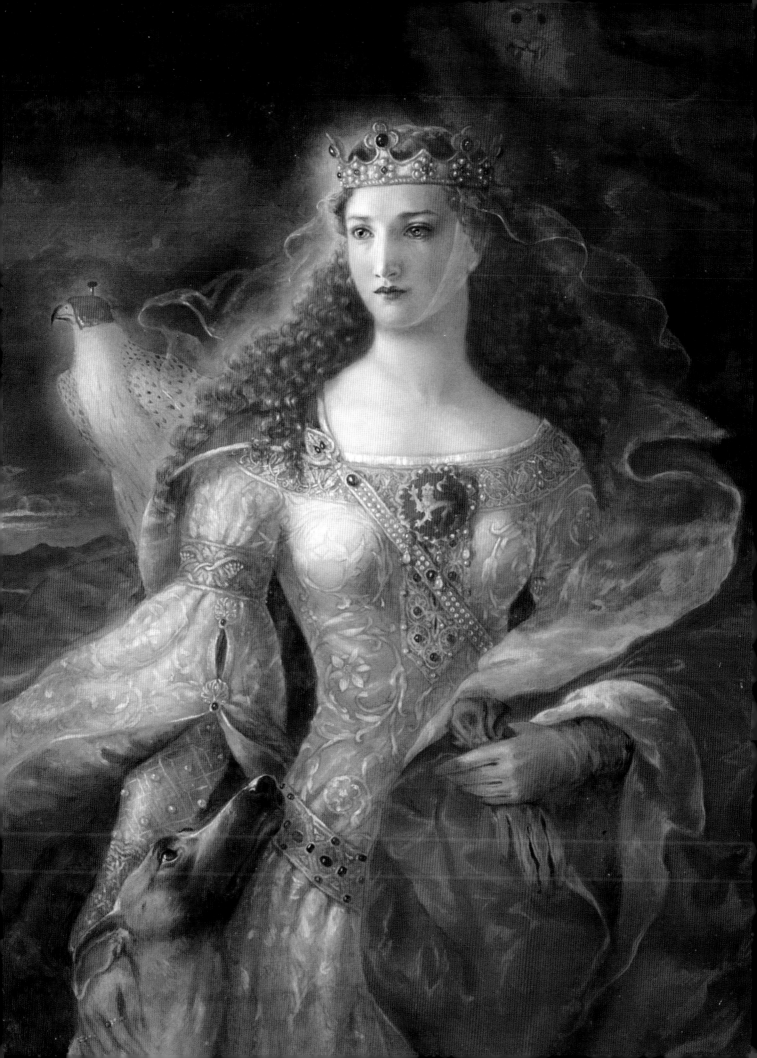

Review

2001 wasn't the year we were expecting.

Realistically, I don't think any of us were genuinely anticipating the Stanley Kubrick/Arthur C. Clarke-world of Pan-Am moon-shuttles and artificial intelligence: those ideas seemed to become less "science" and more "fiction" as enthusiasm for space exploration (thanks to accidents, expense, and public apathy) flagged while the wonders of *2001: A Space Odyssey* faded when compared to the new crop of faster-paced SF shoot-em-up films. We knew we weren't going to be strapping on jet-packs to fly to work (with operating instructions from *Mystery Science Theater*. "Left nipple, right nipple, hop, hop, jump..."), knew there wouldn't be human-looking robots doing our laundry and mowing our yards, and knew that we were as likely to be riding Nessie in our birthday suits as we were to be having much contact with extraterrestrials (regardless of Whitley Streiber's insistence of his repeated probings). We knew all that and it was okay.

Pat Oliphant's editorial cartoon accurately captured the world's impression of al Qaeda ringleader, Osama bin Laden, after the terrorist attacks of September 11th.
Universal Press Syndicate

Because if the reality of 2001 wasn't quite what the books and comics and movies and pundits had led us to believe it might be like (which, given a lot of the doomsday scenarios, was alright by me), there were still plenty of pretty wondrous things in the 2001 we got that could boggle the mind once they were seriously considered. In the '60s cell phones and personal computers, GPS and DVD, were only exciting ideas (if even that): in the first year of the new millennium they were ho-hum aspects of daily life. The Internet, the end of the Cold War, laser surgery, the construction of the space station, cloning? All science fiction. Anyone looking back over the last 30-some years since Kubrick's film (and, more significantly, NASA's race to the moon) would have to admit that, while there were no HAL9000s and still plenty of social, political, and economic problems, 2001 wasn't anything that we couldn't live with.

Until September 11th.

Within a few short hours, 2001 had morphed back into 1941. It was Pearl Harbor with buildings replacing battleships as targets. The terrorist attacks in New York and Washington, D.C. shocked and horrified and frightened and infuriated the country. As with any significant historical event, 9/11/01 brought out the best in some people and the worst in others; greed, bigotry, and mendaciousness were unfortunately as common as selflessness, bravery, and compassion in the hours, days, and weeks following the fall of the twin towers. Patriotism and love of country walked the same path taken by jingoistic rhetoric, generosity was shadowed by exploitation. Smirking cynics like Ted Rall and Michael Moore (whose observations alternate between being painfully astute and deliberately dim) turned the finger of blame for the attacks on ourselves and rhetorically asked, "Is it any wonder that people hate us?" (Of course such a question denies the innate stupidity inherent in virtually *every* government, shocking ignorance of the the way the world has functioned since time immemorial, and the failings of human nature in general: the same question can be asked in every country by every culture, race and creed. Ted, Mike, and company should dig out Tom Lehr's 1960s song "National Brotherhood Week".) On the other side of the fence were shrill goose-stepping commentators like Ann Coulter who wrote after the attacks, "We should invade their countries, kill their leaders and convert them to Christianity." (And be as unifying and successful as were, oh, the Crusades? When I read Ann's holier-than-thou diatribe I immediately flashed back to an old Stan Lee/Jack Kirby *Fantastic Four* comic: a guy watching a superhero/supervillain battle blurts out, "If I was in charge, I'd toss an atom bomb at 'em!" To which someone in the crowd quips, "Maybe that's why you're not in charge.") The Constitution and civil liberties were seen as hindrances to "homeland security": a pall of paranoia clouded the thinking of normally clear heads and people seemed all too willing to surrender some basic freedoms in return for the perception of safety.

The media wags have stated repeatedly, "The world changed on September 11th."

They're wrong.

by Arnie Fenner

opposite: Chris Moore's cover painting for *Altered Carbon* by Richard Morgan [Gollanz].

Nothing is any different now than it was the day before the attacks. Oh, sure, some simmering deep-scated prejudices have bub-

Walt Reed's update of The Illustrator in America *was the reference book every serious student of the field should have picked up in 2001.*

bled to the surface, some people's virtues and others' character flaws have become more apparent, and maybe as a country we've been rudely reminded (unfortunately, once again) that terrible things can happen when and where you least expect them. But nothing has really changed.

The truth is that an Osama bin Laden or a Timothy McVey or some other nameless, faceless lunatic with a real or imaginary axe to grind could have orchestrated or attempted a similar attack at any time and possibly pulled it off. The anthrax mailed to Capitol Hill within days of the 9/11 attacks (from an as yet unidentified perpetrator) perhaps drives that point home. Who can anticipate the actions of sociopaths? People in London and Belfast and Jerusalem and Moscow and Tokyo have experienced the same terror, grief, and fury over the years, if not quite on the same immediate scale, most certainly with the same intensity of feeling. But...Life goes on. Kids have to be raised, jobs have to be done, bills have to be paid, life has to be lived. You pick yourself up. Brush yourself off. Take Care Of Business.

That's why nothing really changed after September 11th. Al Qaeda or Hamas or ETA or the IRA or the Orange Volunteers or November 17 or any other terrorist group can inflict pain and suffering on people, temporarily disrupt daily lives, and have a short-term economic impact...but the one thing they *can't* do is win. I'm not waiving the flag or taking on a John Wayne swagger, I'm just stating a fact.

They have nothing to offer.

The terrorist attacks of September 11th

had nothing to do with American foreign policy; despite assertions otherwise, there was nothing political, nothing religious, not even anything vaguely ideological behind them— "jihad" has been so blithely misused and misinterpreted so often in the last decade that it has ceased to have legitimate meaning. 9/11 had nothing to do with Islam, nothing to do with, well, anything other than the bigoted hatred of a charismatic psychopath. History is unfortunately full of them. The events of September 11 were criminal acts, homicides, planned by a millennial-version of Charles Manson and carried out by his own copies of Tex and Squeaky and Sadie May Glutz.

What does Society do with murderers? Hunt them and either catch them or kill them.

And then we go on. Maybe a little smarter, maybe a little more careful and thoughtful, but we go on. TCOB.

Ahh, 2001. Did I mention Enron and the Arthur Andersen corporate accounting can of worms? Or the controversial inauguration of George Bush, the down-turn in the economy, the evaporation of the projected government surplus, the abandonment of the Kyoto treaty on Global Warming, or significant job lay-offs? No? Well...I guess the long and the short

of it is that it was a tough year. A lot of rocks got tossed in the world's pond and the emotional and economic ripples touched everyone, including artists, publishers, and patrons.

But, regardless of the trials and tribulations of 2001, good things of course happened throughout the year (witness the reappearance of Afganistan's historical art treasures that museum curators had hidden in order to save them from destruction by the Taliban). Art, like life, goes on.

Wonderful books, great comics, energetic exhibitions, terrific films, stacks of neat stuff: 2001 offered something memorable (in a *good* way) for everyone.

ADVERTISING

Corporate scandals, a recession (mild according the the analysts, but hard if you were one of those that lost their job), shifting of brand loyalties among consumers and of course the terrorist attacks on the east coast all combined to make it a difficult year for the advertising industry. While Internet pop-up ads seemed to become more frequent and annoying they didn't necessarily translate into increased sales (or in some instances, any sales at all) for advertisers. Spam e-mail solicitations clogged computer mailboxes. An increase in the number of cable and satellite television channels continued to erode the dominance of the major networks, which in turn suffered from a decrease in ad revenues.

A leaner market translated into meaner prices and fewer opportunities for traditional artists. While there was certainly an enormous amount of advertising appearing in all available venues throughout the year, the vast

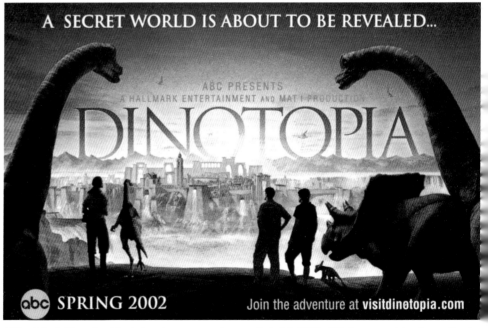

Billboards for the Dinotopia *mini-series began to appear across the country in the Fall of 2001. ABC also announced plans for a weekly series.*

majority were information, rather than visually, driven. And the largest percentage of the works that *did* rely on graphic panache to sell an idea or product were created in Photoshop with manipulated photography.

In the largely anonymous field of advertising I *was* still able to identify some excellent art by Bill Mayer, Douglas Smith, Mark Summers, Gary Kelly, Rafal Olbinski, David Beck, Tim Bowers, and Anita Kunz (whose ad for Rusty Truck was hilarious).

B O O K S

I'm still waiting for the death of print and the dominance of the e-book, the renaissance of print-on-demand.

My sarcasim is understandable considering the amount of media buzz the idea has generated in the trade for the last few years. The whole electronic book "revolution" has yet (never say never) to materialize for all of the reasons I mentioned in *Spectrum 8*: prohibitive costs, limited selection, ill-conceived concept, poor quality, and, perhaps above all else, lack of *personality*. And, yes, *real* books have personalities; despite the best efforts of some to treat them as product that can be plopped in a box and sold like dog-food, books are something special. They form a relationship with their readers, become cogs in the machines that make us who we are. Computers, whether dominating a desk or fitting in your palm, are cold and heartless. As sappy as it sounds, good books (and you'll notice the caveat) have souls; they can be friends. Until someone is able to add warmth to a computer screen, e-books (including down-loadable or online fiction) will continue to be oddities that few people want.

And how about print-on-demand books? Well...a Xerox® by any other name (bound or not) is still a Xerox®. And while it is true that there are many worthwhile titles and authors that are currently o.p., there are most assuredly an equal or greater number of books that should never be reprinted and writers that perhaps don't deserve a few megs on some computer server much less shelf space.

Besides, the book industry as a whole had more than tech-snakeoil to think about through the year: whether it was Random House's acquisition of Golden Books in a bankruptcy auction, France-based Vivendi's purchase of Houghton Mifflin, new policies at indepedent distributors that limited access to the mass-market to small presses, AOL Time Warner's pasting on the stock market, or anthrax jitters that had publishers discarding unsolicited submissions unopened, there was more than enough to distract people from battery-operated gee-gaws. Even the record-setting box-office success of the adaptations of *Harry Potter and the Sorceror's Stone* and *The Lord of the Ring*s didn't start a new round of

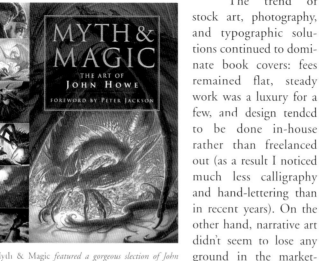

Myth & Magic *featured a gorgeous slection of John Howe's paintings. Howe's art was also well represented in Peter Jackson's long-awaited adaptation of* The Lord of the Rings: The Fellowship of the Rings. *John was one of the film's main designers (along with Alan Lee).*

the same sort of licensing/publishing frenzy that had blown up in the industry's collective face only a year or two before. Maybe some lessons were learned afterall: less *is* more.

The trend of stock art, photography, and typographic solutions continued to dominate book covers: fees remained flat, steady work was a luxury for a few, and design tendcd to be done in-house rather than freelanced out (as a result I noticed much less calligraphy and hand-lettering than in recent years). On the other hand, narrative art didn't seem to lose any ground in the marketplace, either. John Jude Palencar's paintings for *The Onion Girl* by Charles de Lint, *Kushiel's Dart* by Jacqueline Carey, and *Son of the Shadows* by Juliet Marillier [all from Tor] were remarkable examples of cool sophistication; Lisa Desimini's cover for *Dead Until Dark* by Charlaine Harris [Ace] was whimsically spooky; and Kinuko Craft's canvas for *Priestess of Avalon* by Marion Zimmer Bradley [Viking] was a finely-crafted multi-faceted jewel. Likewise I was greatly impressed by covers by Jon Foster (*Bloodtide* by Melvin Burgess [Tor]), Daniel Craig (*Ill-Made Mute* by Cecilia Dart-Thornton [Warner]), Stephan Martinere (*Cosmonaut Keep* by Ken MacLeod [Tor]), Stephen Hickman (*The Storm of Heaven* by Thomas Harlan [Tor]), Charles Vess (*Quartet* by George Martin [NESFA]), Jon Sullivan (*Always Forever* by Mark Chadbourn [Gollanz]), Mark Harrison (*Skin Folk* by Nalo Hopkinson [Warner]), Michael Koelsch (*Plutonium Blonde* by John Zakour and Lawrence Ganem [Putnam]), and Tom Canty (*The Year's Best Fantasy & Horror* edited by Ellen Datlow and Terri Windling [St. Martin's Press]). Exceptional work was also spotted by Greg Spalenka, Bruce Jensen, Tom Kidd, Charles Keegan, John Harris, Cliff Nielsen, Daniel Merriam, Doug Beekman, Gregory Bridges, and Phil Parks to name only a very few.

Back in 1998 Gary Gianni became the

Artist Randy Broecker did a more than respectable job of trying to chronicle the fantasy field in his book for Collector's Press. Over-sized and printed entirely in color, Fantasy of the 20th Century *was a delight. Cover painting by Donato Giancola.*

definitive illustrator of Robert E. Howard's character Solomon Kane with *The Savage Tales of Solomon Kane* for Wandering Star: in 2001 he added another notch to his REH belt with his equally sumptuous drawings and paintings for *Bran Mak Morn: The Last King* (also from Wandering Star). Gary also found the time to exquisitely illustrate Jules Verne's *Twenty Thousand Leagues Under the Sea* [Hieronymous Press]. Equally arresting was Tom Kidd's lush oils for *The War of the Worlds* by H.G. Wells [Books of Wonder]. Yoshitaka Amano provided art to Greg Rucka's *Elektra and Wolverine: The Redeemer*, a three volume prose story marketed to comics shops by Marvel; similarly, *Hellboy: The Bones of Giants* by Christopher Golden was the third fiction spin-off from the popular comic series, which also benefited from creator Mike Mignola's stark interior drawings. Illustrated books of note aimed at younger readers included *Mansa Musa* by Khephra Burns (paintings by Grand Masters Leo and Diane Dillon [Harcourt]), Shaun Tan's *The Red Tree* [Lothian], *Baloney (Henry P.)* by Jon Scieszka (art by Lane Smith [Viking]), and *The Shark God* by Rafe Martin (illustrated by David Shannon [Scholastic]).

The were a *lot* of single artist collections that showed up during the year, so many in fact that it got progressively harder to keep up. *The Art of Chesley Bonestell*, skillfully edited by Frederick C. Durant III and Ron Miller [Paper Tiger] was easily one of the year's best collections—and it was hardly alone. *The Art of Richard Powers* (edited by Jane Frank), Brom's second compilation, *Offerings,* [both from Paper Tiger], *Myth & Magic: The Art of John Howe* [Harper Collins UK], Ashley Wood's *Uno Fanta* [Idea+Design Works], *Koan: Paintings by Jon J Muth and Kent Williams* [Allen Spiegel Fine Arts], and *Wings of Twilight: The Art of Michael William Kaluta* [NBM] were all worth tracking down and savoring. *Skullfucker* (*gotta* love the title) by Wes Benscoter [Mondo Bizzarro] and *Anima Mundi* by Mark Ryden [Last Gasp] became instant sell-outs and just as quickly became hot properties on eBay™. Luis Royo had a

pair of books appear: *Prohibited Vol. 2* [Heavy Metal] and *Evolution* [NBM]; Heavy Metal also released *The Art of Simon Bisley* while Verotik produced *Hyper-Real: The Art of Martin Edmond*; Istvan Banyai was celebrated in ▪ ▪ ▪ [Abrams], *Animerotics: A Forbidden Culture* was a showcase for David Delamare [Collector's Press], and *The Artful Dodger: Images and Reflections* put the spotlight on *Griffen & Sabine's* Nick Bantock [Chronicle]. And there were more! Weighing down the shelves were *Paradox* by Stephen Youll [Paper Tiger], *Sentury* by Syd Meade [Oblagon], *Brushfire: Illuminations From the Inferno* by Wayne Barlowe [Morpheus International], *James Christensen* [Greenwich Workshop], *Gray Morrow: Visionary* (edited by Mark Wheatley and Allan Gross [Insight Studios]), *Haku* by Suemi Jun [Asahisonorama], and *Testament* by Frank Frazetta (edited by Cathy and I [Underwood Books]). And you couldn't forget *Sanjulian: Master Visionary*, *Rich Larson's Haunted House of Lingerie*, or *The Art of John Bolton* [all from SQP]. Good gravy, there were collections by Greg and Tim Hildebrandt, Michael Gagné, Jim Warren, Christopher Shy, Dorian Cleavenger, Fred Gambino, and David Hardy, examinations of the careers of Hal Foster and Jack Cole (art spiegelman's and Chip Kidd's *Jack Cole & Plastic Man* [Chronicle] was especially worthwhile), and retrospectives of Hieronymous Bosch and Gustav Klimt. And there was plenty that I missed.

And of course there were a number of volumes featuring a "miscellaneous" selection of creators. A personal favorite was certainly Walt Reed's *The Illustrator in America 1860—2000*, closely followed by the 42nd *Illustrators* annual [both from Watson Guptill]. I think Randy Broeker did an excellent job on *Fantasy of the 20th Century*, as did Richard Lupoff with his *The Great American Paperback* [both from Collector's Press]. *IS Art* [Insight Studios], *Visions of Spaceflight*, a catalog of Frederick Ordway's collection [Four Walls, Eight Windows], *Imagining Space* by Roger Launius and Howard McCurdy [Chronicle], *The Wildlife of Star Wars* by Bob Carrau and featuring the art of Terryl Whitlatch [also from Chronicle], and the tremendously entertain-

Chesley Bonestell finally got a book that did his influential work justice in this Paper Tiger edition, easily one of the year's best books.

ing *Blast Off!* edited by S. Mark Young, Steve Duin, and Mike Richardson [Dark Horse] were all worth searching for and snapping up.

Whew! That barely scratches the surface! Who can keep up? There was a time not too terribly long ago when books that celebrated SF and fantasy art were few and far between: when a new entry popped up there was a scramble to add it to a prized spot in our collections. Now...well, I think the quantity of titles today is a decidedly mixed blessing. Enthusiasm for the field is always laudable, but there can be too much of a good (and not so good) thing. And, yes, there were a number of books that appeared in 2001 that should not have been produced. Unless publishers start to pace themselves instead of racing to build a backlist, unless editors begin to seriously evaluate the readiness of some and the need of others, there will be an implosion. It's happened in every other genre, in every field, and the fantasy art market is rapidly reaching its saturation point. Don't misunderstand, *good* books should always be published, regardless of what else is in the market. But to fill the shelves with marginal titles hurts, rather than helps, everyone. Trust me.

But where do you find the good books? Well, pretty much everywhere. I help keep people employed at the biggest chains and the smallest mom&pop bookseller. If UPS isn't dropping off a package from Amazon regularly, they call and ask if I'm okay. But, of course, for the *real* stuff I go to Bud Plant Comic Art (catalogs are available for $3 by calling 800-242-6642, writing to P.O. Box 1689, Grass Valley, CA 95945, or checking their website at www.budplant.com). Bud and his staff are simply the best. Period.

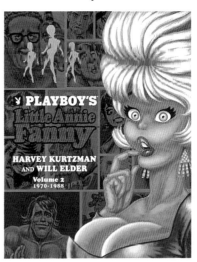

Dark Horse Comics second volume of the complete Little Annie Fanny *satirical strips from the pages of* Playboy *was enthusiastically greeted by fans. Featuring biting scripts and layouts by Harvey Kurtzman and stunning paintings by Will Elder (with occasional help from Russ Heath, Jack Davis, Bill Stout, and Frank Frazetta), "Little Annie Fanny" was the precursor to the painted comic books that are currently popular.*

C O M I C S

When I was a kid, we were divided into three comic book camps: Marvel readers, DC readers, and the I-couldn't-care-less readers. (A fourth camp—the Archie/Disney contin-

gent—were patted on the head then shoved out the door.) The Marvel and DC guys would get into it all the time, who was stronger, who was better, bla, bla, bla: real Republican/Democrat sorts of fisticuffs that rarely resulted in any serious damage (or clear victories, either). The editors at Marvel and DC informally encouraged these sorts of friendly rivalries; it was all part of the fun, but you never got the impression that there was any actual animosity between the companies. As you might've guessed, I was in Camp 3. I was just as happy to plop 12¢ into the crude comics vending machine at the Sav-On department store (a sort of low-rent precursor to Wal-Mart) for a copy of *Sergeant Rock* (and as good as Joe Kubert was, I have to admit I was a Russ Heath man) as I was for a copy of *Spider-Man*. When an issue of Russ Manning's *Magnus Robot Fighter* or Wally Wood's *Total War* turned up, I was equally happy. When I was really flush I'd swing by the magazine rack and snag a copy of *Creepy* or *Eerie* and not even acknowledge the cocked eyebrows and worried looks from my Marvel and DC friends. I never bagged, slabbed, boxed, or laminated anything (and I'm willing to bet I got—and continue to get—a lot more enjoyment out of my stuff than a lot of the more serious collectors did, do, or ever will out of theirs). Anyway, I never took any "rivalries" seriously and didn't think anyone else did either. Silly me.

A funny thing happened: long-time fans grew up and joined the ranks of the comics professionals...and they brought their partisan feelings with them. Starting in the late 1980s and continuing through the '90s it seemed that the comics community had recognized that there were some leaks in the industry's boat and everyone would have to man the pumps if it was going to stay afloat. But in 2001 it appeared that the days of friendly cooperation had come to a skretching halt: there were endless potshots between senior representatives of virtually every company at conventions, in press releases, and on Internet message boards. The game of one-

up-manship was played fast and furious. It would be easy to blame the lack of professionalism on the pressures plaguing the field: little growth, aging consumers, increased costs, losses in stock valuation, corporate boards impatient for higher returns, dissatisfied retailers, combative writers and artists, and a growing stack of lawsuits. All valid reasons to get a little short-tempered once in awhile, but I can't help but think that the bickering and backbiting, the current spate of insults and inuendos, could be traced directly back to those fanboy days of Who Is Better.

Life is a circle.

Of course, there were some great funnybooks put out in the last twelve months. Stand-outs at DC included *Wonder Woman: Spirit of Truth* (written by Paul Dini with art by Alex Ross), the collaborative *JLA: Riddle of the Beast* (written by Alan Grant with a cadre of artists including Jon Foster, Carl Critchlow, Gregg Staples, Hermann Mejia, and an army of other worthys), *Harley & Ivy: Love On the Lam* (written by Judd Winick with art by Joe Chiodo), and *Desperadoes: Quiet of the Grave* (under the WildStorm imprint, written by Jeff Mariotte with art by the legendary John Severin). There were great covers by Tim Bradstreet (*Hellblazer*), Dave McKean (various *Sandman* tie-ins), and Phil Noto (*Birds of Prey*). Also noted were some exceptional works by Brian Bolland, John Bolton, Teddy Kristiansen, Adam Hughes, and Bill Wray. DC produced a number of excellent archive collections of classic comic titles, though at $50 a pop they were out of the price range of the average reader.

Artistic diversity seemed to be more noticable at Marvel in 2001, thanks in no small part I'm sure to the tastes of artist-turned-editor-in-chief Joe Quesada. Tim Sale's *Daredevil: Yellow* (written by Jeph Loeb) and Richard Corben's take on the Hulk (*Banner*, story by Brian Azzarello) were tip-top. Ashley Wood, Bill Sienkiewicz, Julie Bell, Alex Ross, Glen Fabry, Duncan Fegredo, and Steve Rude all created memorable work. Marvel, too, actively contributed to the market for archive collections with a modestly priced selection of books (a personal favorite was the *Captain America* volume featuring the art of Jack Kirby and Jim Steranko).

Naturally the year wouldn't have been complete without Dark Horse releasing a Hellboy miniseries by Mike Mignola. *Hellboy:*

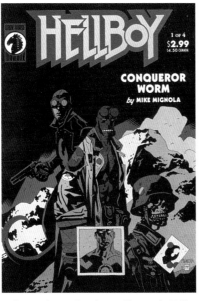

Mike Mignola created another installment in his Hellboy *series before taking time off to work on a film adaptation.*

Conqueor Worm was easily one of the highlights of 2001. The staccato noirish writing, powerful minimalist art, and frankly hilarious dialogue makes Mignola's work addictive. (I gush like a geek everytime I see Mike: I've got to learn to stop that.) Other DH work of merit included Craig Russell's *Ring of the Nibelung* and a string of brilliant *Star Wars* covers by Jon Foster: I can't say enough positive things about Jon's art. And how about their second volume of *Little Annie Fanny* by the astonishing team of Harvey Kurtzman and Will Elder (with a little help from Bill Stout, Jack Davis, and friends)? Great satire and great art that was too irresistible to pass by.

Some noteworthy art that appeared under other publishers' banners included Rick Berry's string of covers for *The Victorian* [Penny-Farthing Press], Charles Vess' *Rose* (with Jeff Smith) [Cartoon Books], Dave Dorman's first stab at sequential storytelling, *Wasted Lands* (written by Del Stone, Jr.) [Image], and Ashley Wood's manic oil/digital covers for various issues of *Spawn* and *Sam & Twitch* [also from Image].

As intimated earlier, the market for graphic novels and comics-related books continued to grow in the traditional chain bookstore and library trades during the year and publishers were happy to feed the market. Besides archive editions collecting the early adventures of *Batman*, *The Spirit*, and *Spider-Man*, there was a new book by Bill Waterson (*Calvin & Hobbes: Sunday Pages 1985-1995* [Andrews McMeel]) commemorating an exhibit at Ohio State University, a long-overdue collection of Antonio Prohias' "Spy Vs Spy" *Mad* feature (*Spy Vs Spy: The Complete Casebook* [Watson-Guptill]), and Les Daniel's latest in his series devoted to DC's superheroes (*Wonder Woman Masterpiece Edition* [Chronicle], which also featured a dandy WW action figure sculpted by Joe DeVito). Other worthwhile titles included *The Great Women Cartoonists* by Trina Robbins [Watson-Guptill], *Mutts: Sunday Mornings* by Patrick

McDonnell [Andrews McMeel], *Marvel: The Characters & Their Universe* by Michael Mallory [Hugh Lauter Levin], *The Warren Companion* edited by David A. Roach and Jon B. Cooke, *Little Lit: Strange Stories for Strange Kids* edited by art spiegelman and François Mouly [Harper Collins], and *Arnold Roth Freelance: A 50 Year Retrospective* [Fantagraphics].

The mix of magazines geared toward the comics market remained unchanged: the acidic *Comics Journal* was the quasi-*60 Minutes* of the industry while I guess *Wizard* was the QVC ("Everything is just so wonderful you should buy TEN now!"). Jon Cooke's *Comic Book Artist* cheerfully examined comics of the 1960s to the '80s and Russ Cochran's *Comicbook Marketplace* was a must-have for the classic collector. But (where's my soapbox again? ahh, there it is!) with as large and complicated as the comics industry is, there is more of a need now than ever before for an impartial trade journal that would have everyone's interests and concerns at heart. Comics is divided up into a group of hostile territories, each coveting something they think the other has. They periodically exchange artillery barrages that wind up achieving nothing but more artillery barrages. There is no professionally unifying forum, no mediators or independent promoters, for the comics field: maybe if there were, not only would the art form be taken more seriously, but the trap-

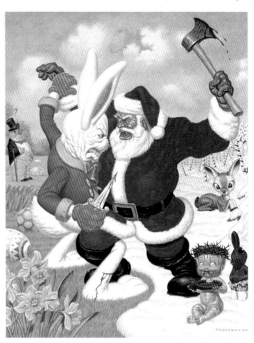

One of the major shows of 2001 was a retrospective of Todd Schorr's work at the Art and Culture Center of Hollywood, FL. His "A Clash of Holidays" [above] caused such a stir among locals that radio stations were clogged with peabrains (including state and local politicians) calling for censorship. The humor, obviously, was lost on them.

pings of legitimacy and professionalism might eventually rub off and curb some of the petty public displays that we witnessed in 2001.

It's time for the industry to grow up. Again.

DIMENSIONAL

I was talking earlier about saturation points and I think the dimensional market reached theirs last year. A plethora of product combined with a softening in the economy added up to a lot of unsold inventory and difficult times for companies and creators alike. Some tried to jump on the Hallmark bus and produced lines of figural Christmas ornaments; others moved into action figures and toys; still others scaled back prices and production and took a wait-and-see attitude.

Part of the problem, of course, was that there was an awful lot of fish feeding in the same small pond: regardless of potential, the market in this country for comic and fantasy-themed statues and collectibles is relatively modest. And at a cost of anywhere from $50 to $250 a shot, consumers started thinking about more than just available shelf space when new statues and busts were announced.

In the model market sculptors and manufacturers were routinely ripped off by bootleggers who would recast an original kit and sell it to fans for a fraction of the cost. Much like pirate videos of hit movies, bootleg copies of a potentially successful kit started competing in the marketplace within days or weeks of the original's release. A lot of frustrated sculptors threw up their hands and started hunting for other ways to earn a living. If you notice a void in original "garage" model kits and figurines in the next few years, blame the thieves who don't respect copyrights and the people they sell to.

Busts were the hot thing in the market last year (and let's keep it clean here): Randy Bowen sculpted virtually the entire Marvel Universe, Tim Bruckner tackled the DC side of the market (his "Superman" and "Batman" were both especially nice), Moore Creations featured a line based on *Buffy the Vampire Slayer*, and Sideshow/Weta meticulously captured the characters from the first *Lord of the Rings* film. I was less enamored with the majority of statuettes released in 2001 than in years past: only a handful seemed to exhibit both imagination and craft. Tim Bruckner's interpretation of the *Detective #38* cover was spot-on and Barsom's sculpt of "Poison Ivy" (from Bruce Timm's design) was one of the cutest figures of the year [both from DC Direct]. I liked Randy Bowen's "Sue Storm" (invisible version) quite a bit [Bowen Design] and thought Steve West's "Deadly Awakening" model kit was a knock-out [Cellar Cast]. And it won't surprise anyone that I *had* to buy Katsya Terada's sculpture of "Hellboy" [Dark Horse/Koto, Inc.]. I couldn't help myself.

Naturally there were a number of figures available to the mainstream collector market: Disney figures, Real Musgrave's "Pocket Dragons", Will Bullas' whimsical animals from the Greenwhich Workshop, some intricate Michael Whelan dragons and several nice bronzes based on Boris Vallejo's art from the Franklin Mint, all vied for our attention.

EDITORIAL

I've been so mouthy this time, I'm going to have to buckle down and race toward the end. *Analog* ran some nice covers by George Krauter, Vincent Di Fate, David Egge, and Dominic Harman; Fred Gambino was the stand out on *Asimov's SF*, *Absolute Magnitude #15* sported a dandy painting by Bob Eggleton, and James Christensen provide a beautiful cover for *The Leading Edge #41*. I also spotted worthwhile pieces by Mike Bohatch on *The Third Alternative* and George Barr on *Weird Tales*. *Aboriginal SF* was the year's fatality among the fiction magazines.

Jim Vadeboncoeur, Jr. took the plunge into publishing with the over-sized *ImageS* (www.bpib.com/images.htm), devoted to vintage art, while *Illustration* made an equally impressive debut with its focus on 1950s–1970s creators. A third issue of *Art Visionary* appeared and there were a pair of how-to magazines, *Draw!* and *Sketch*.

Out of genre, Greg Manchess painted a superb primitive man for the cover of 7/23 issue of *Time*, *Juxtapoz* was an eye-popping forum for art-on-the-edge, Istvan Banyai depicted Santa running afoul of airport security on the 12/3 issue of *The New Yorker*, and *Playboy*...

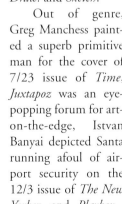

Drawing upon Jim Vadeboncouer, Jr.'s encyclopedic knowledge (and extensive collection), ImageS premiered as a colorful resource for fans of pre-1930s illustration.

well, *Playboy* is still the most visually arresting magazine on the newsstand. It's fun, it's consistently fresh, and art director Tom Staebler and staff utilizes today's best illustration talent. It's a pleasant surprise every month–and how many magazines can you say *that* about?

Still the best way to track the comings and goings in our field is to read *Locus*: sample issue $8 from P.O. Box 13305, Oakland, CA 94661. After 35 years, you gotta figure they're doing *something* right!

INSTITUTIONAL

In the space left I can't really do justice to all of the tremendous art that appeared as, in, or on a wondrous variety of products, formats, and venues. There were a lot of prints (by the always delightful Scott Gustafson, Travis Charest, Yoshitaka Amano, Joseph Michael Linsner, and Charles Keegan), calendars (by Boris Vallejo & Julie Bell, Michael Whelan, and H.R. Giger, naturally), cards, film design (Alan Lee, John Howe and company helped bring *The Lord of the Rings* to life, and consider the computer masters involved with *Final Fantasy*, *Shrek*, and *Monsters, Inc.*), game designs, gallery shows (Todd Schorr and Kent Williams), and more collectibles than you could shake a stick at. The best I can do is steer everyone toward the Institutional Category in the book for a taste of what the year offered.

For those yearning to own originals two of the best places to shop were Worlds of Wonder, (P.O. Box 814, McLean, VA 22101, www.wow-art.com) and Graphic Collectible (22 Blue Hills Dr, Saugerties, NY 12477, www.graphiccollectibles.com). I can recommend both highly.

IN PASSING

In the first year of the new millennium we said farewell to these notable members of the arts community:

Maurice de Bevére [b. 1923], comic artist.
Herbert Block [b. 1909], cartoonist.
Henry Boltinoff [b. 1914], comic artist.
Johnny Craig [b. 1926], comic artist/writer.
Chuck Cuidera [b. 1915], comic artist.
Dan Decarlo [b. 1919], comic artist.
George Evans [b. 1920], comic artist.
Ronn Foss [b. 1939], comic artist.
George Gately [b. 1928], cartoonist.
Dave Graue [b. 1926], cartoonist.
William Hanna [b. 1910], animator.
Mentor Huebner [b. 1918], film designer.
Hank Ketcham [b. 1920], cartoonist.
Josh Kirby [b. 1928], artist.
Fred Lasswell [b. 1917], cartoonist.
Gray Morrow [b. 1934], comic artist.
Maurice Noble [b. 1910], film designer.
Seymour V. Reit [b. 1918], comic artist.
Mischa Richter [b. 1910], cartoonist.
Ed "Big Daddy" Roth [b. 1932], artist. †

Spectrum 9 Call For Entries poster by Tim Holter Bruckner.

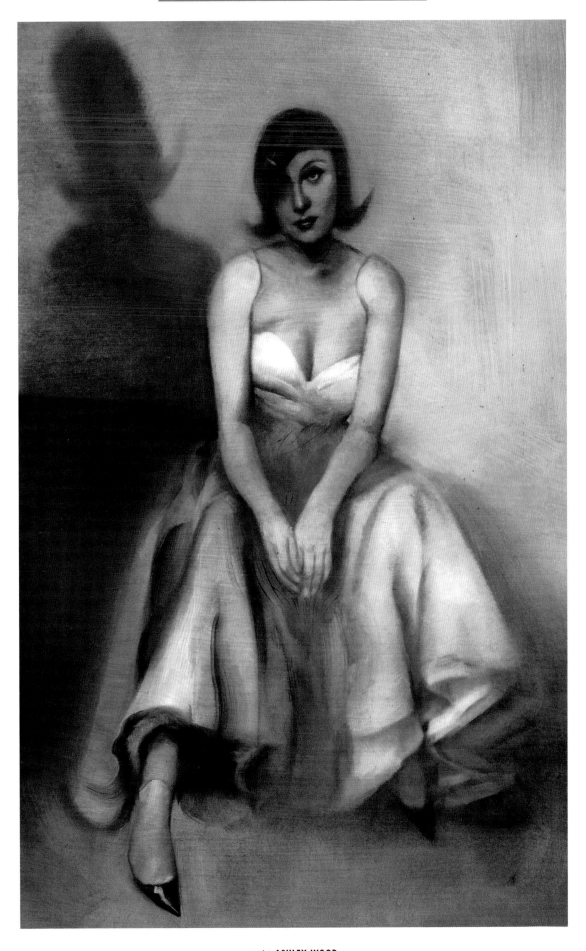

artist: **ASHLEY WOOD**
art director: Ashley Wood *client:* Idea & Design Works *title:* PopBot Blue *medium:* Oil/digital *size:* 8 1/2″x11″

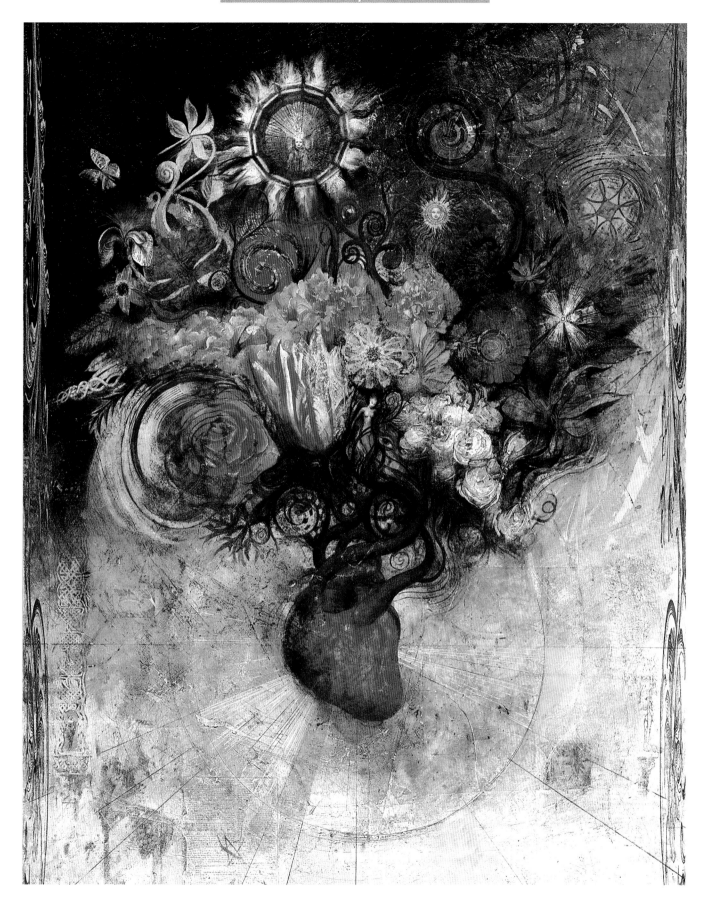

artist: **GREG SPALENKA**

art director: Anthony PaDilla client: Art Institute of Southern California title: Art Heart medium: Mixed size: 27"x40"

1

2

3

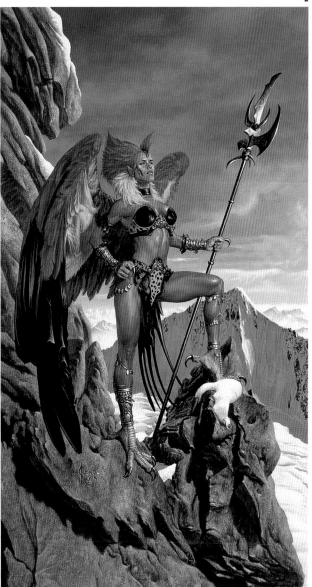

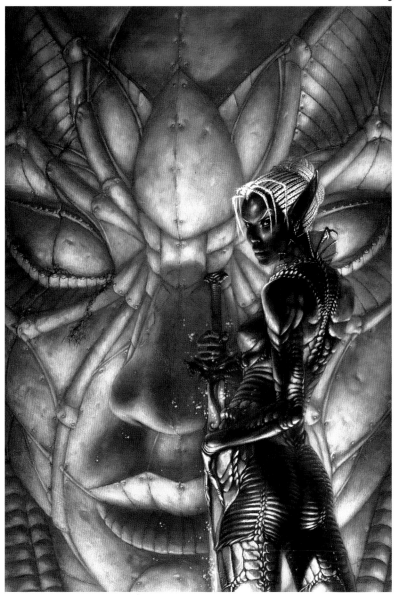

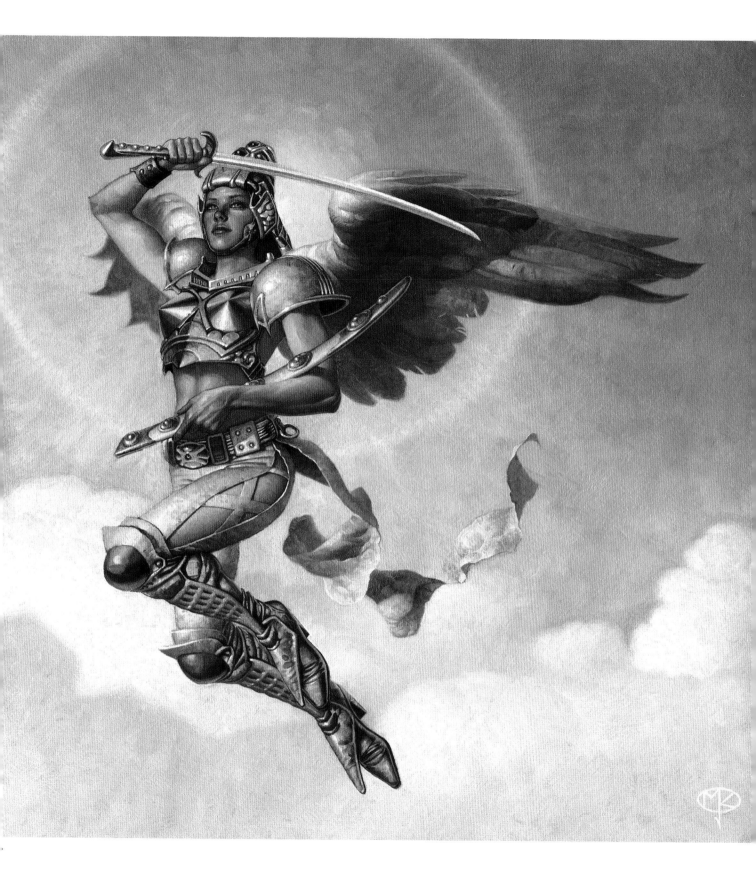

Advertising

1
artist: **Glen Orbik**
art director: Peter Bickford
client: Human Computing
title: Comic Base #6
medium: Oil
size: 17"x22"

2
artist: **Cory Strader**
client: Stainless Steel Studio
medium: Digital

3
artist: **Douglas Smith**
art director: Hilde McNeil
designer: Hilde McNeil
client: Pioneer Theater Company
title: The Mystery of Edwin Drood
medium: Scratchboard/watercolor
size: 8"x11"

4
artist: **Wes Benscoter**
client: BizarreArt
title: Bird Watcher
medium: Acrylic/digital
size: 7 1/2"x9"

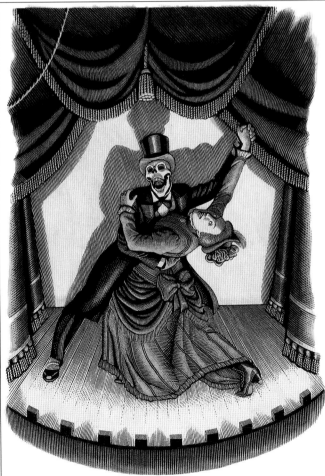

1

2

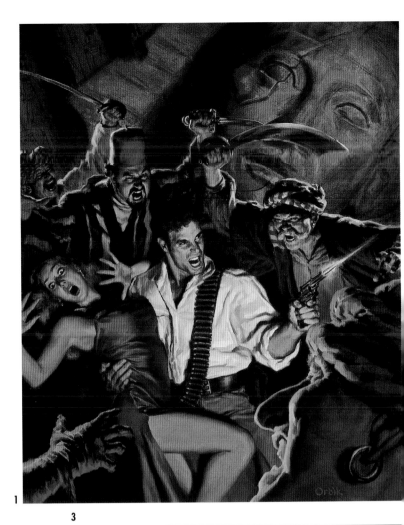

3

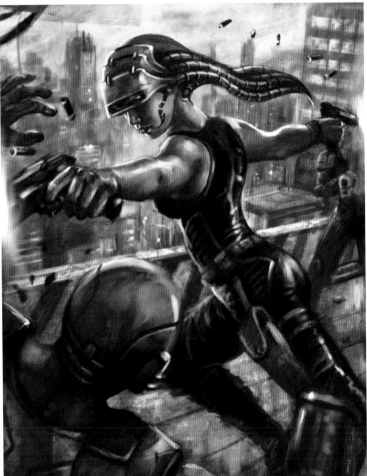

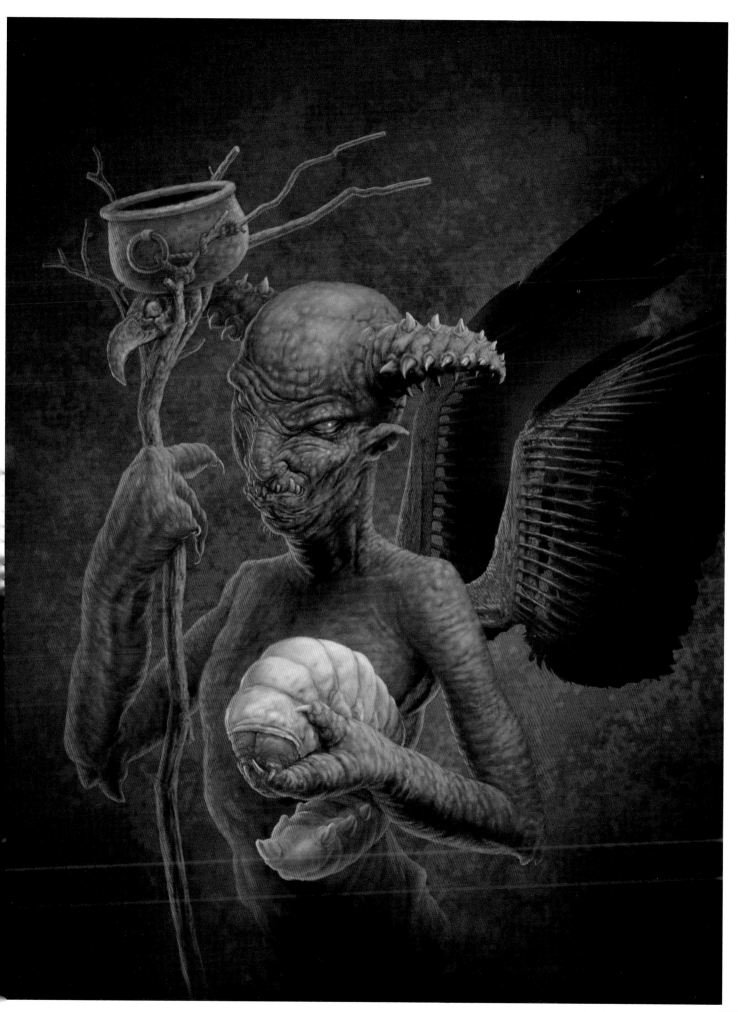

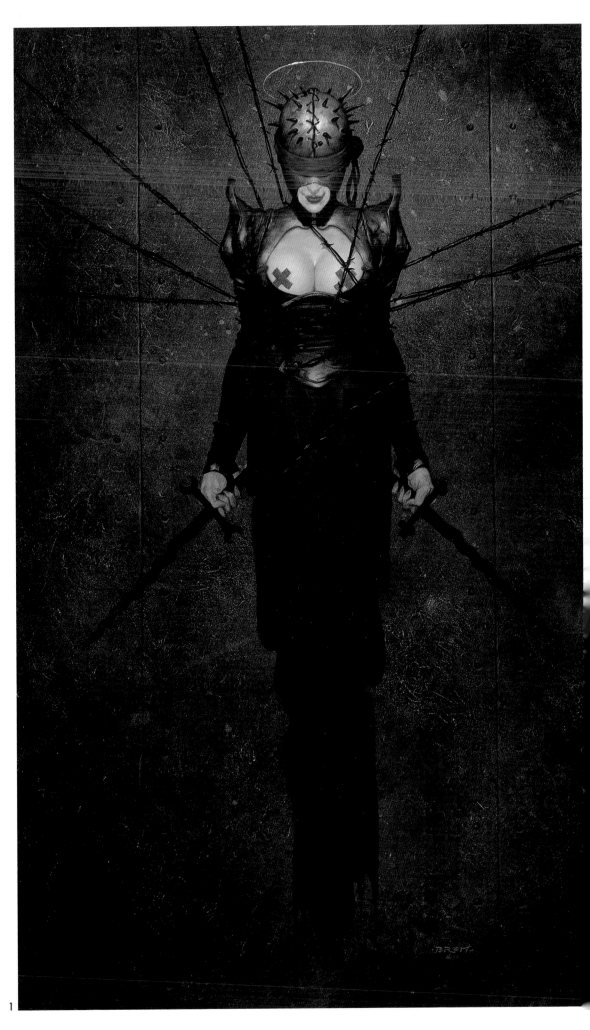

1

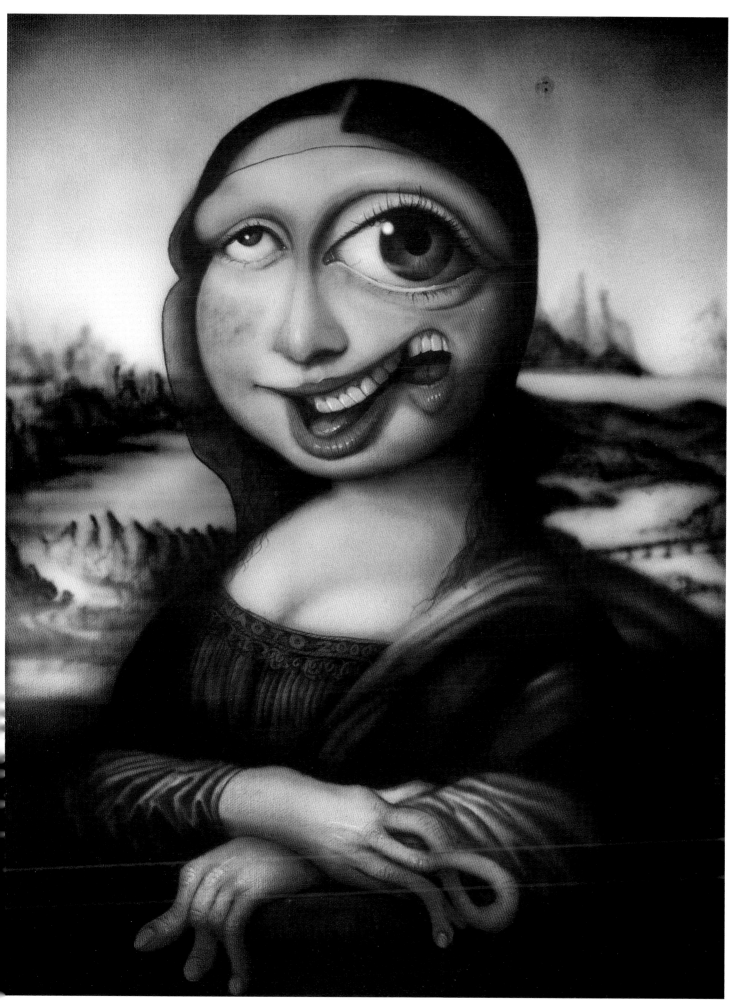

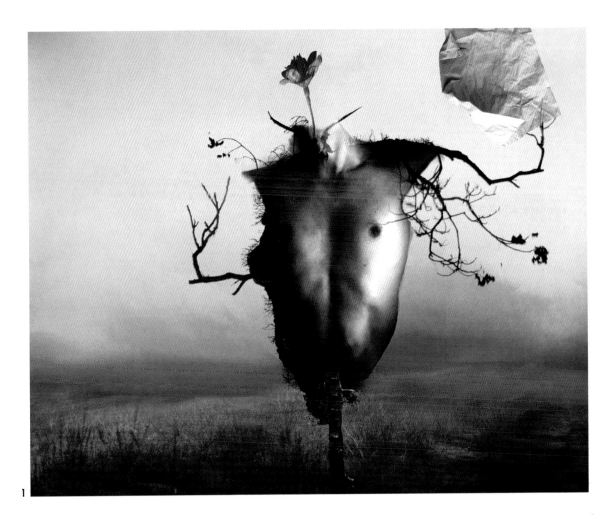

1

2

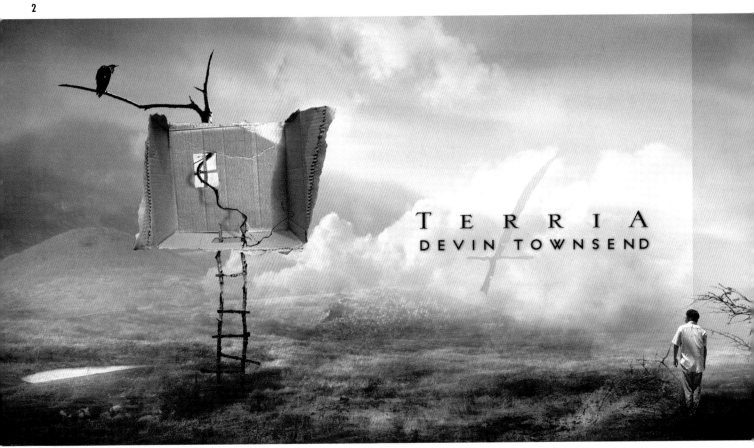

TERRIA
DEVIN TOWNSEND

3

1
artist: **Vince Natale**
art director: Brian Bourke
designer: Brian Bourke & Associates
client: Chicago Navy Pier
title: Dinofest
medium: Oil
size: 15"x20"

2
artist: **Ashley Wood**
art director: Ashley Wood
designer: Ashley Wood
client: Idea + Design Works
title: Savage Membrane
medium: Oil/digital
size: 8 1/2"x11"

3
artist: **Jerry Lofaro**
art director: Michelle Pruett/Jay Casmirri
client: Arush Entertainment
title: Primal Prey
medium: Acrylic
size: 14"x20"

4
artist: **Gregory Manchess**
art director: Jim Burke
client: Dellas Graphics
title: First Contact
medium: Oil on canvas
size: 18"x22"

1

2

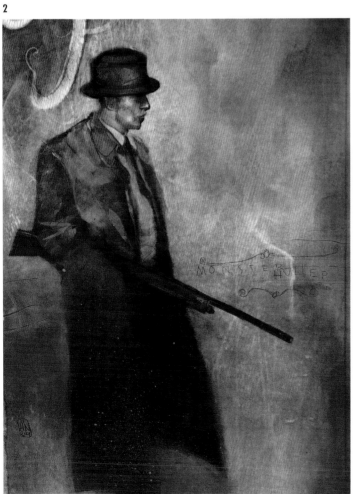

3

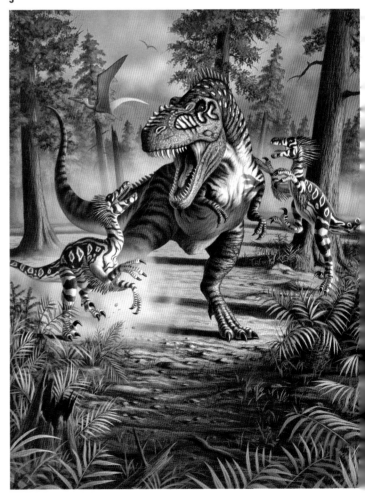

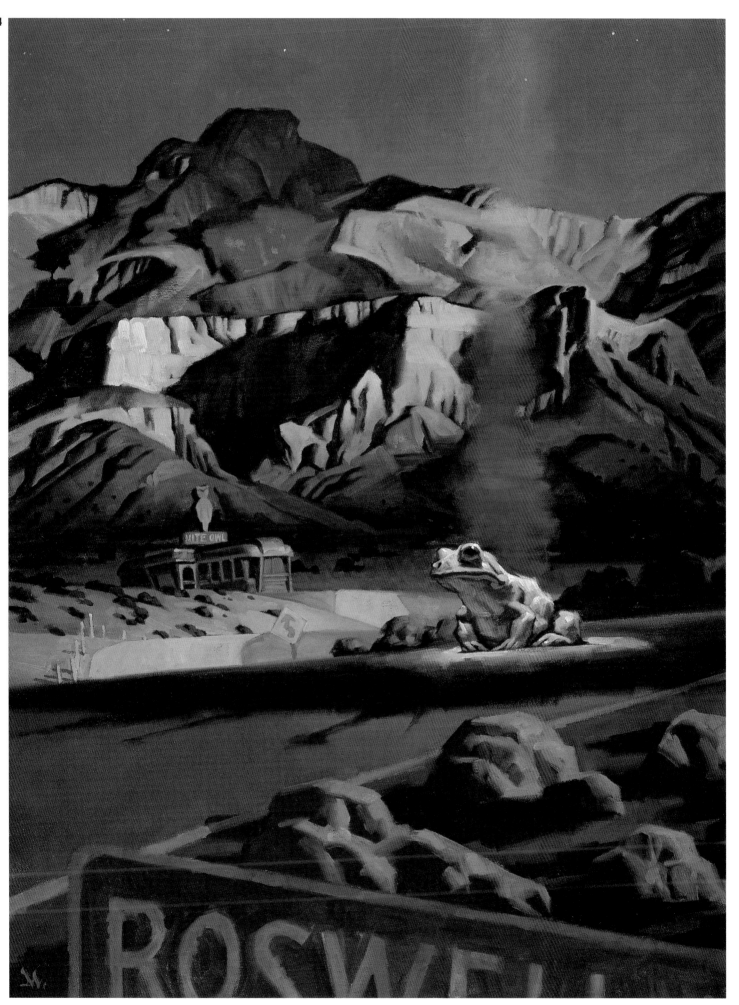

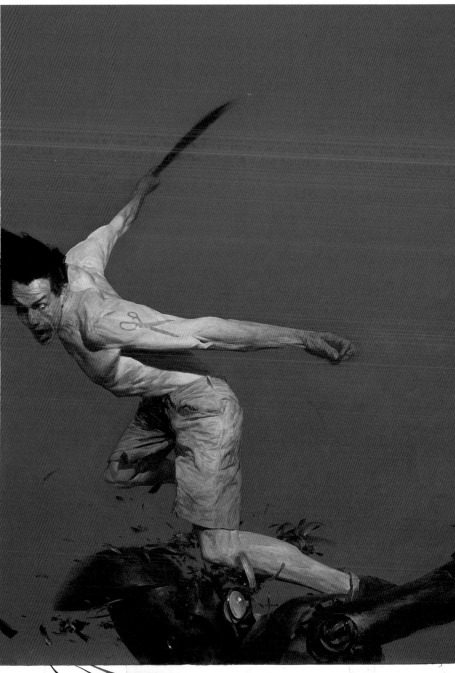

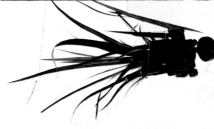
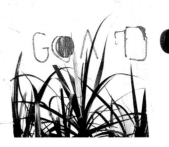

artist: **PHIL HALE**

art director: Robert Weiner client: Donald M. Grant Books title: Goad medium: Oil

note: *Juror Phil Hale was excluded from the voting for this award.*

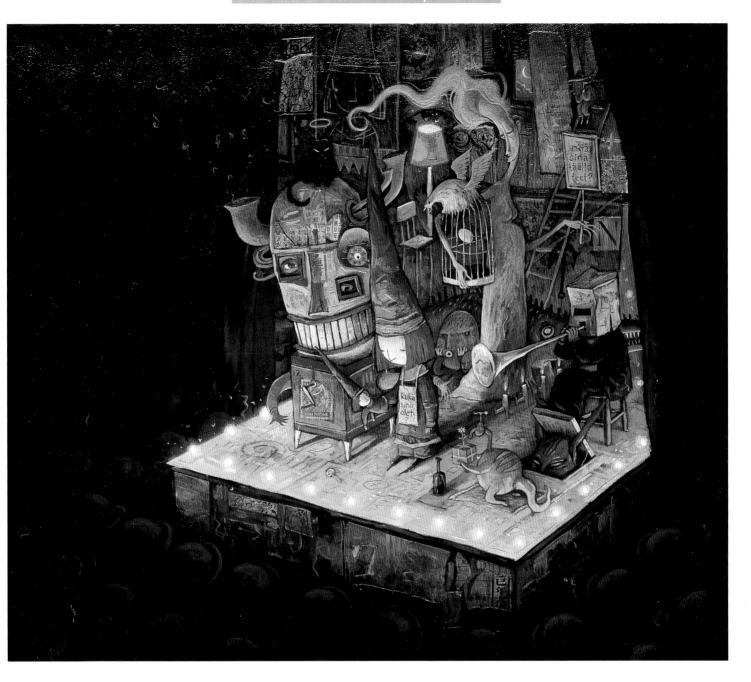

artist: **SHAUN TAN**
art director: Shaun Tan *client:* Lothian Books *title:* Sometimes you just don't know what you are supposed to do *medium:* Oil/acrylic/collage

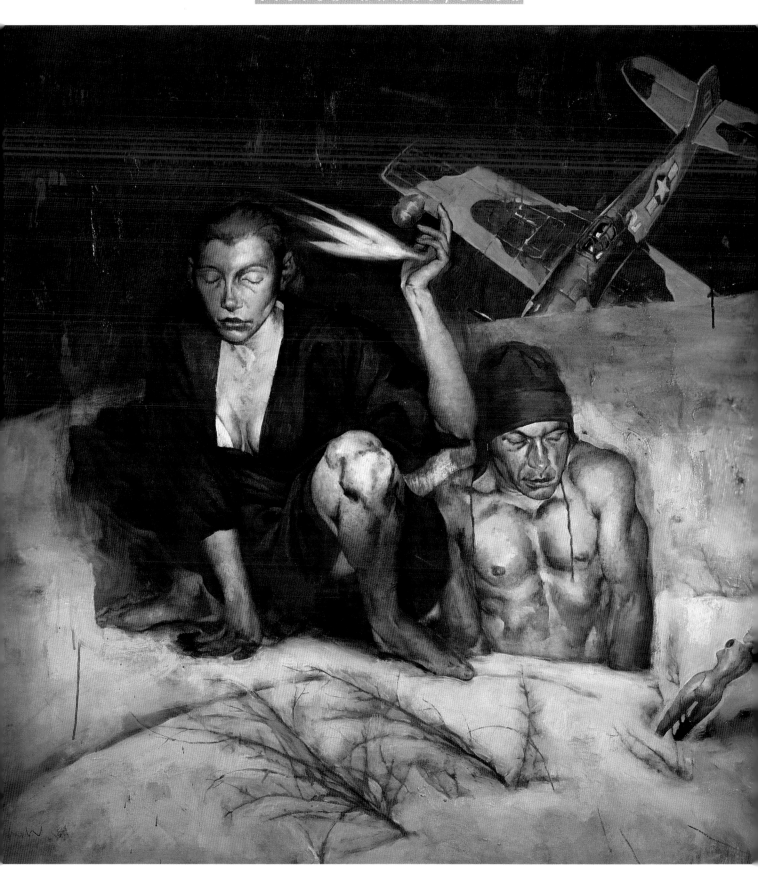

artist: **KENT WILLIAMS**

art director: Kent Williams designer: C.T. Edwards client: Allen Spiegel Fine Art title: Crash—Bento cover size: 60"x48" medium: Oil

1

artist: **John Picacio**
art director: Marty Halpern
client: Golden Gryphon Press
title: The Fantasy Writer's
Assistant
medium: Oil/digital
size: 13¼"x9"

2

artist: **David Seeley**
art director: Irene Gallo
client: Tor Books
title: Archform Beauty
medium: PhotoDigital

3

artist: **Dick Krepel**
art director: Jill Bossert
client: Society of Illustrators
title: Thorny Lies
medium: Mixed
size: 13"x16"

2

3

B o o k

1
artist: **Gary A. Lippincott**
art director: Toby Schwartz
client: BookSpan/Science Fiction Book Club
title: The Other Wind
medium: Watercolor
size: 16"x20"

2
artist: **Daniel R. Horne**
client: Meisha Merlin
title: Myth Book 1
medium: Oil on masonite
size: 22"x30"

3
artist: **Gary Gianni**
art director: Marcelo Anciano
client: Wandering Star
title: Hour of the Dragon
medium: Oil
size: 30"x40"

4
artist: **Gary Gianni**
art director: Marcelo Anciano
client: Wandering Star
title: The People of the Black Circle
medium: Oil
size: 30"x40"

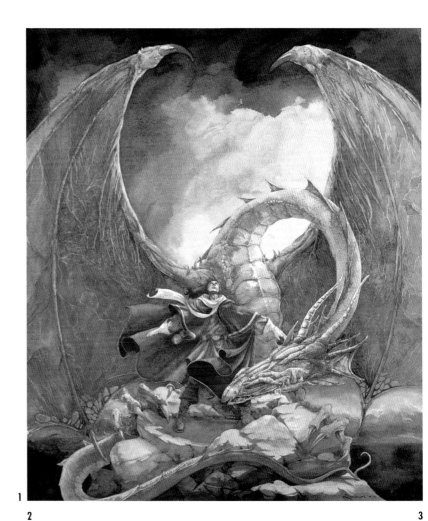

1

2

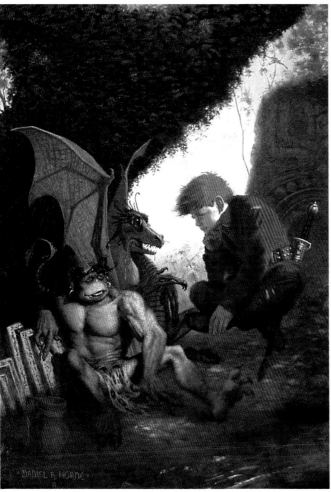

3

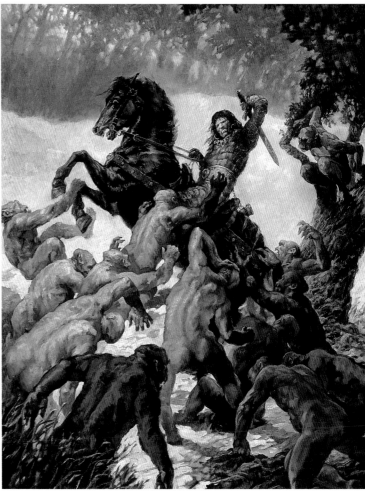

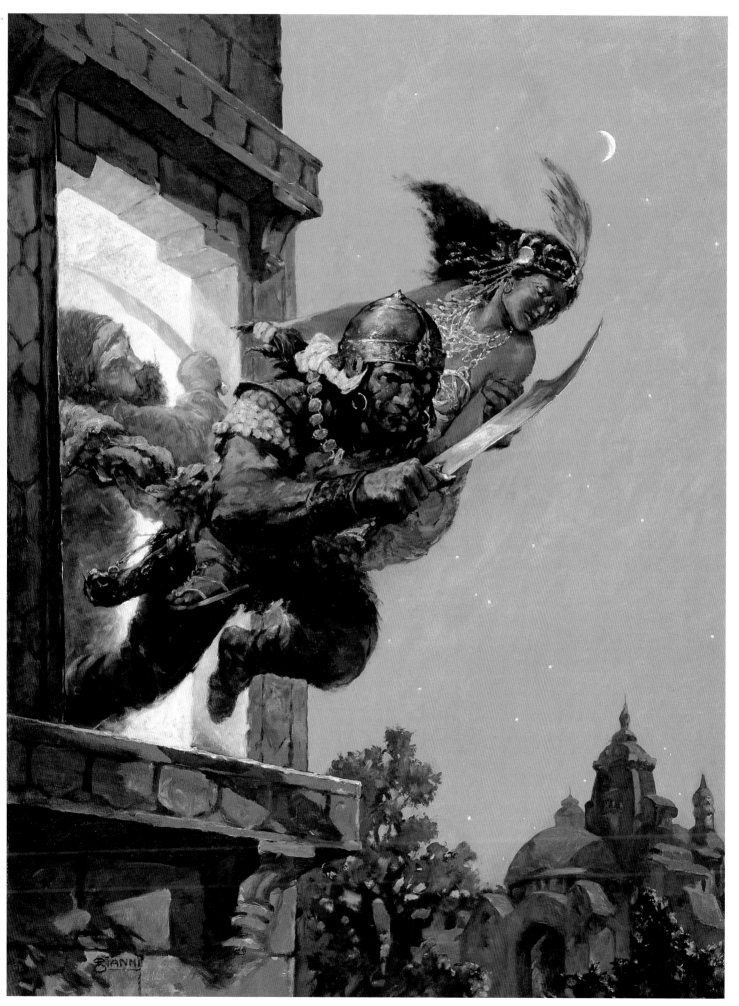

B O O K

1
artist: **Robh Ruppel**
art director: Robh Ruppel
client: Lyrael World
title: Descending
medium: Digital

2
artist: **Mark Harrison**
art director: David Stevenson
client: Ballantine Books
title: Diuturnity's Dawn
medium: Acrylic
size: 11"x18"

3
artist: **Stephan Martiniere**
art director: Irene Gallo
client: Tor Books
title: American Zone
medium: Digital

4
artist: **Bruce Jensen**
art director: Irene Gallo
client: Tor Books
title: Maelstrom
medium: Digital
size: 6½"x9½"

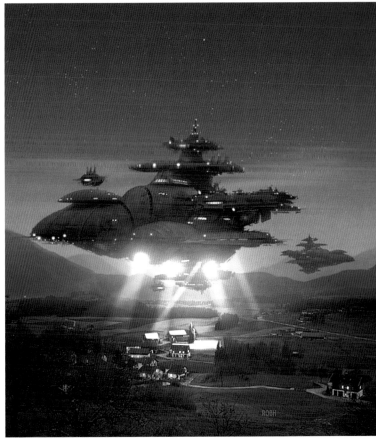

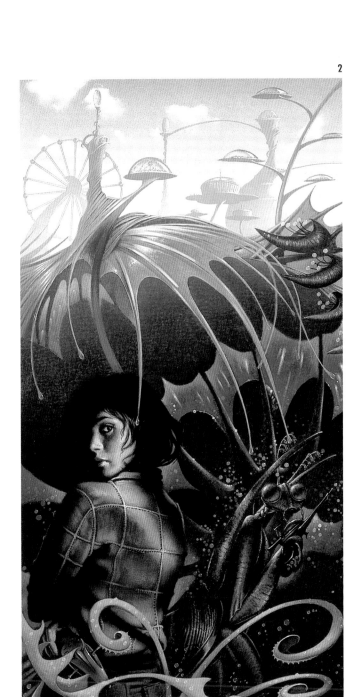

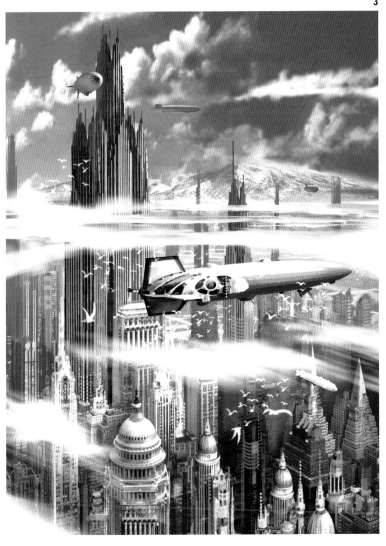

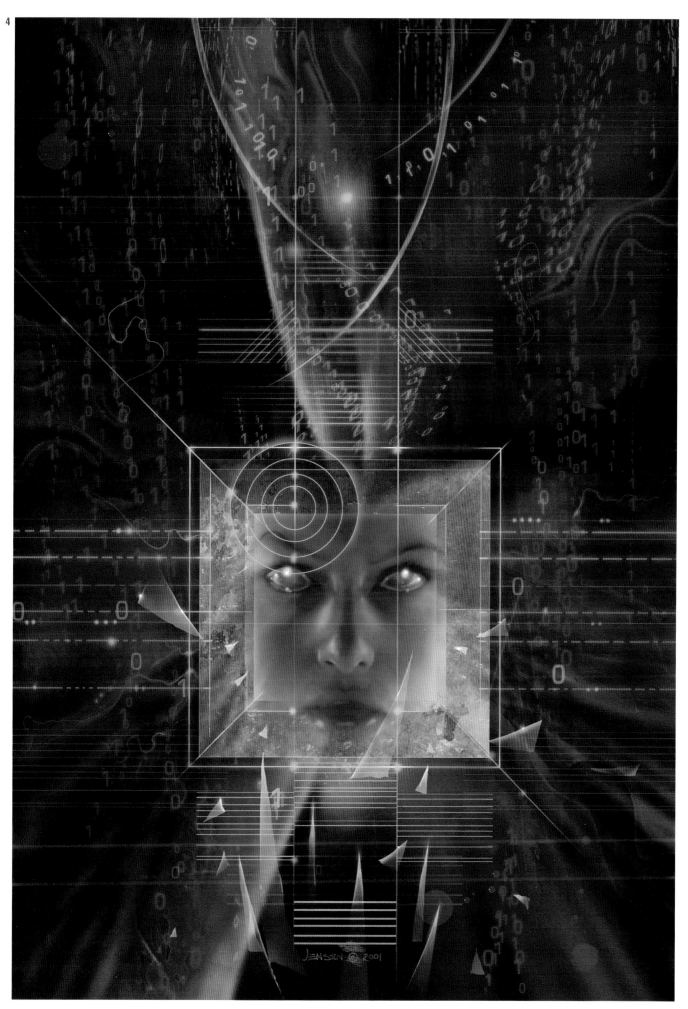

JENSEN © 2001

B O O K

1
artist: **Shaun Tan**
art director: Shaun Tan
client: Lothian
title: Darkness overcomes you
medium: Oil
size: 51cmx43cm

2
artist: Patrick Arrasmith
art director: Kristen M. Pettit
client: Parachute Press
title: Losers (Haunting Hour)
medium: Scraperboard
size: 12"x9"

3
artist: **Tony DiTerlizzi**
editor: Kevin Lewis
designer: Greg Stadnyck
client: Simon & Schuster
title: The Spider & The Fly
medium: Gouache
size: 28"x13"

4
artist: **Tony DiTerlizzi**
editor: Kevin Lewis
designer: Greg Stadnyck
client: Simon & Schuster
title: The Spider & The Fly
medium: Gouache
size: 28"x13"

5
artist: **Z-Ko Chuang**
title: The Animal Village
medium: Acrylic
size: 15"x6¹/2"

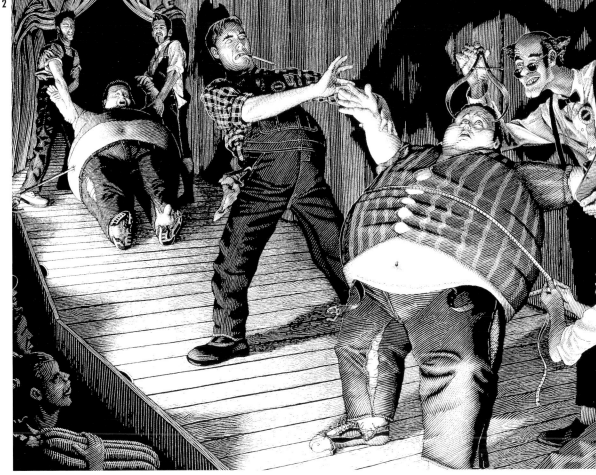

1

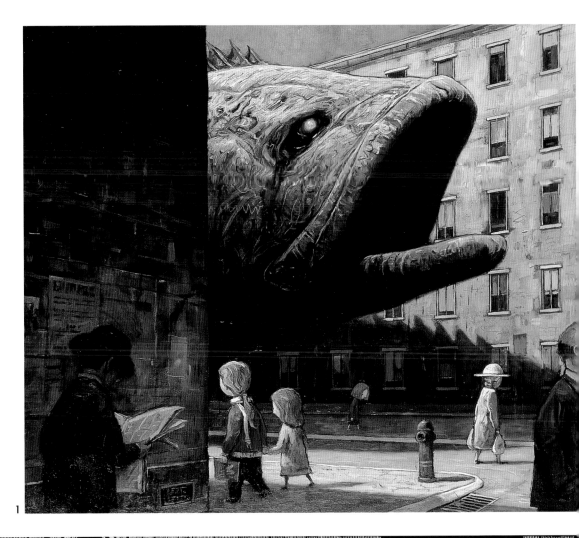

2

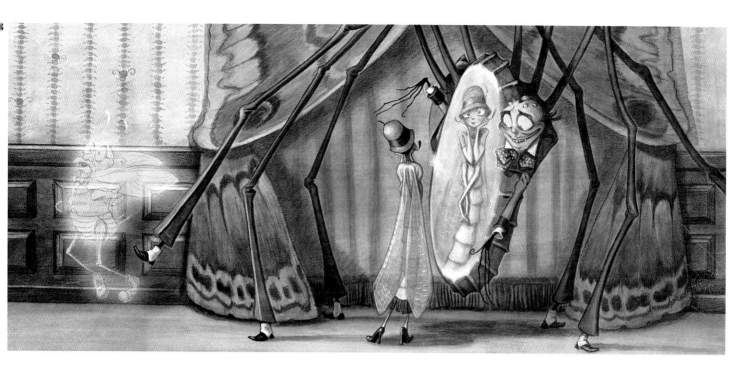

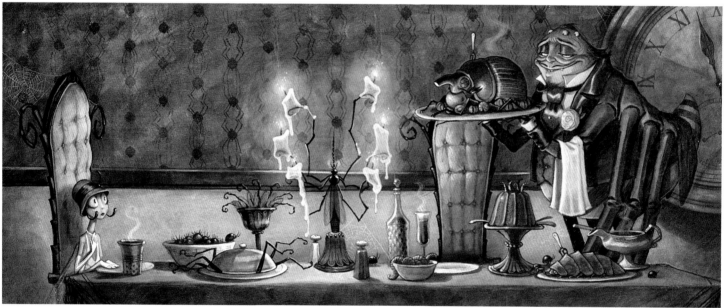

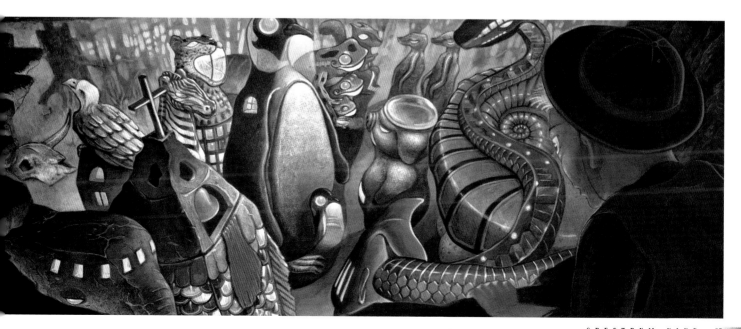

B O O K

1
artist: **Vince Natale**
art director: Susan Lurie
client: Parachute Publishing
title: The Nightmare Room—
 "Dear Diary, I'm Dead"
medium: Oil
size: 8"x9"

2
artist: **Eikasia**
client: Étoiles Vives
title: Lestoz
medium: Digital
size: 5"x7"

3
artist: **David Ho**
art director: David Ho
title: One Man's Ceiling is
 Another Man's Floor
medium: Digital
size: 8½"x11"

4
artist: **David Bowers**
art director: Kathleen Flanigan
client: Harper Collins
title: Floating Girl
medium: Oil
size: 12"x17½"

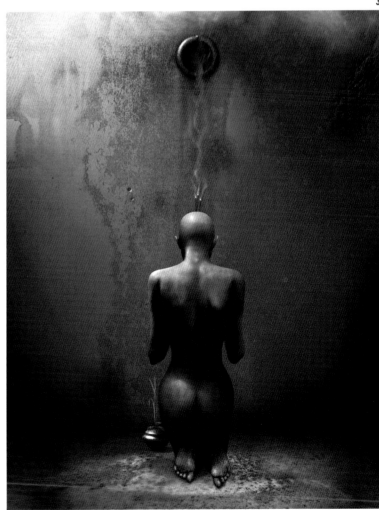

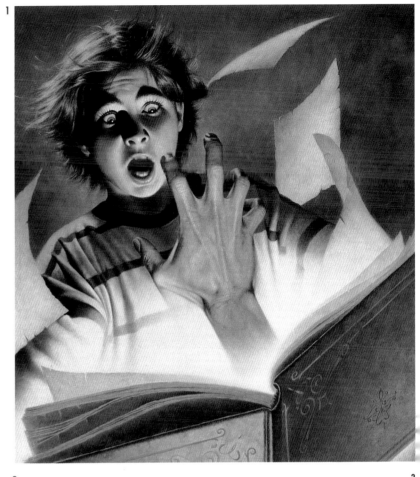

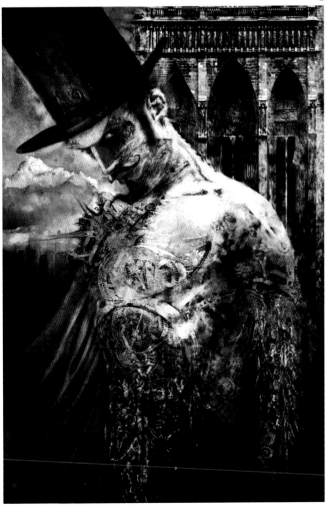

4

B o o k

1
artist: **Beet**
art director: Jim Pinto
client: Alderac Entertainment Group
title: Rokugan—Oriental Adventures
medium: Digital

2
artist: **Marc Sasso**
art director: Rob Boyle
client: FanPro
title: The Order of the Temple
medium: Mixed/digital

3
artist: **Omar Rayyan**
art director: Debra Sfetsios
client: Simon & Schuster
title: The Troll King
medium: Watercolor
size: 10³/₄"x14¹/₂"

4
artist: **John Zeleznik**
client: Palladium Books
title: Rifts: Book of Magic
medium: Acrylic
size: 12"x16"

5
artist: **Scott Grimando**
art director: Steve Roman
designer: Grimstudios.com
client: iBooks
title: Nightwings
medium: Digital
size: 8¹/₂"x11"

1

3

5

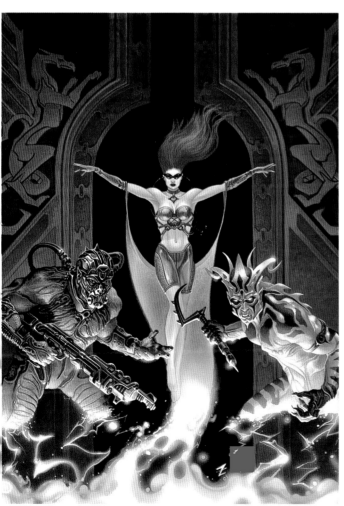

Book

1
artist: **Vincent Di Fate**
art director: Irene Gallo
client: Tor Books
title: Dark As Day
medium: Arcylic

2
artist: **Paul Youll**
art director: David Stevenson
client: Ballantine Books
title: Onslaught: Demontech
medium: Oil
size: 18"x24"

3
artist: **Phil Hale**
client: Donald M. Grant Books
title: Coo-coo
medium: Oil

4
artist: **Ashley Wood**
art director: Ashley Wood
designer: Ashley Wood
client: Idea & Design Works
title: PopBot Alpha
medium: Oil/digital
size: 8½"x11"

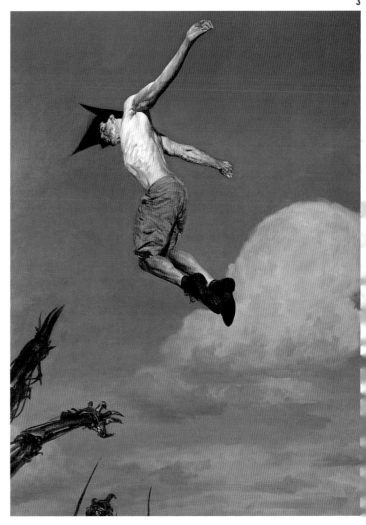

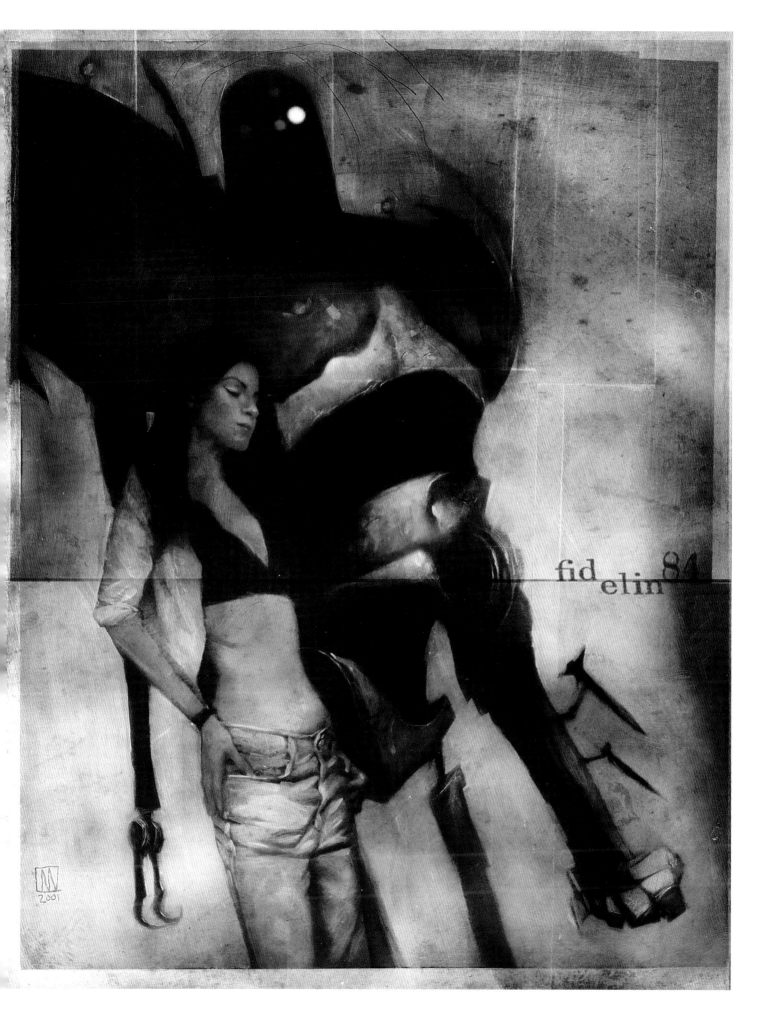

fid elin 84

Bᴏᴏᴋ

1
artist: **David Bowers**
art director: Kathleen Flanigan
designer: Karin Paprocki
client: Harper Collins
title: A Tale of Time City
medium: Oil
size: 12"x17³/4"

2
artist: **Jody A. Lee**
art director: Elizabeth Wollheim
client: DAW Books
title: The Serpent's Shadow
medium: Oil/acrylic/ink
size: 22"x27"

3
artist: **Michael Whelan**
art director: Irene Gallo
client: Tor Books
title: Legend
medium: Acrylics on panel
size: 24"x36"

4
artist: **Cliuelo**
client: Dac Editions
medium: Acrylic
size: 10"x14"

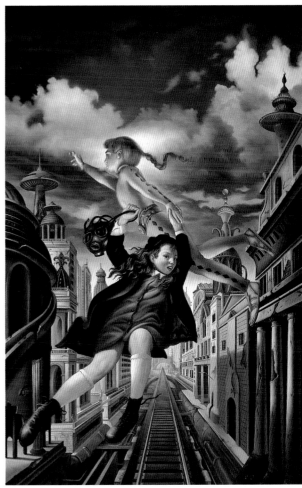

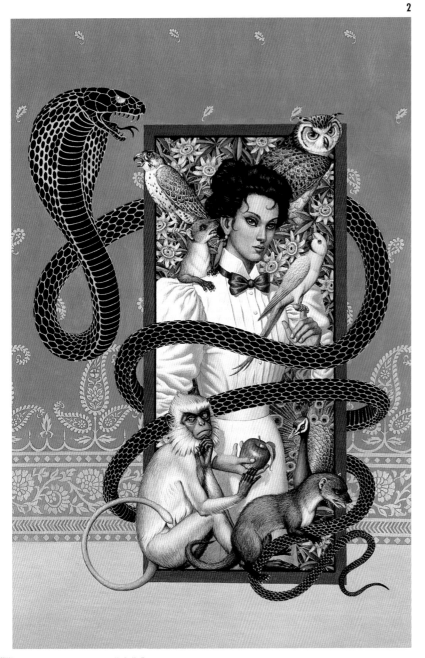

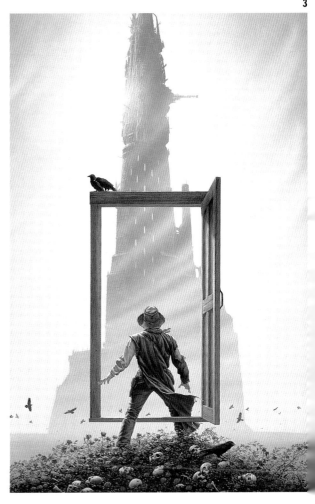

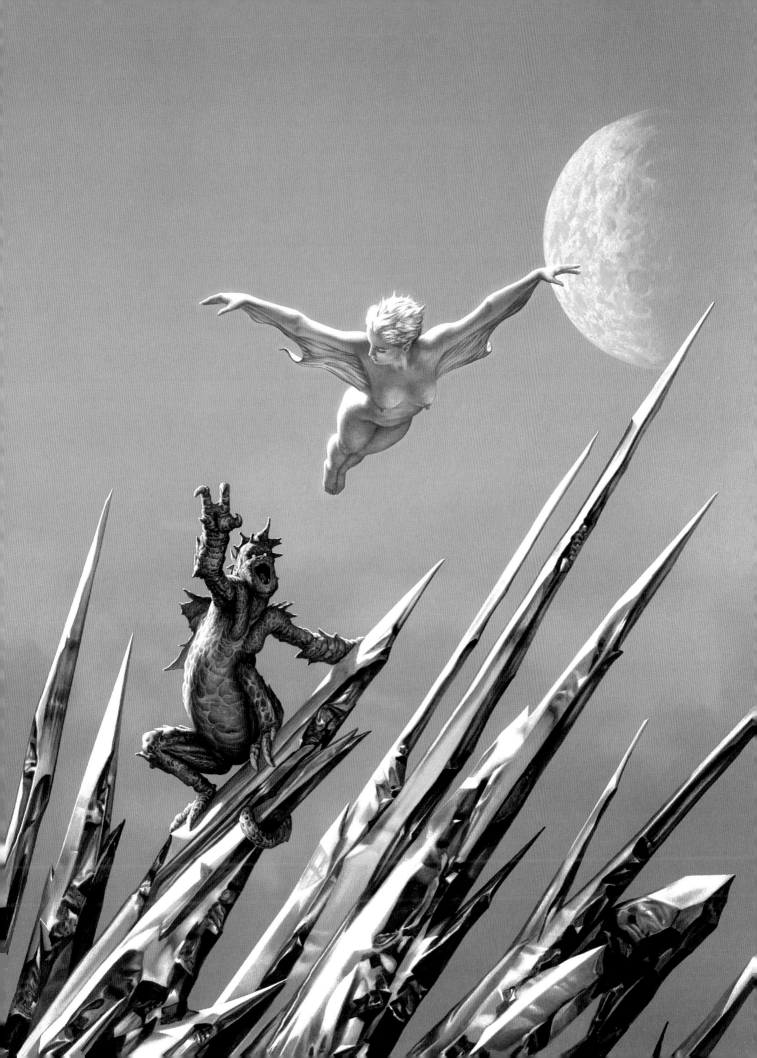

B O O K

1
artist: **Douglas Smith**
art director: Dan Taylor
designer: Douglas Smith
client: Regan Books/Harper Collins
title: Lost
medium: Scratchboard/watercolor
size: 8¹/₂"x12¹/₄"

2
artist: **Ian Miller**
art director: Toby Schwartz
client: BookSpan/Science Fiction Book Club
title: Black Seas of Infinity
medium: Ink/acylic
size: 9"x13"

3
artist: **Greg Newbold**
art director: Irene Gallo
designer: Howard Grossman
client: Tor Books/Starscape
title: Dogland
medium: Acrylic
size: 9"x12"

4
artist: **John Van Fleet**
art director: Rich Thomas
designer: Philip Reed
client: White Wolf/Cartouche Press
title: Vampire
medium: Mixed
size: 9"x12"

5
artist: **Tristan Elwell**
art director: Vikki Sheatsey
client: Delecourt Press
title: Goddess of Yesterday
medium: Oil on board
size: 11¹/₂"x10¹/₂"

1

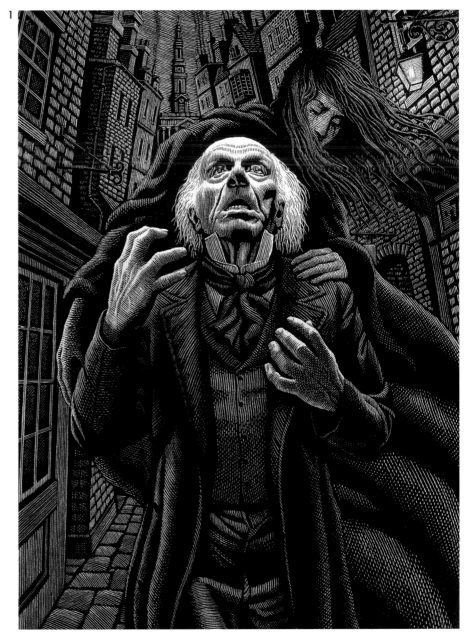

2

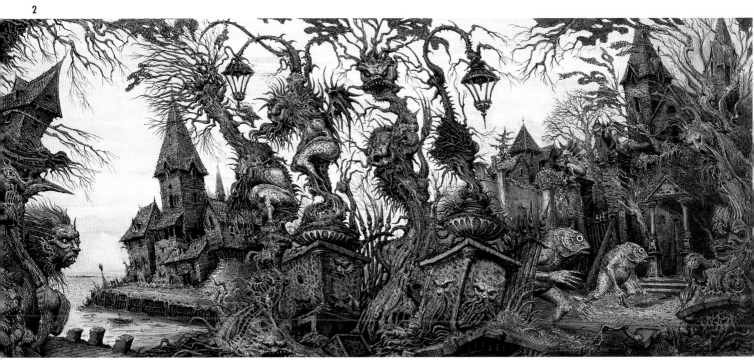

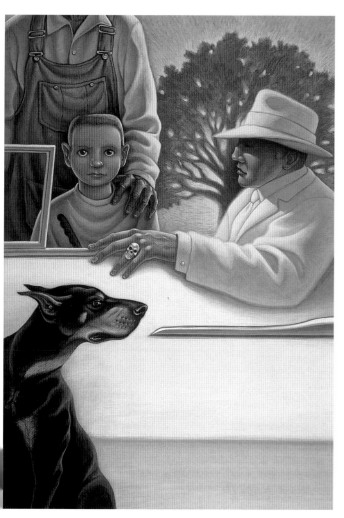

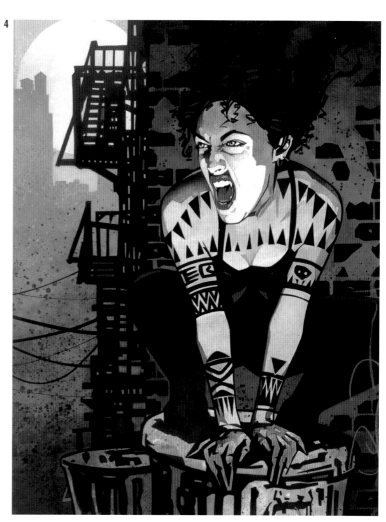

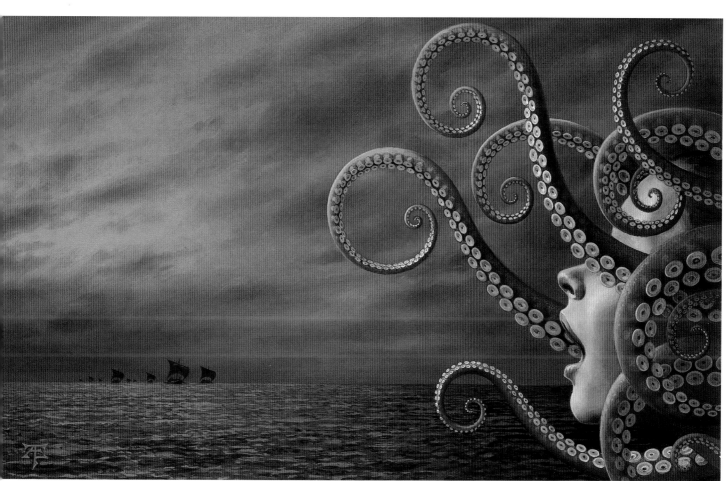

B O O K

1
artist: **Jon Foster**
art director: Matt Adelsperger
client: Wizards of the Coast, Inc.
title: The Wizard War
medium: Oil/digital
size: 30"x30"

2
artist: **John Jude Palencar**
art director: Irene Gallo
client: Tor Books
title: The Onion Girl
medium: Acrylic

3
artist: **John Jude Palencar**
art director: Irene Gallo
client: Tor Books
title: Kushiel's Chosen
medium: Acrylic

1

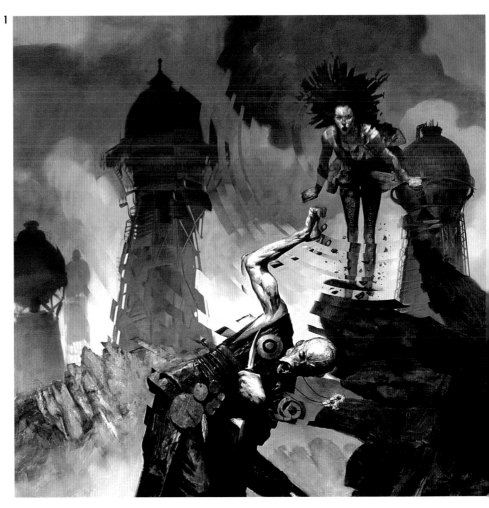

2

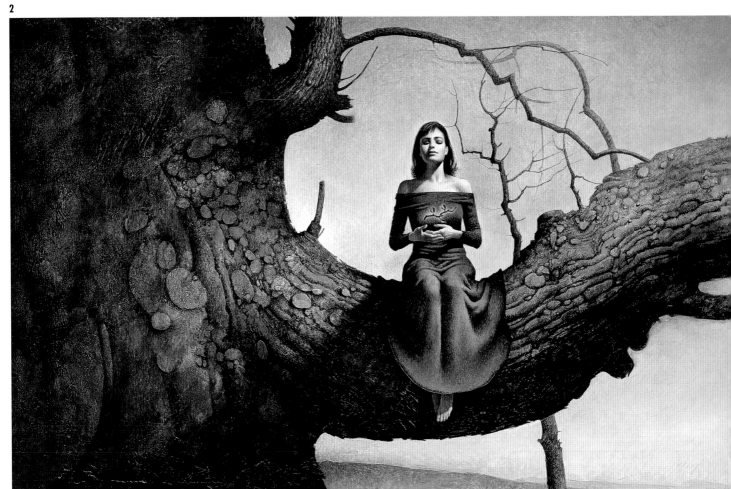

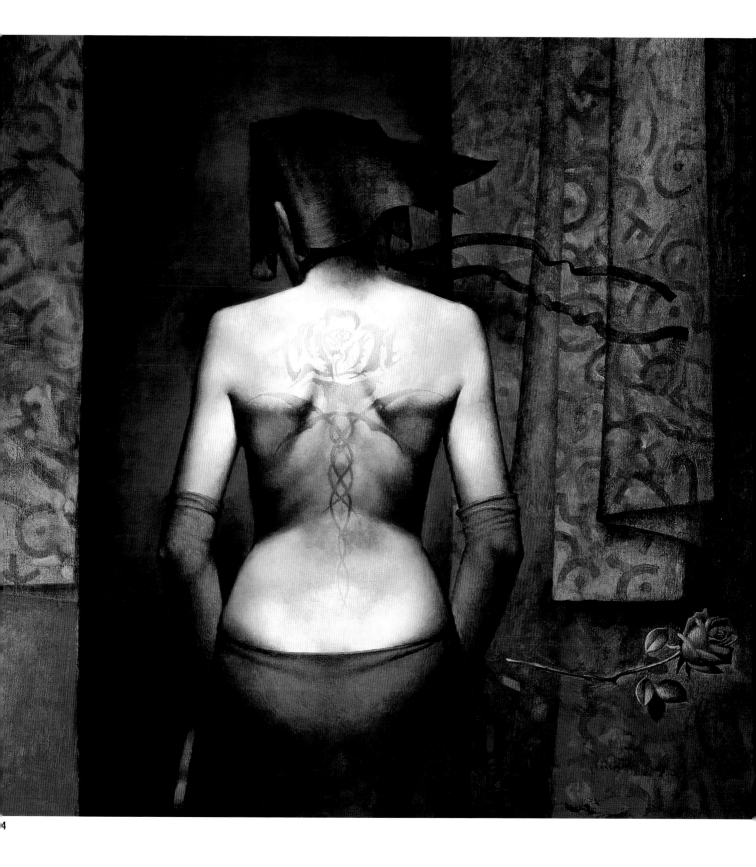

4

1
artist: **Gregory Manchess**
art director: Irene Gallo
client: Tor Books
title: The Impossible Bird
medium: Oil
size: 24"x34"

2
artist: **Griesbach/Martucci**
art director: Kathleen Flannigan
designer: Karin Paprocki
client: Harper-Collins
title: Pharaoh's Daughter
medium: Oil on masonite
size: 12"x16"

3
artist: **Greg Spalenka**
art director: Tom Egner
client: Avon Books
title: The Visitor
medium: Mixed/digital
size: 11"x14"

4
artist: **Leo & Diane Dillon**
client: Walker & Company
title: Enchantress from the Stars
medium: Mixed

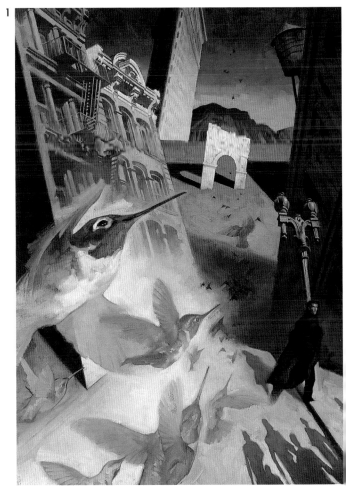

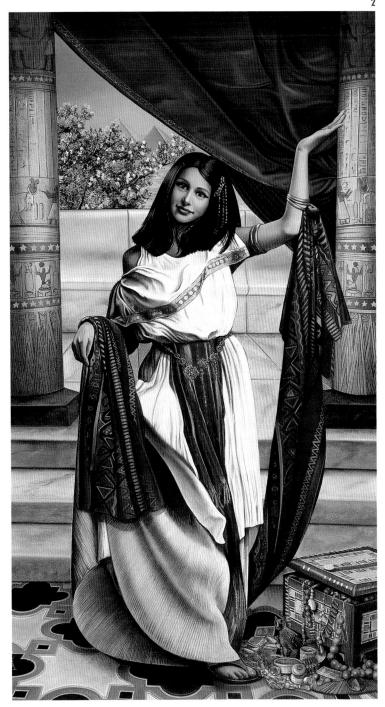

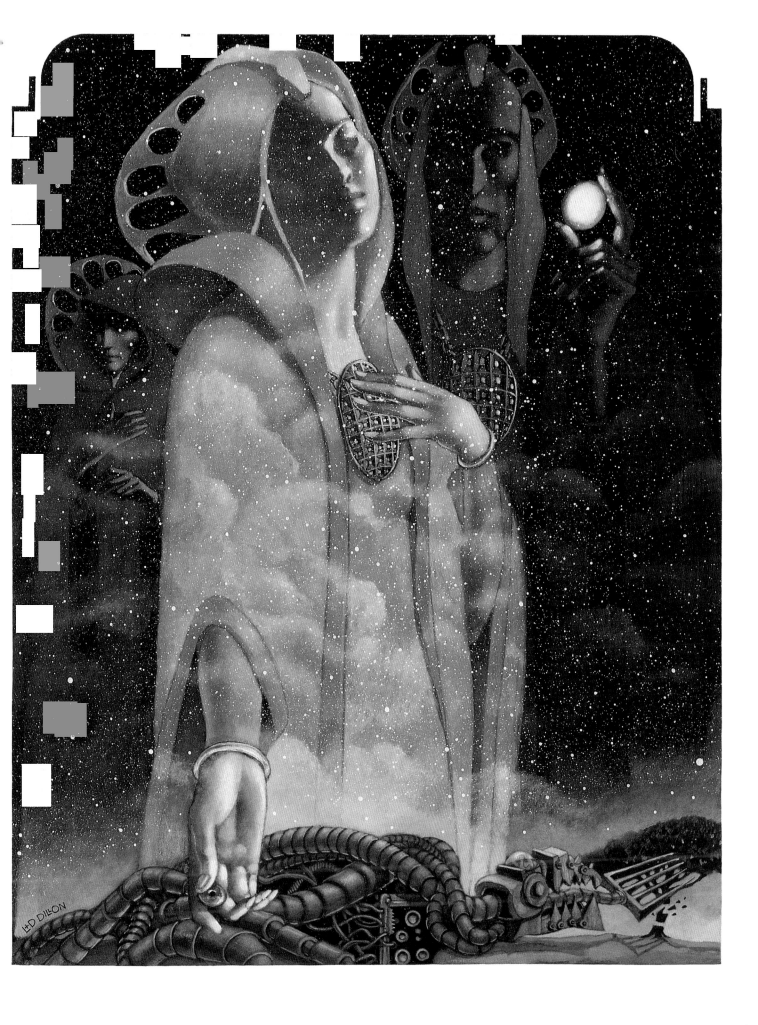

Book

1
artist: **Tom Kidd**
art director: Barbara Fitzsimmons
client: HarperCollins
title: Endpaper #2
medium: Oil

2
artist: Jon Foster
art director: Irene Gallo
client: Tor Books
title: Orvis
medium: Oil/digital
size: 30"x40"

3
artist: **Tom Kidd**
art director: Barbara Fitzsimmons
client: HarperCollins
title: Specimen
medium: Oil

4
artist: **Tom Kidd**
art director: Barbara Fitzsimmons
client: HarperCollins
title: London Death
medium: Oil

1

2

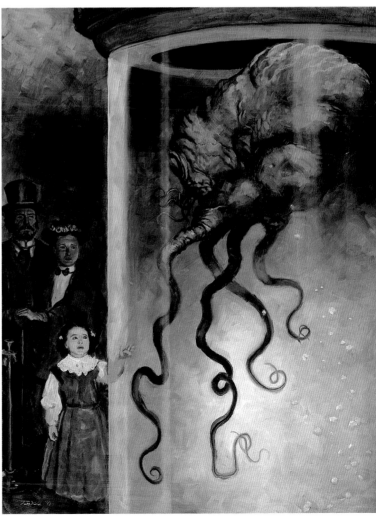

3

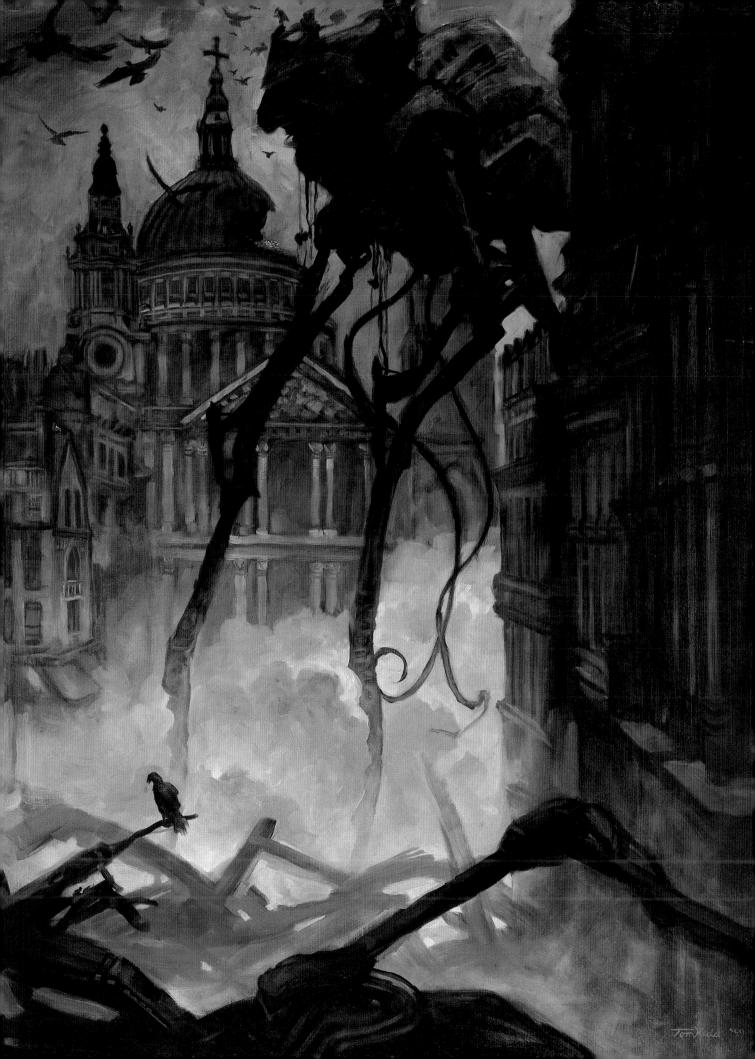

B o o k

1
artist: **Frank Cho**
art director: Frank Cho
designer: Frank Cho
client: Insight Studios Group
title: Coppertone Cavewoman
medium: Pen & ink
size: 11"x17"

2
artist: **William Stout**
art director: Marcelo Martinez/
Michael Bayouth
client: Gauntlet Press
title: Abu and the 7 Marvels
medium: Watercolor/ink on board
size: 10"x15"

3
artist: **Matt Wilson**
client: Privateer Press
title: Witchfire: Alexia Returns
medium: Oil
size: 16"x20"

4
artist: **William Stout**
art director: Marcelo Martinez/
Michael Bayouth
client: Gauntlet Press
title: Abu and the Genie
medium: Watercolor/ink on board
size: 10"x15"

5
artist: **Eric Bowman**
art director: Nicholas Krenitsky
client: HarperCollins
title: The Princess of Bamarre
medium: Oil
size: 13 1/2"x18"

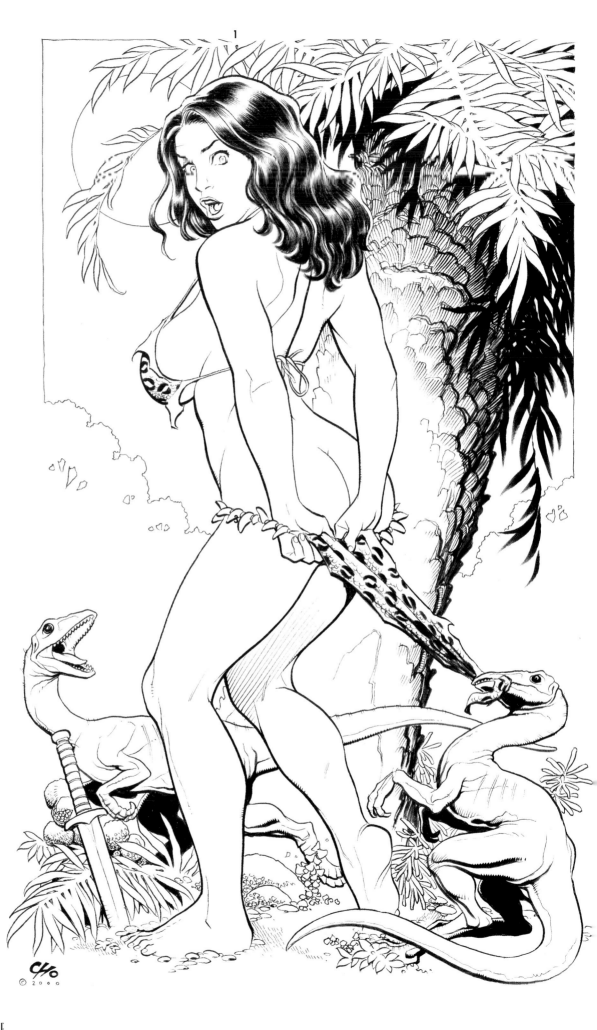

2

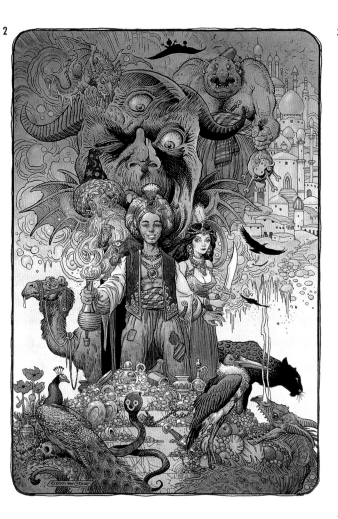

3

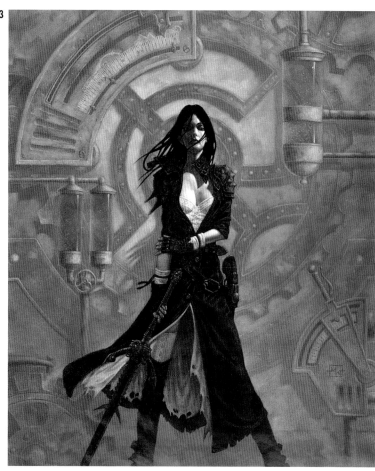

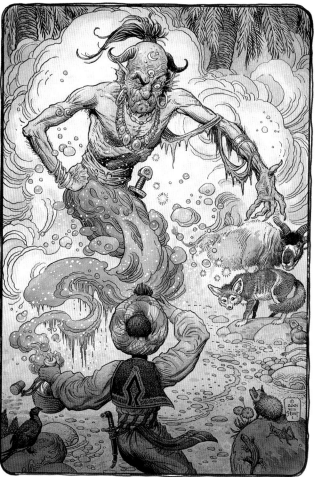

5

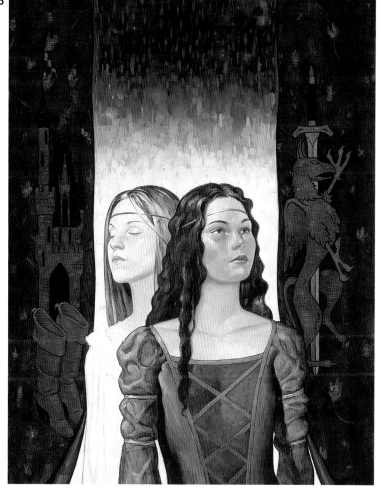

1
artist: **Luis Royo**
art director: Luis Royo
client: Norma Editorial
title: Conceptions
medium: Acrylics
size: 18"x12"

2
artist: **Mark Jug**
art director: Matt Adelsperger
client: Wizards of the Coast
title: Dragon Isles
medium: Oil

3
artist: **Frank Cho**
art director: Frank Cho
client: Insight Studios Group
title: Maiden of Mars
medium: Pen & ink
size: 11"x17"

4
artist: **Terese Nielsen**
art director: Robert Raper
client: Wizards of the Coast
title: Wheel of Time: Moiraine
medium: Mixed
size: 5"x7"

5
artist: **Kinuko Y. Craft**
art director: Judy Murello
client: Berkley Books
title: Ombria In Shadow
medium: Oil over watercolor
size: 21"x13³/₄"

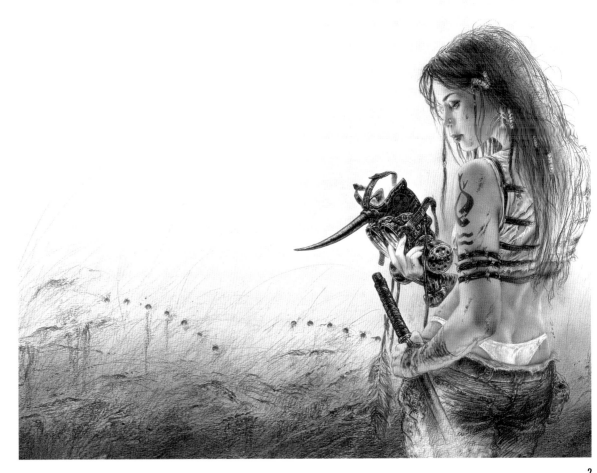

2

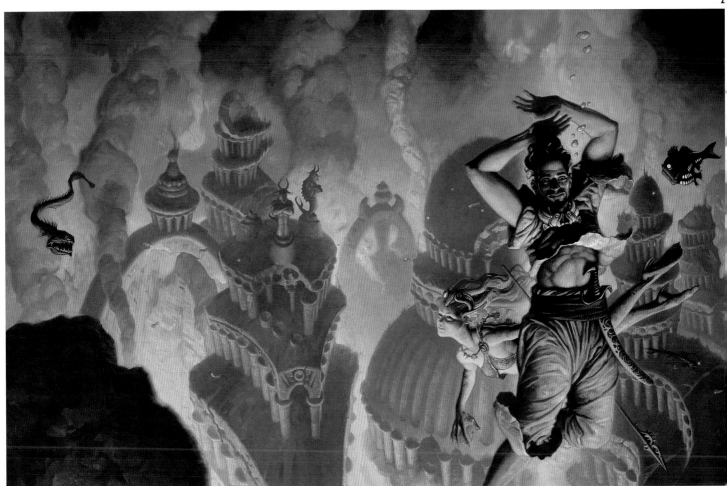

3

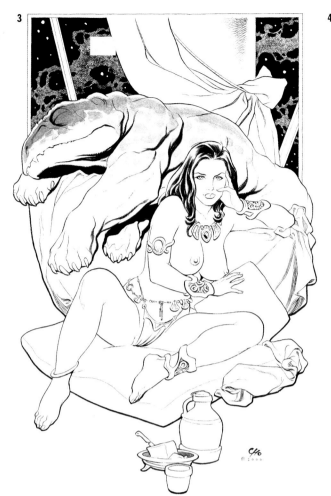

4

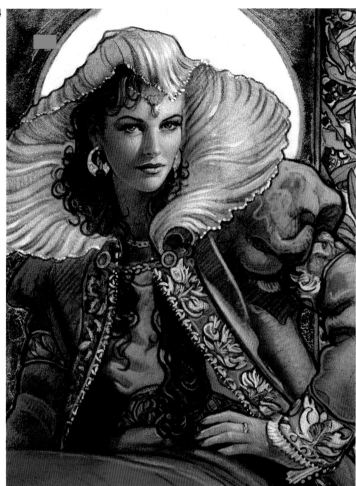

5

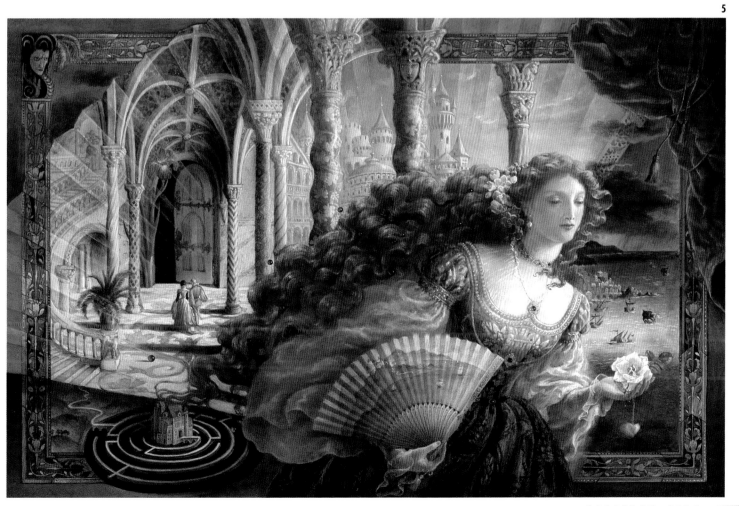

B o o k

1
artist: **Justin Sweet**
art director: Dave Stevenson
client: Del Rey Books
title: Fifth Sorcerous
medium: Digital

2
artist: **William O'Connor**
art director: Peter Corless
client: Green Knight Publishing
title: The Grail Quest
medium: Oil
size: 32"x24"

3
artist: **Jeff Crosby**
art director: Creston Ely
designer: Victoria Wortmann
client: Grosset & Dunlap
title: Chinese Dragon
medium: Oil on paper
size: 16"x8"

4
artist: **J.P. Targete**
art director: Tom Egner
client: HarperCollins
title: Might & Magic/The Sea of Mist
medium: Oil on masonite
size: 20"x30"

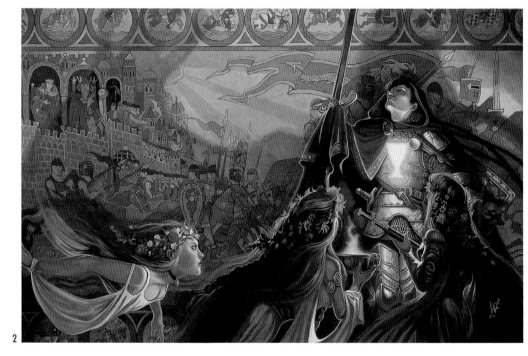

1

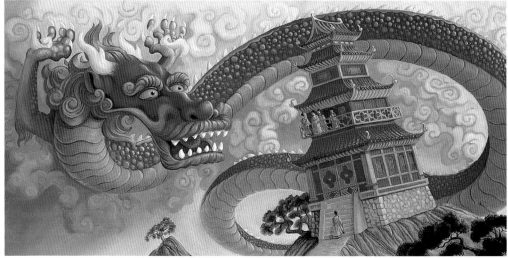

2

3

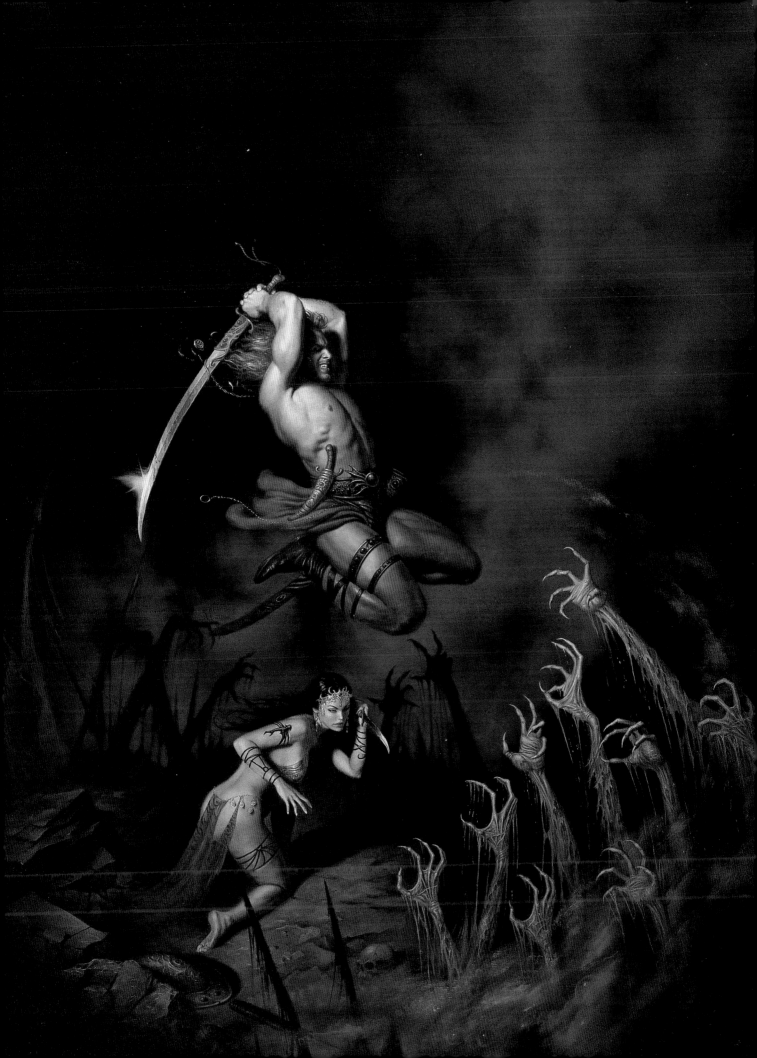

B o o k

1
artist: **Kinuko Y. Craft**
editor: Julia Kushnirsky
designer: Julia Kushnirsky
client: St. Martin's Press
title: Eleanor of Aquitaine
medium: Oil over watercolor
size: 19"x18"

2
artist: **Matt Stawicki**
art director: Matt Adelsperger
client: Wizards of the Coast
title: Conundrum
medium: Digital

3
artist: **Gordon Crabb**
editor: Sheila Gilbert
client: DAW Books
title: Guardian of the Promise
medium: Acrylics
size: 11³/4"x16¹/2"

4
artist: **Jon Sullivan**
art director: Matt Adelsperger
client: Wizards of the Coast
title: The Temple of
 Elemental Evil
medium: Oil
size: 16"x22"

5
artist: **Luis Royo**
art director: Luis Royo
client: Avalanche
title: Fallen Angel
medium: Acrylics
size: 12"x24"

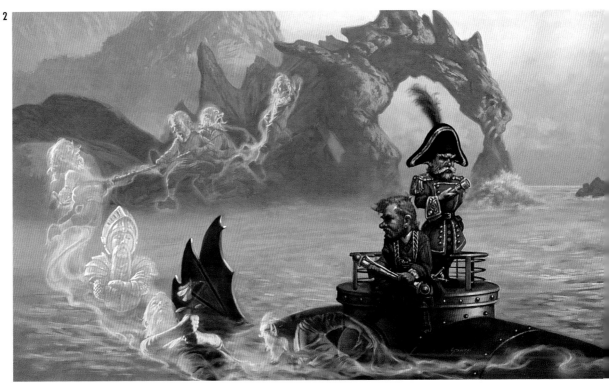

1

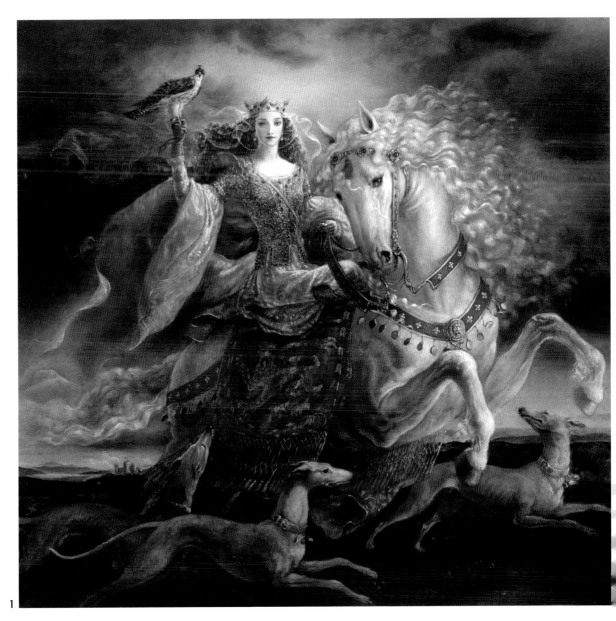

2

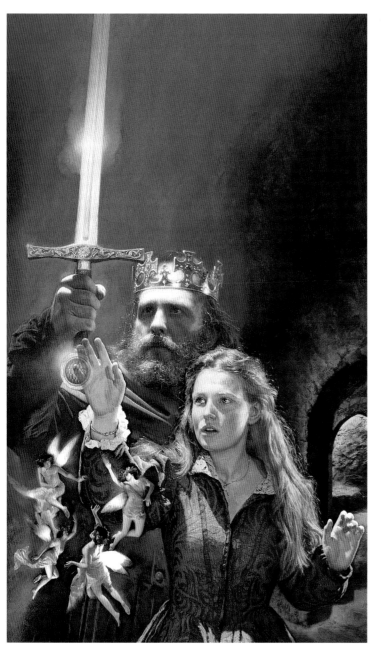

4

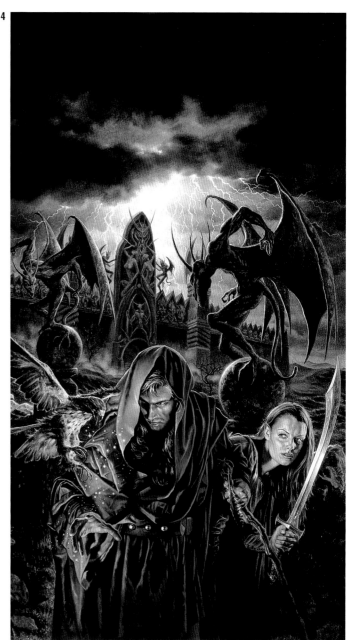

5

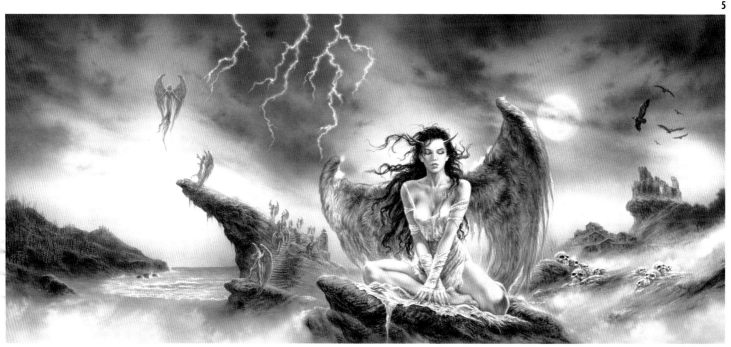

Book

1
artist: **Jim Burns**
art director: Irene Gallo
client: Tor Books
title: Kil'n People
medium: Acylics
size: 32"x21"

2
artist: **Fred Gambino**
art director: Peter Cotton
client: Time Warner Books U.K.
title: Remnant Population
medium: Digital

3
artist: **Chris Moore**
art director: Sue Mechniewicz
client: Orion Books
title: Roderick
medium: Digital

4
artist: **Patrick Arrasmith**
art director: Irene Gallo
client: Orb Books (Tor)
title: Bones of the Moon
medium: Scraperboard
size: 12"x19"

1

2

3

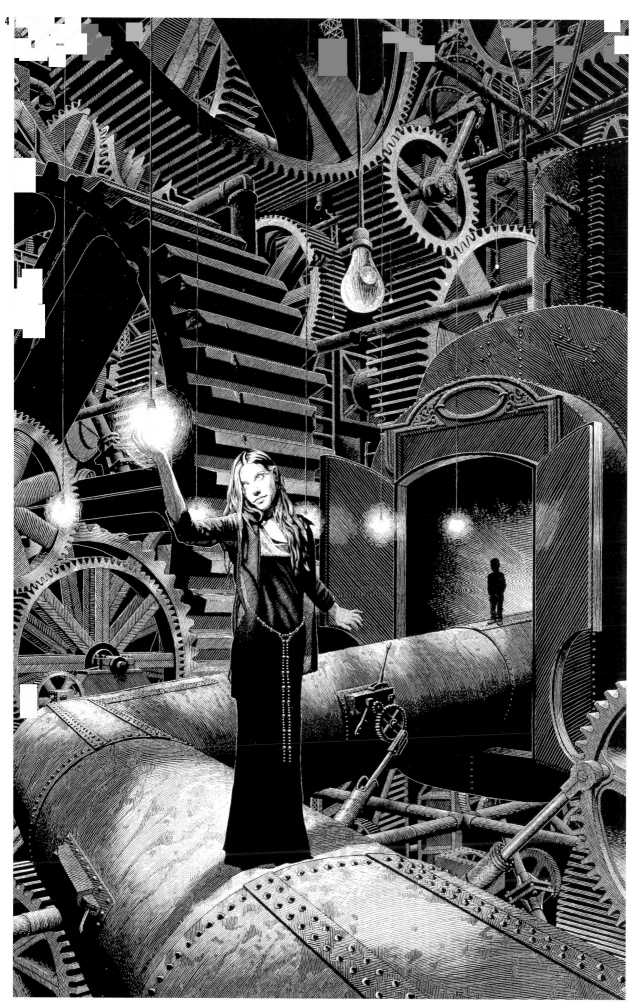

B o o k

1
artist: **Matt Wilson**
client: Privateer Press
title: Witchfire: Alexia
medium: Oil
size: 15"x20"

2
artist: **Ravenwood**
art director: Irene Gallo
client: Tor Books
title: Nightmare At 20,000 Feet
medium: Oil on linen
size: 42"x12"

3
artist: **Gris Grimly**
art director: Irene Gallo
client: Starscape Books
title: The Cockatrice Boys
medium: Acrylic

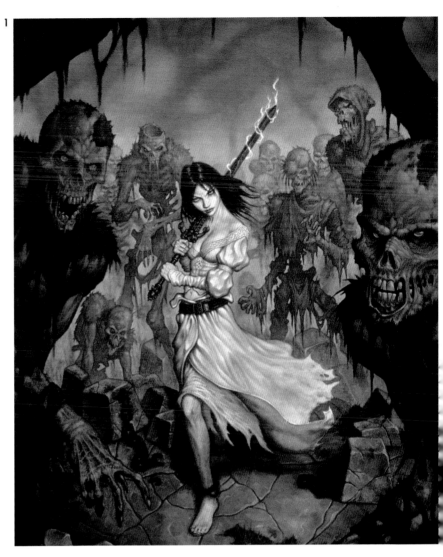

1

2

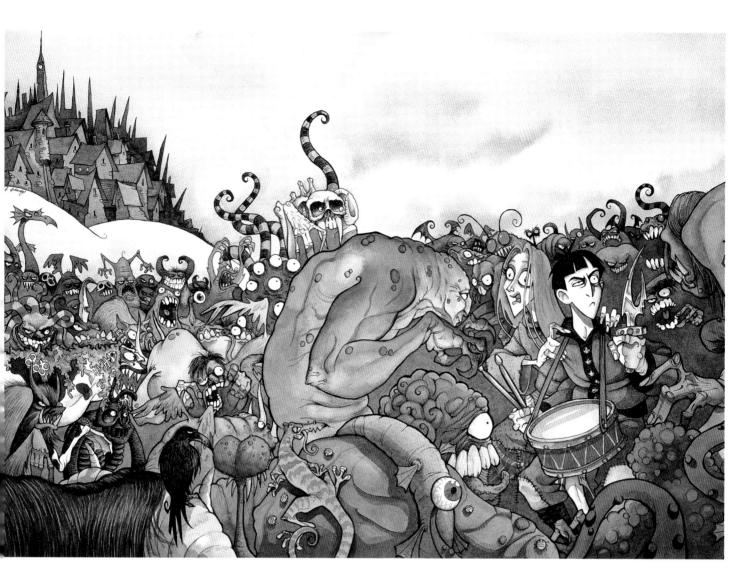

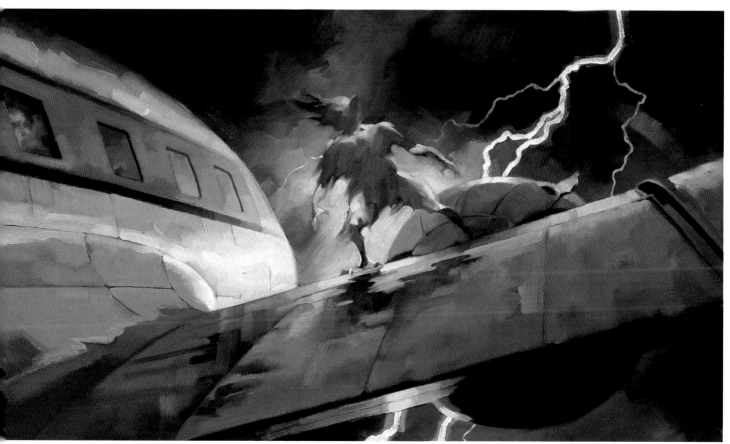

B O O K

1
artist: **Dave McKean**
art director: Terry Nantier
designer: Dave McKean
client: NBM Publishing
title: Cages
medium: Mixed
size: 10"x14"

2
artist: **John Jude Palencar**
art director: David Stevenson
client: Del Rey Books
title: Shadows Over Innsmouth
medium: Acrylic

3
artist: **Petar Meseldžija**
title: A Legend Called Steel-Bashaw
medium: Oil
size: 17¼"x25½"

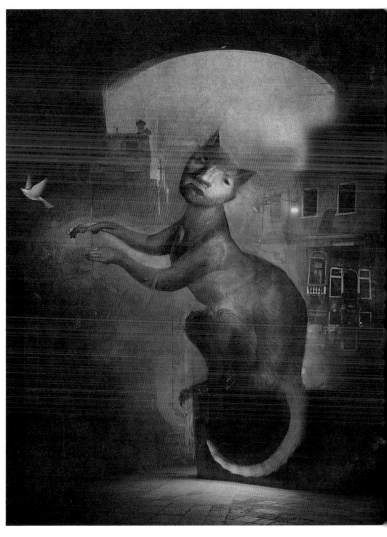

1

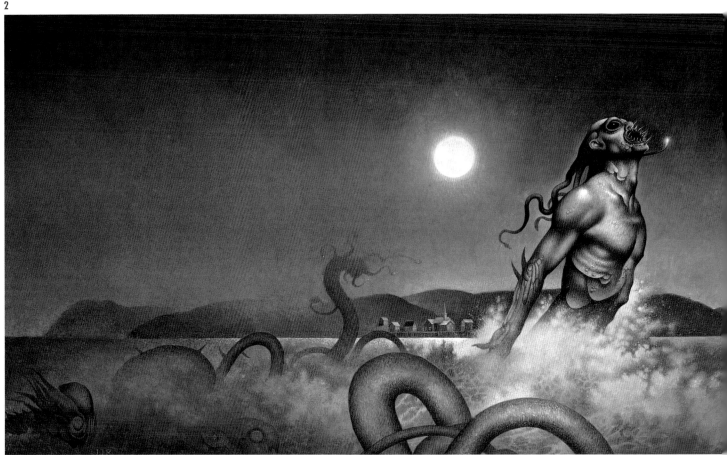

2

3

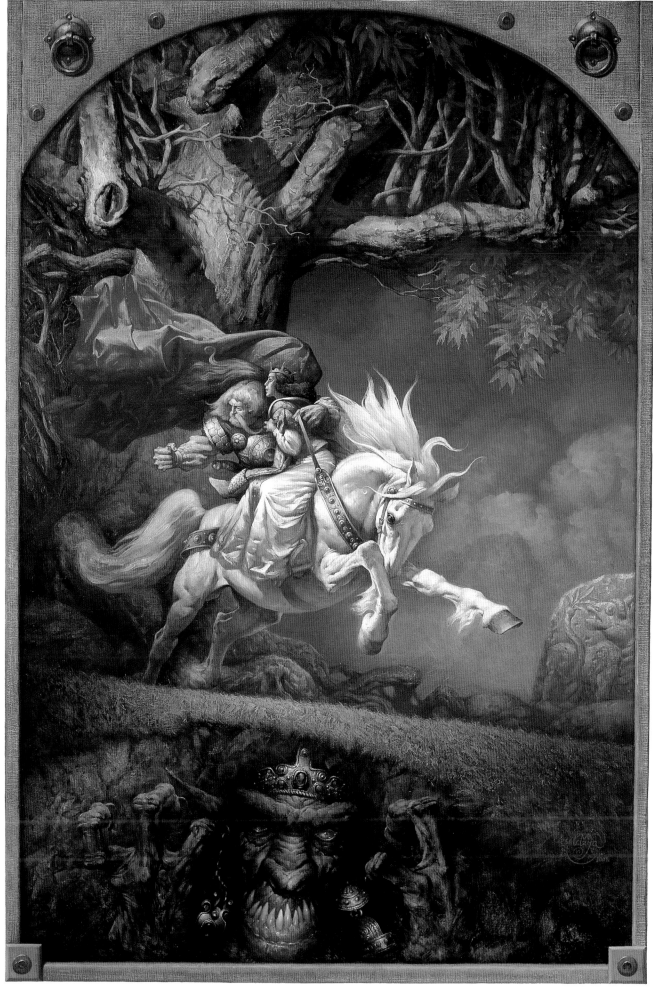

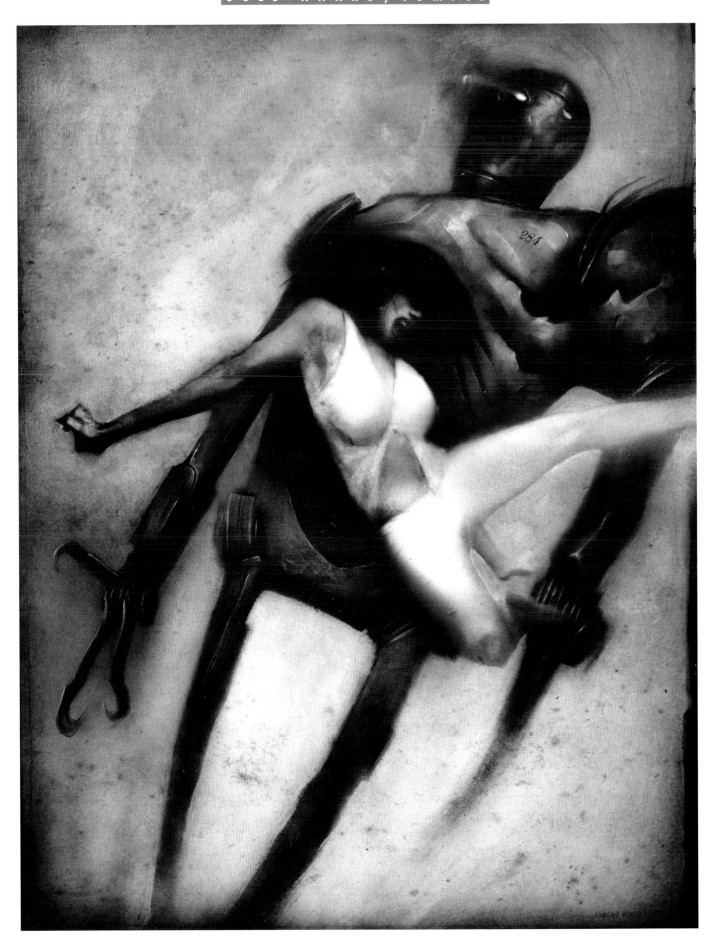

artist: **ASHLEY WOOD**

art director: Ashley Wood designer: Ashley Wood client: Idea & Design Works title: Luwona Angry tmedium: Oil/digital size: 8^1/2"x11"

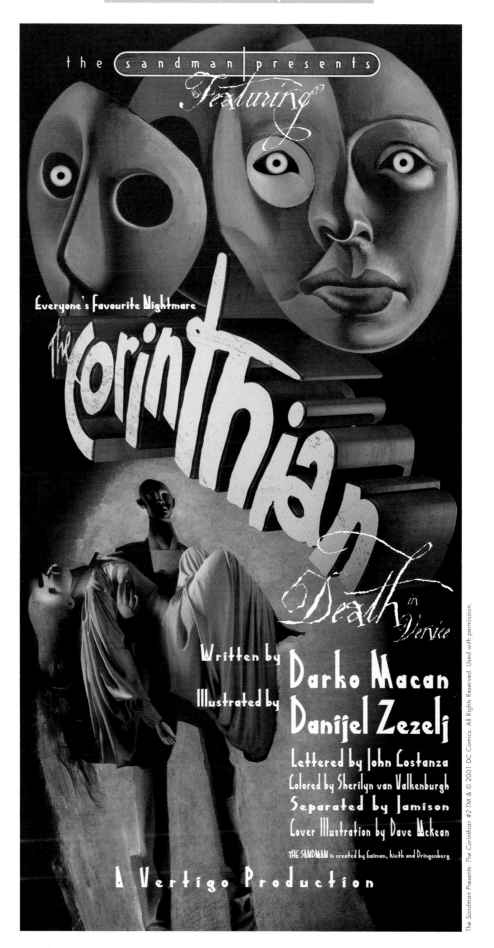

artist: **DAVE McKEAN**

art director: Shelly Pond designer: Dave McKean client: DC/Vertigo Comics title: Sandman Presents The Corinthian #2 medium: Mixed

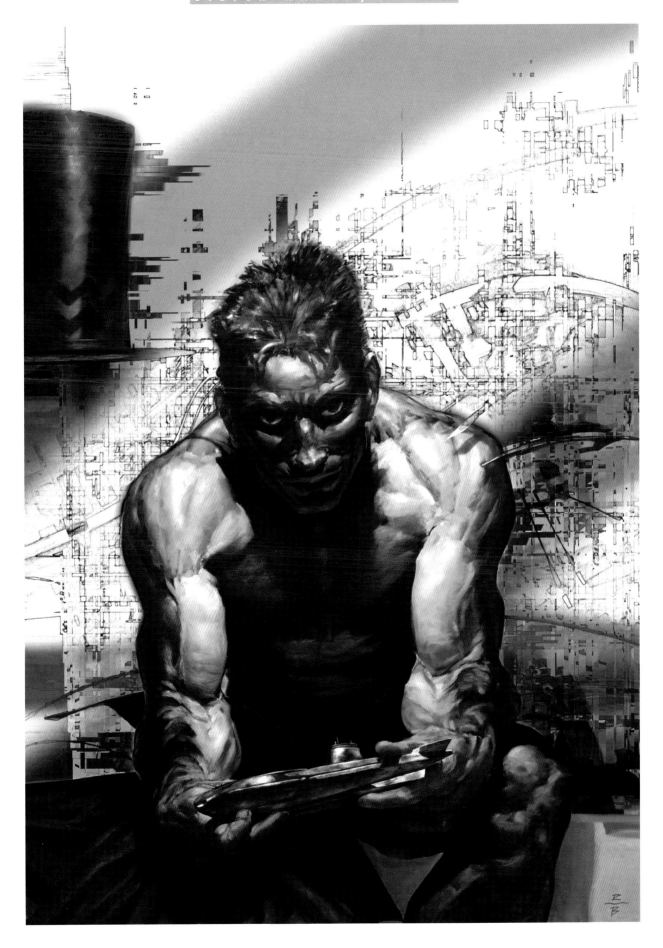

artist: **RICK BERRY**

art director: Teal Marie K. Chimblo client: Penny-Farthing Press, Inc. title: Tin Toy/The Victorian #11 medium: Oil

note: Juror Rick Berry was excluded from the voting for this award.

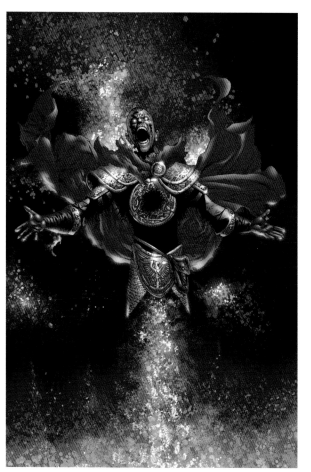

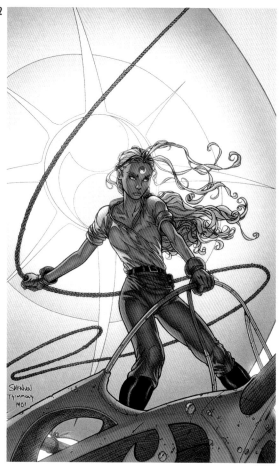

2

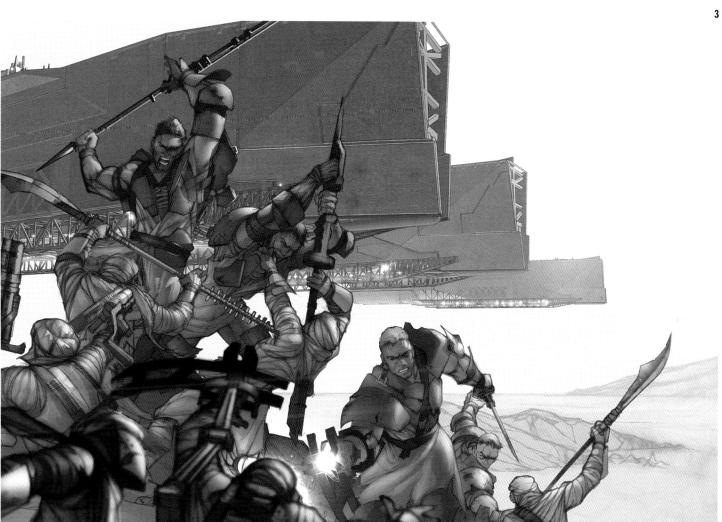

1
artist: **Greg Land**
inker: Drew Geraci
colorist: Caesar Rodriguez
art director: Bart Sears
client: Crossgeneration Comics
title: Sojourn
medium: Pencil/ink/digital
size: 6⁷/₈"x10³/₈"

2
artist: **Steve McNiven**
inker: Tom Simmons
colorist: Morry Hollowell
art director: Bart Sears
client: Crossgeneration Comics
title: Meridian
medium: Pencil/ink/digital
size: 6⁷/₈"x10³/₈"

3
artist: **Christian Gossett**
colorist: Snakebite
3D modeling: Allen Coulter
title: The Red Star/
Battle at Kar Dathra's Gate
medium: Mixed/digital

3

C O M I C S

1
artist: **Jon Foster**
art director: Heidi MacDonald
client: DC Comics
title: Hunter #8
medium: Oil/digital
size: 22"x20"

2
artist: **Jon Foster**
art director: Dave Land
client: Dark Horse Comics
title: Blue
medium: Oil/digital
size: 20"x30"

3
artist: **Jon Foster w/ Darron Laessig**
art director: Jon Foster
client: Slave Labor Graphics
title: Punch
medium: Oil/digital
size: 11"x17"

4
artist: **Jon Foster**
art director: Dave Land
client: Dark Horse Comics
title: Star Wars 34
medium: Oil/digital
size: 30"x40"

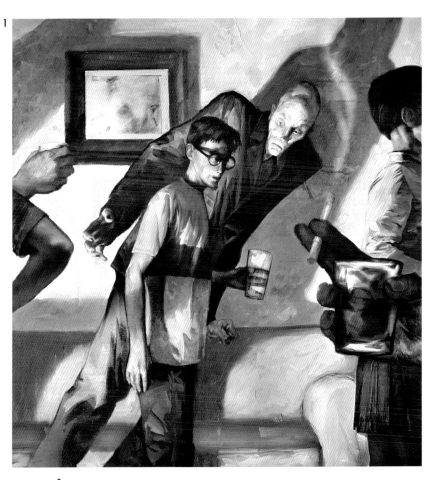

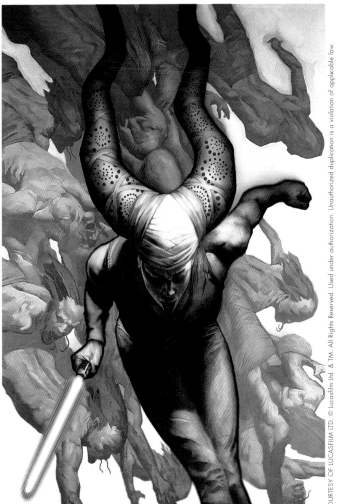

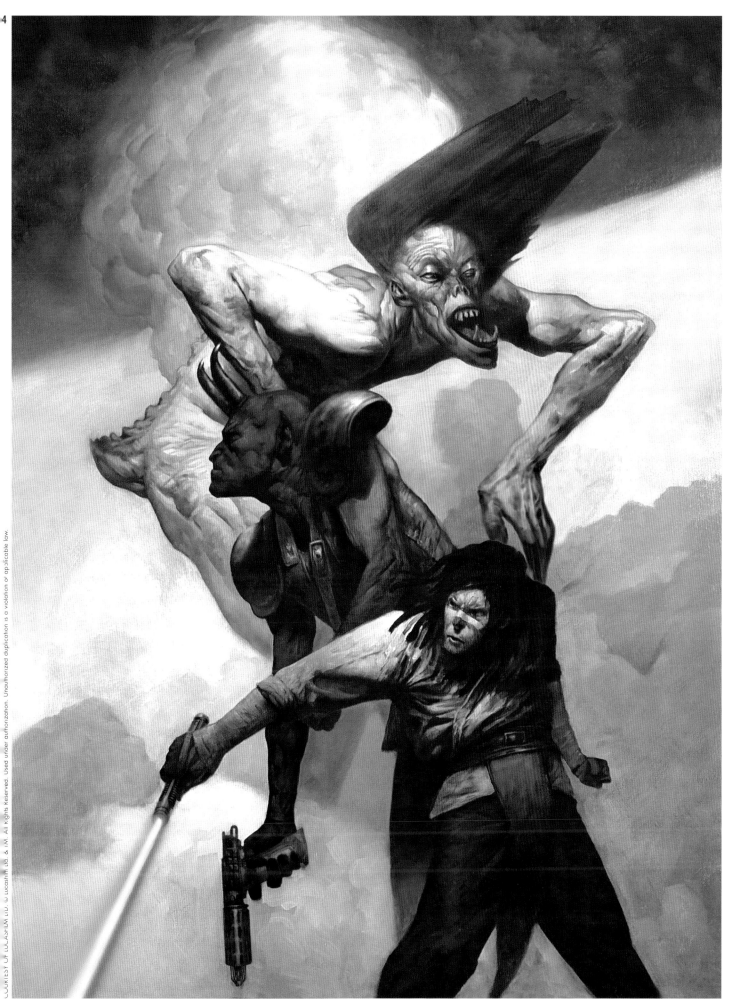

C O M I C S

1
artist: **Joe Quesada/Richard Isanove**
art director: Joe Quesada
client: Marvel Enterprises, Inc.
title: Ultimate Spider-Man
medium: Mixed
size: 11"x15¹/₂"

2
artist: **Steve Rude**
client: Marvel Enterprises, Inc.
title: Godstorm #2
medium: Watercolor/gouache
size: 18"x28"

3
artist: **Joe Quesada/Richard Isanove**
art director: Joe Quesada
client: Marvel Enterprises, Inc.
title: Origin #3
medium: Mixed
size: 7"x10¹/₂"

4
artist: **Adam Kubert/Richard Isanove**
art director: Mark Powers
client: Marvel Enterprises, Inc.
title: Ultimate X-Men: Gambit
medium: Mixed
size: 7"x10¹/₂"

1

2

3

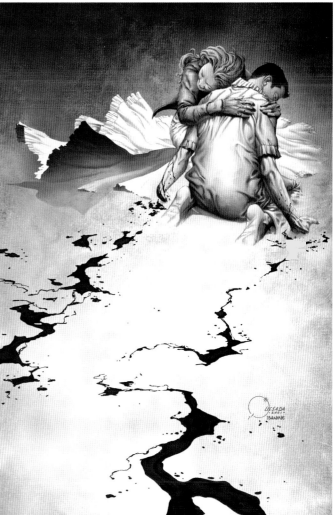

Comics

1
artist: **Timothy Bradstreet**
art director: Timothy Bradstreet
designer: Timothy Bradstreet
client: Marvel Comics
title: Daywalker 2/*Blade #2*
medium: Pen/brush/ink/watercolor
size: 10¹/₂"x16"

2
artist: **Matt Dicke**
art director: Matt Dicke
client: Hard Left Press
title: Hollow
medium: Mixed
size: 24"x9"

3
artist: **Frazer Irving**
art director: Andy Diggle
client: 2000AD/Rebellion
title: A Love Like Blood
medium: Ink/digital
size: 303mmx200mm

4
artist: **Christopher Moeller**
art director: Shelly Bond
client: DC/Vertigo
title: Lucifer 18
medium: Acrylic on board
size: 20"x30"

5
artist: **Joe Jusko**
client: Top Cow Productions
title: Inferno
medium: Acrylic
size: 18"x26"

6
artist: **Brian Horton/Paul Lee**
art director: Scott Allie
client: Dark Horse Comics
title: Buffy the Vampire Slayer/Lost & Found
medium: Mixed
size: 7"x10¹/₂"

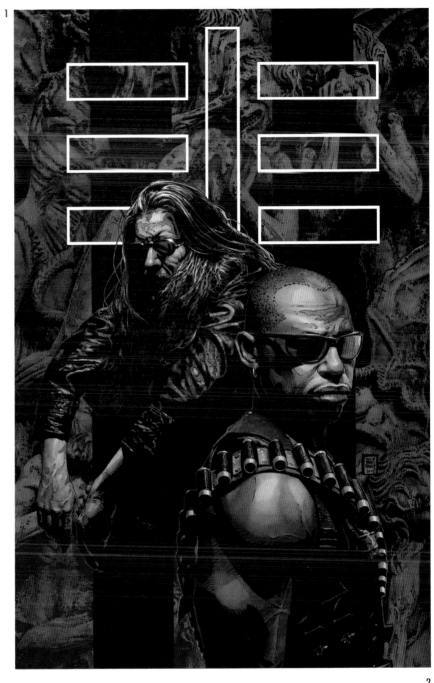

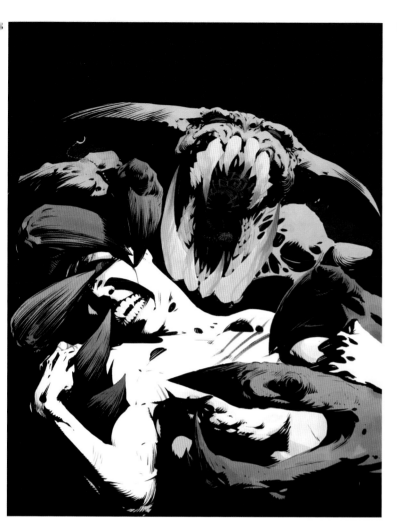

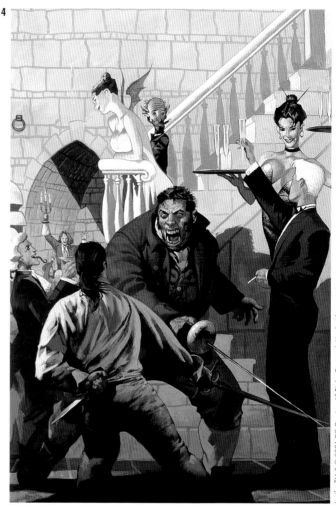

4

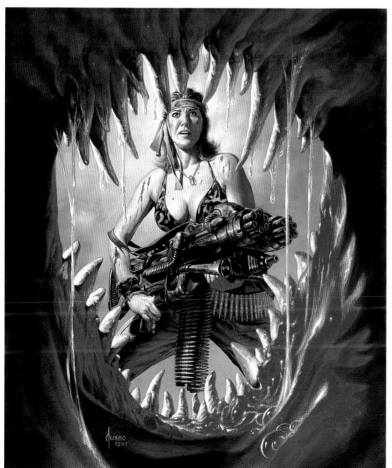

6

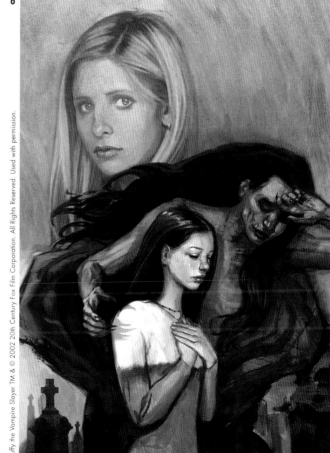

1
artist: **Christopher Moeller**
art director: Shelly Bond
client: DC Comics/Vertigo
title: The Crusades #2
medium: Acrylic on board
size: 20"x30"

2
artist: **Timothy Bradstreet**
art director: Timothy Bradstreet
designer: Timothy Bradstreet
client: DC Comics/Vertigo
title: One Punk John/
 Hellblazer #163
medium: Brush/ink/watercolor
size: 10½"x16"

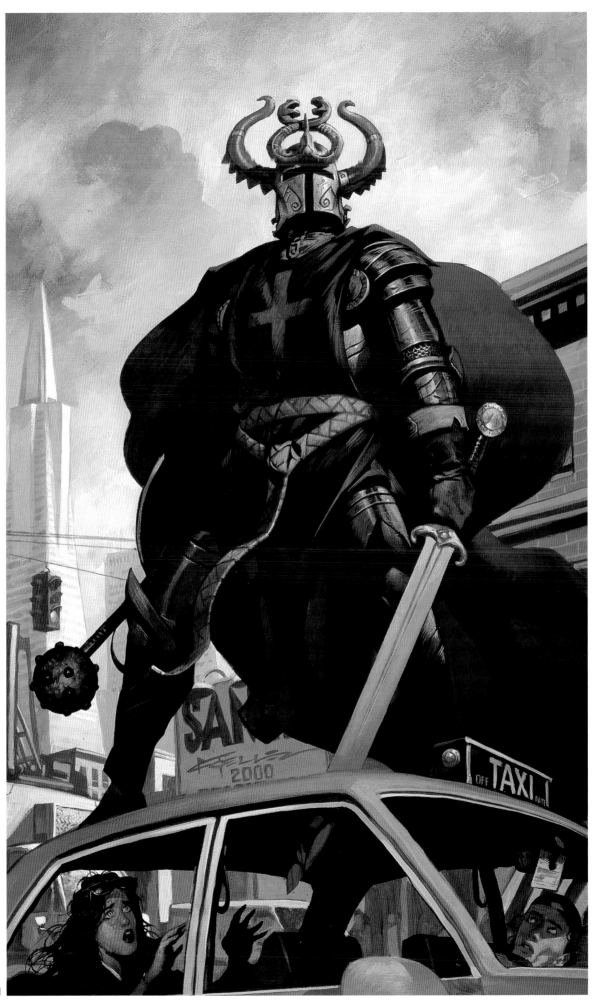

1

Comics

1
artist: **Simon Davis**
art director: Nick Percival
client: Coolbeansworld.com
title: Dark Frankenstein
medium: Gouache

2
artist: **Rick Berry**
art director: Teal Marie K. Chimblo
client: Penny-Farthing Press, Inc.
title: Brassworks
medium: Oil/digital

3
artist: **Zak Jarvis**
art director: Dennis Cramer
client: Fantagraphics Books
title: Mara 10th Anniversary
medium: Digital

4
artist: **John Van Fleet**
art director: Mark Chiarello
designer: Philip Reed
client: DC Comics
title: Bat Eye
medium: Mixed
size: 9"x12"

1

2

3

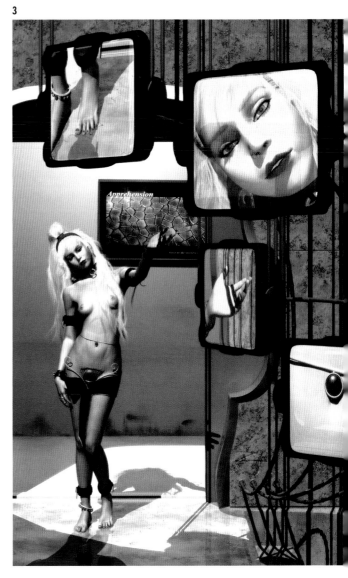

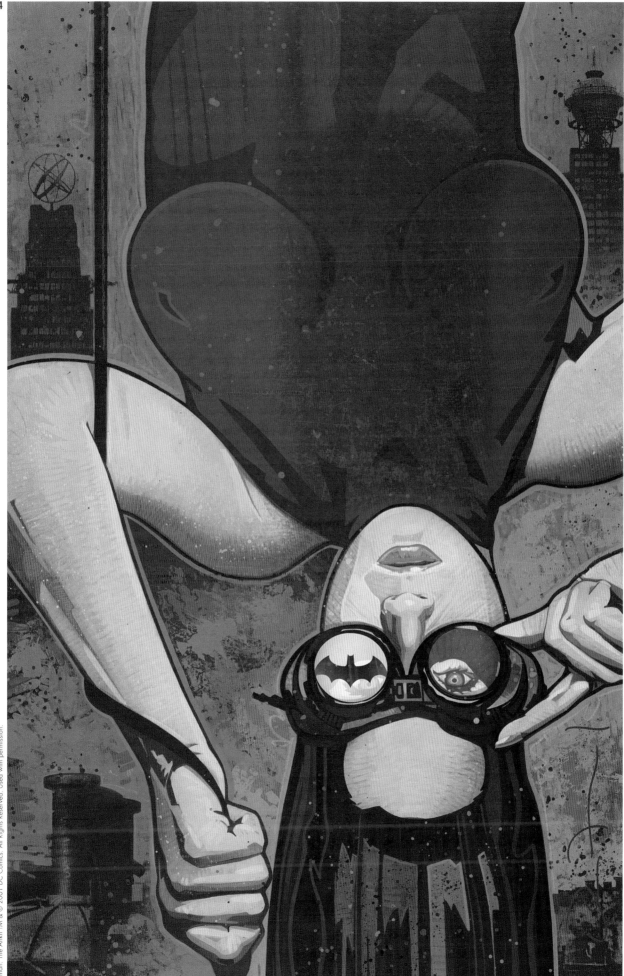

Comics

1
artist: **Simon Davis**
art director: Nick Percival
client: Coolbeansworld.com
title: Sin
medium: Gouache

2
artist: **Dave McKean**
art director: Shelly Bond
client: DC/Vertigo Comics
title: The Sandman Presents 1
medium: Mixed

3
artist: **Charles Vess**
art director: Charles Vess
designer: Charles Vess
client: Atlantis Fantasy World
title: Beneath the Waves
medium: Colored inks
size: 11"x18"

4
artist: **Justin Sweet**
client: DC Comics
title: JLA: Riddle of the Beast
medium: Oil/digital

1

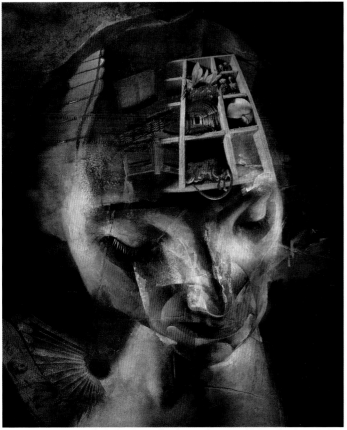

2

The Sandman Presents: Everything You Always Wanted To Know About Dreams But Were Afraid To Ask TM & © 2001 DC Comics. All Rights Reserved. Used with permission.

3

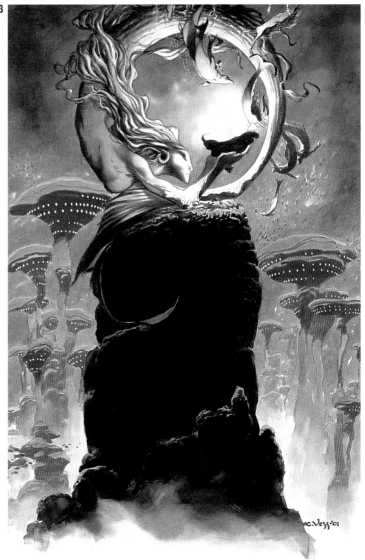

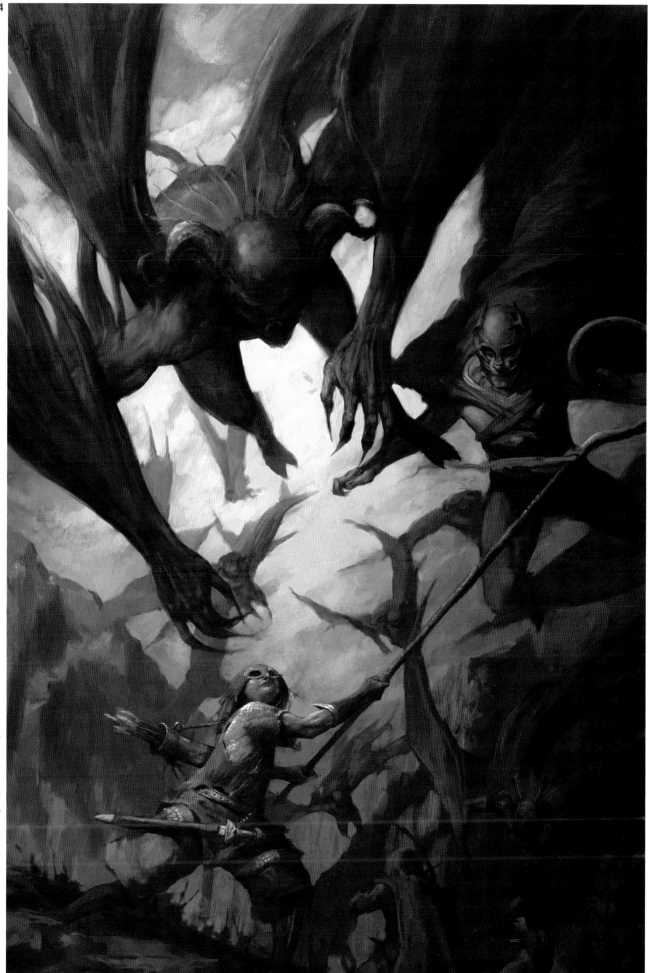

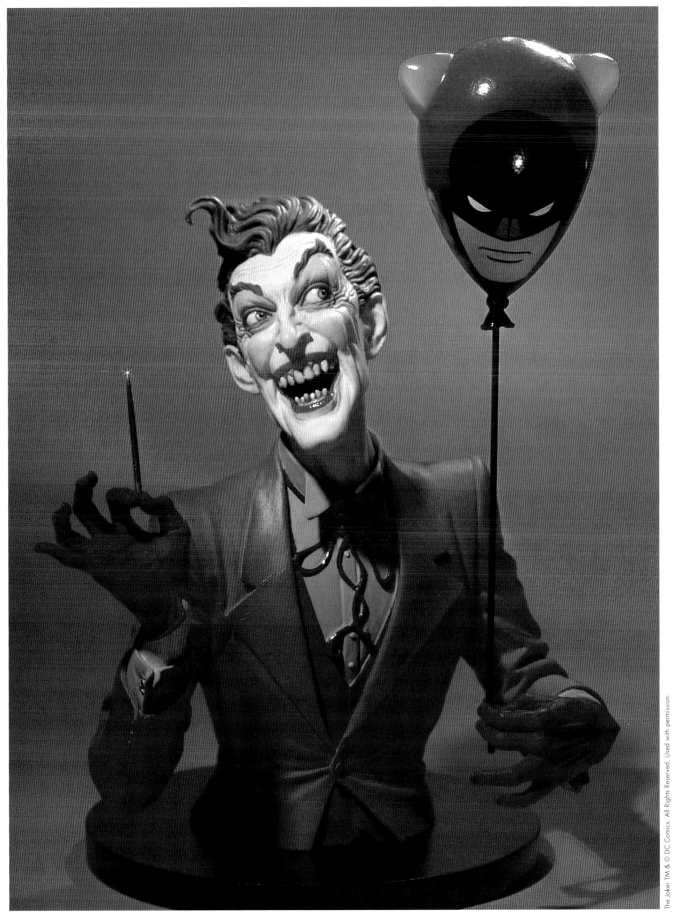

artist: **TIM HOLTER BRUCKNER**

art director: Georg Brewer *designer:* Tim Holter Bruckner *client:* DC Comics *title:* The Joker *medium:* Painted resin *size:* 5"x5"

note: *Juror Tim Bruckner was excluded from the voting for this award.*

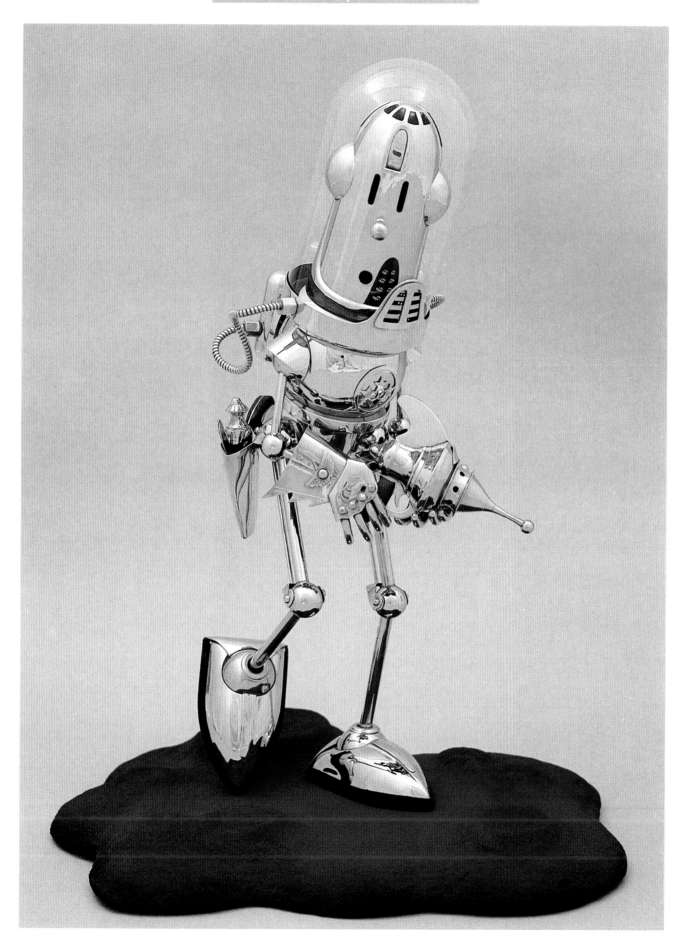

artist: **LAWRENCE NORTHEY**
designer: Lawrence Northey title: L-Roy medium: Glass and metal size: 20" tall

Dimensional

1
artist: **Emily Fiegenschuh**
title: Thor
medium: Sculpy
size: 10" tall

2
artist: **Clayburn Moore**
art director: Clayburn Moore
client: Top Cow Productions
title: Fathom
medium: Resin
size: 12" tall

3
artist: **Tim Holter Bruckner**
art director: Georg Brewer
designer: Tim Holter Bruckner
client: DC Comics
title: Lex Luthor
medium: Painted resin
size: 5"x5"

4
artist: **Clayburn Moore**
art director: Clayburn Moore
client: Top Cow Productions
title: Aphrodite IX
medium: Resin
size: 12" tall

5
artist: **Joe DeVito**
art director: Steve Korte/Georg Brewer
designer: Alex Ross
client: DC Comics/Chronicle Books
title: Wonder Woman Masterpiece Edition
medium: Super sculpy/parafin wax
size: 8¹/₂" tall

4
artist: **Kim Graham**
art director: Kim Graham
photographer: Michael Edenfield
title: Red Mermaid
medium: Super sculpy & coral
size: 14" tall

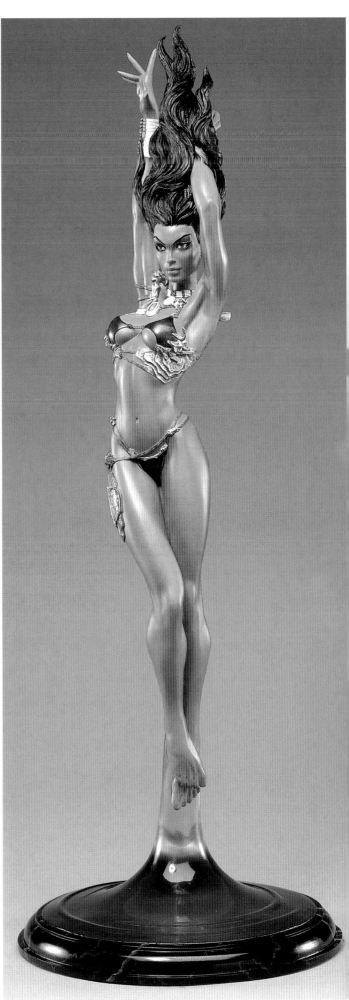

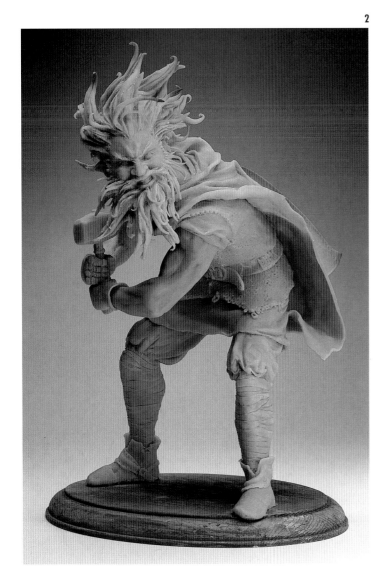

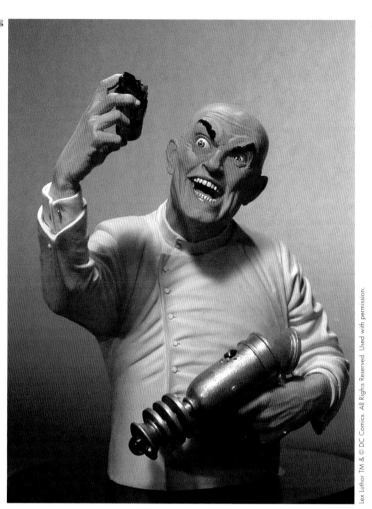

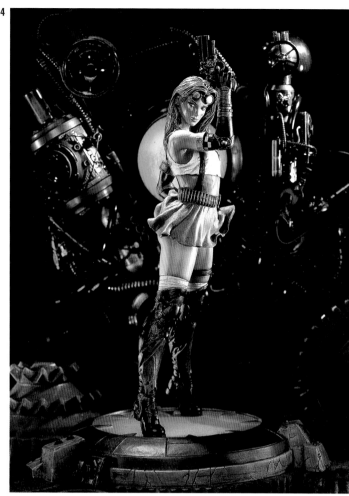

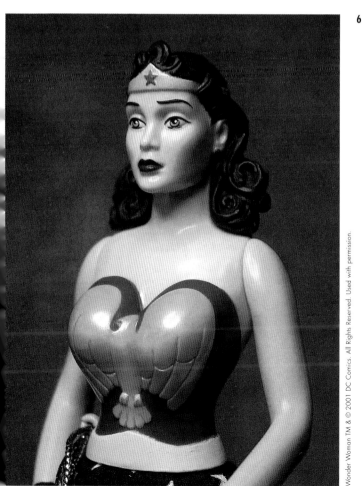

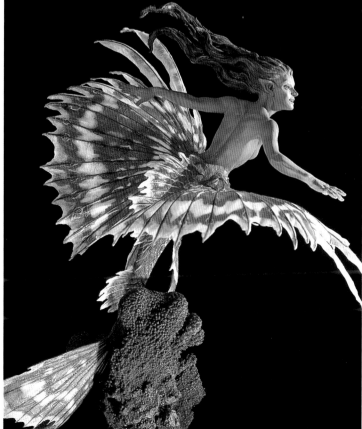

DIMENSIONAL

1
artist: **Lawrence Northey**
designer: Lawrence Northey
title: USA-Star 1
medium: Glass/metal/electronics
size: 38" tall

2
artist: **Lisa Snellings**
designer: Lisa Snellings
title: Paper Dolls (Paper Dolls Series)
medium: Papiermaché
size: 18" tall

3
artist: **Barsom**
art director: Georg Brewer
designer: Bruce Timm
client: DC Comics
title: Poison Ivy
medium: Painted resin
size: 10" long

4
artist: **Daniel R. Horne**
art director: Daniel R. Horne
client: Flying Carpet Studioz
title: All That Glitters
medium: Super sculpy/oil paint
size: 10"x12"x12"

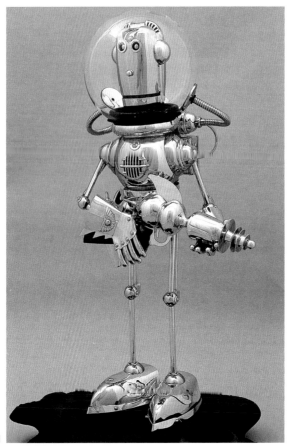

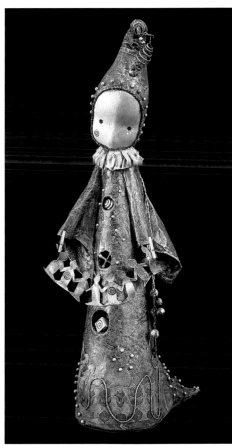

1

2

3

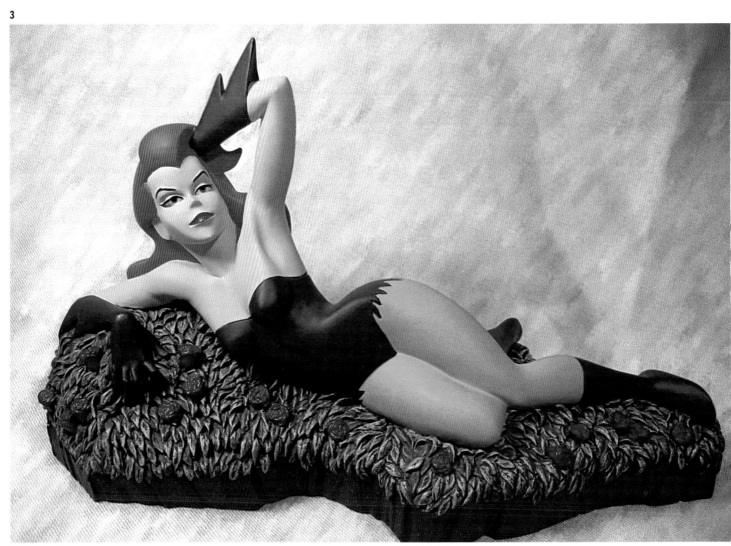

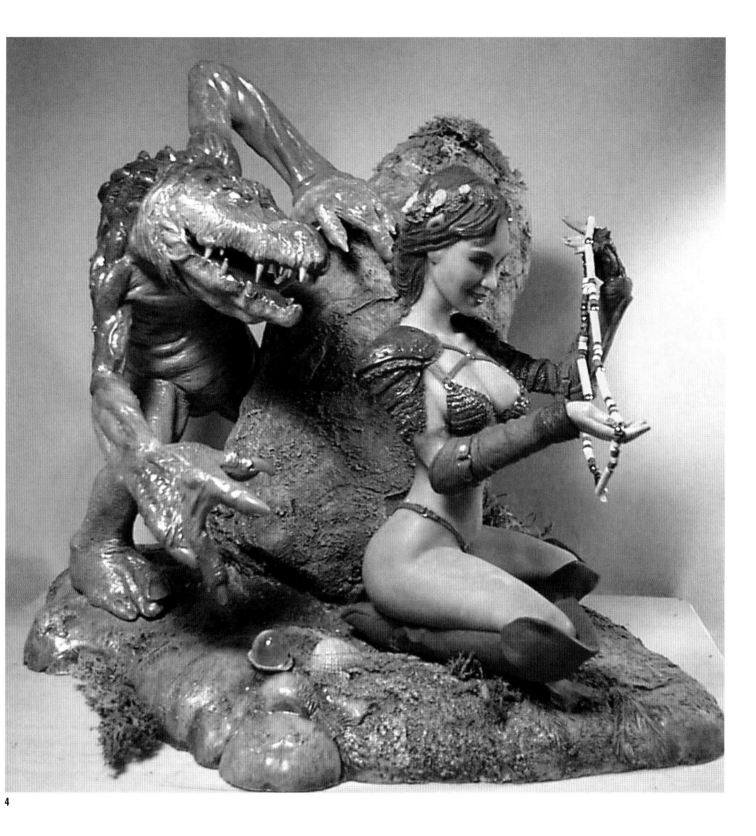

4

DIMENSIONAL

1
artist: **James M. Elliott**
art director: James M. Elliott
designer: Hal Stata
client: Zillion Concepts
title: Capt. Nemo's Locomotive
medium: Styrene/brass
size: 3'x9"

2
artist: **Tim Holter Bruckner**
art director: Tim Holter Bruckner
designer: Tim Holter Bruckner
client: The Art Farm
title: The Dance of O
medium: Painted resin
size: 18"x8"

3
artist: **Scott W. Hahn**
title: Corporate Brain (Hammer Corps Series)
medium: Sculpy
size: 11"x15"x8"

4
artist: **Daniel Hawkins**
art director: Daniel Hawkins
designer: Daniel Hawkins
client: Hawkins Design Studio
title: The Alchemist
medium: Mixed
size: 14"x10"

5
artist: **Jean-Louis Crinon**
designer/photographer: Jean-Louis Crinon
title: Kroack
medium: Resin/oil paint
size: 9³/4" tall

6
artist: **Cleté Shields/Sandy Collora/**
 George Gaspar
art director: Sandy Collora
designer: Sandy Collora
client: Mezco Toyz
title: Captain Nemo
medium: Resin/plastic
size: 11"x7"

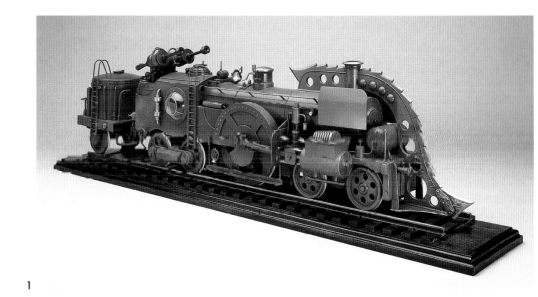

1

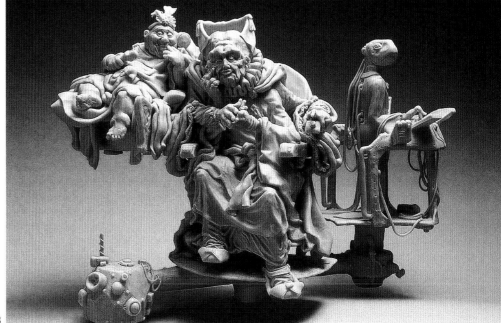

2

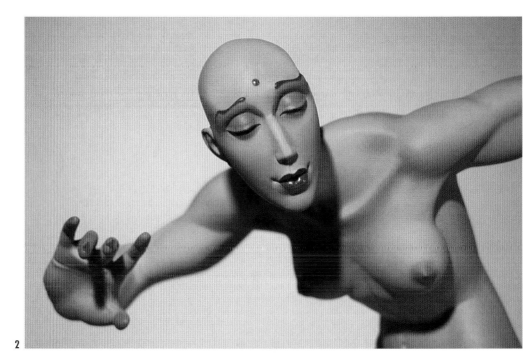

3

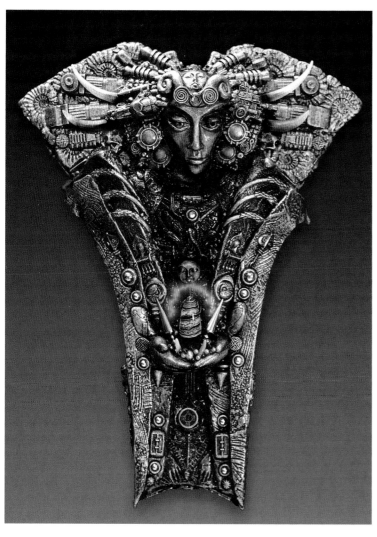

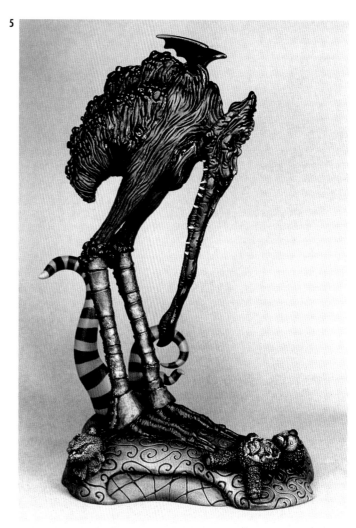

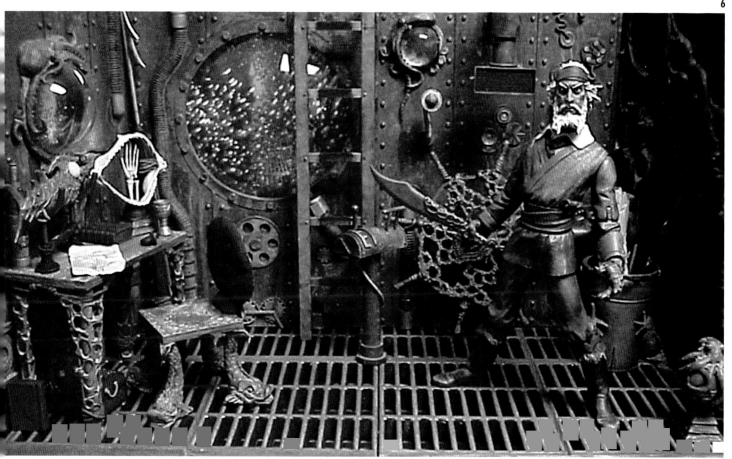

DIMENSIONAL

1
artist: **Steven W. West**
photographer: Michael Edenfield
client: Cellar Cast
title: Wizard
medium: Resin
size: 8" tall

2
artist: **Jordu Schell**
art director: Jordu Schell
photographer: Michael Edenfield
title: Dudley
size: 15" tall

3
artist: **Barsom**
art director: Coop
designer: Coop
client: Simian Productions
title: Devil's Delight
size: 1/4 scale

4
artist: **Dennis Beckstrom**
client: Self promotion
title: Frankenstein's Monster
medium: Chavant (intended for bronze)
size: Life-size

5
artist: **Mike Sosnowski**
art director: Mike Sosnowski
designer: Mike Sosnowski
client: Soz Studios
title: Demon in the Box
medium: Chavant
size: 28" tall

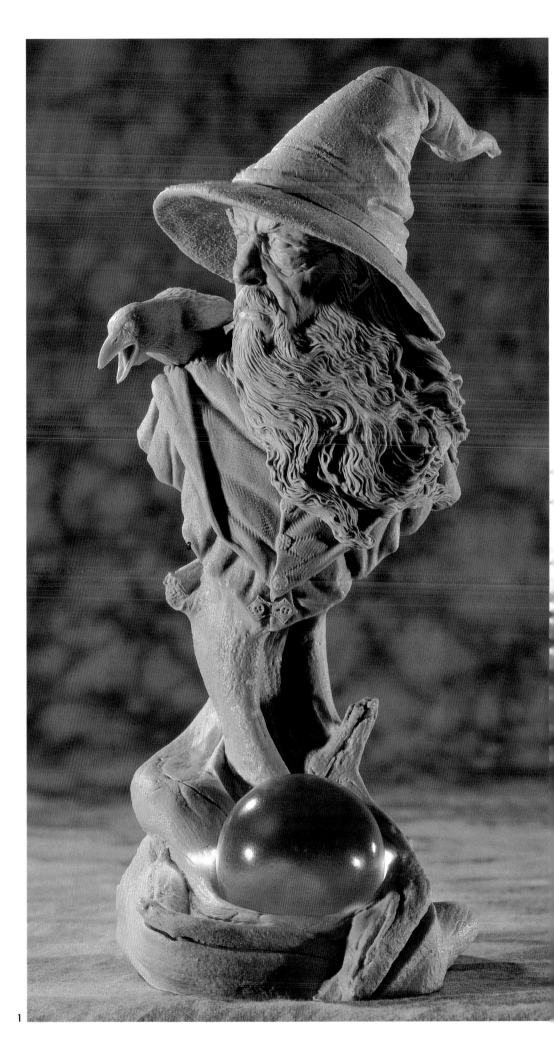

1

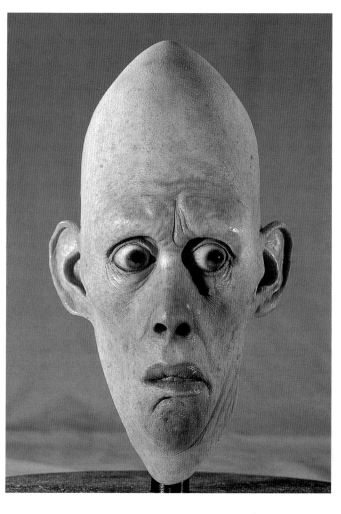

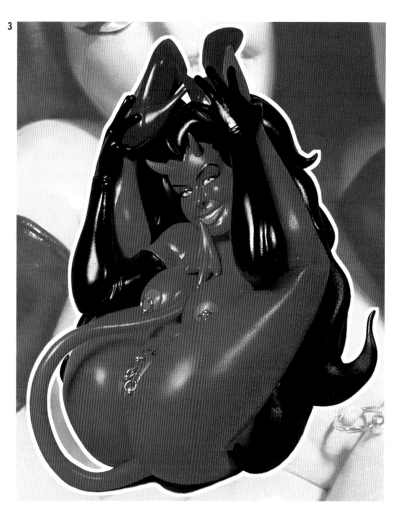

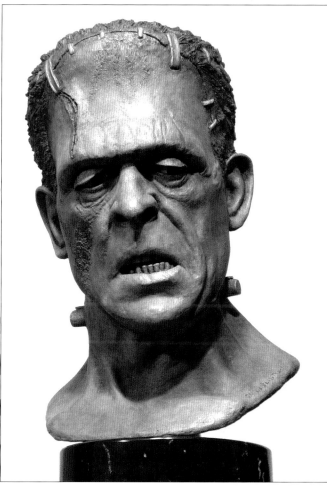

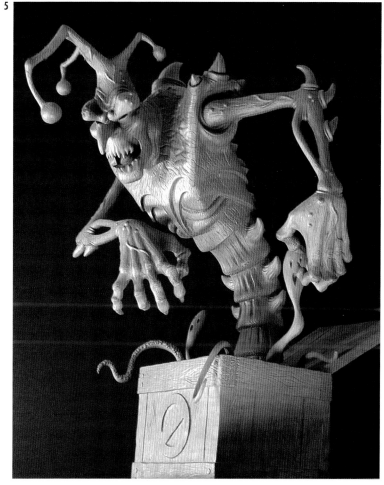

DIMENSIONAL

1
artist: **Joe Lester**
art director: Joe Lester
designer: Joe Lester
title: Dr. Grinn
medium: Roma Plastilina
size: 8" tall

2
artist: **Daniel Hawkins**
art director: Daniel Hawkins
designer: Daniel Hawkins
client: Hawkins Design Studio
title: Xenomorphic Artifact
medium: Mixed
size: 14"x8"

3
artist: **Jean-Louis Crinon**
designer/photographer: Jean-Louis Crinon
title: Diabolo
medium: Resin/metal/oil paint
size: 11" tall

4
artist: **Sandra Lira**
title: Transport
medium: Polymer clay
size: 15"x20"

5
artist: **Mark Rehkopf/R.C.I.**
art director: Mark Rehkopf
designer: Mark Rehkopf/R.C.I./C.M.N.
client: Research Casting International/
Canadian Museum of Nature
title: Daspletosaurus
medium: Polyester resin
size: Life-size/30' length

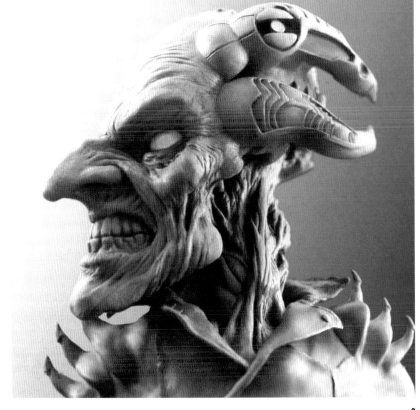

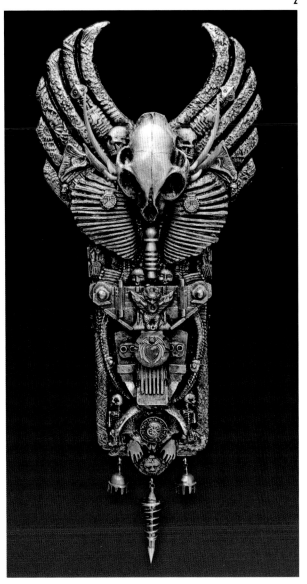

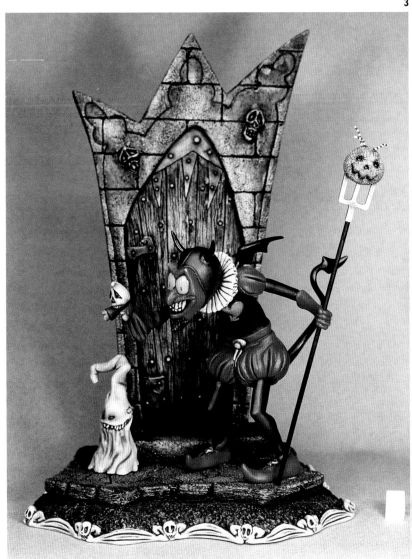

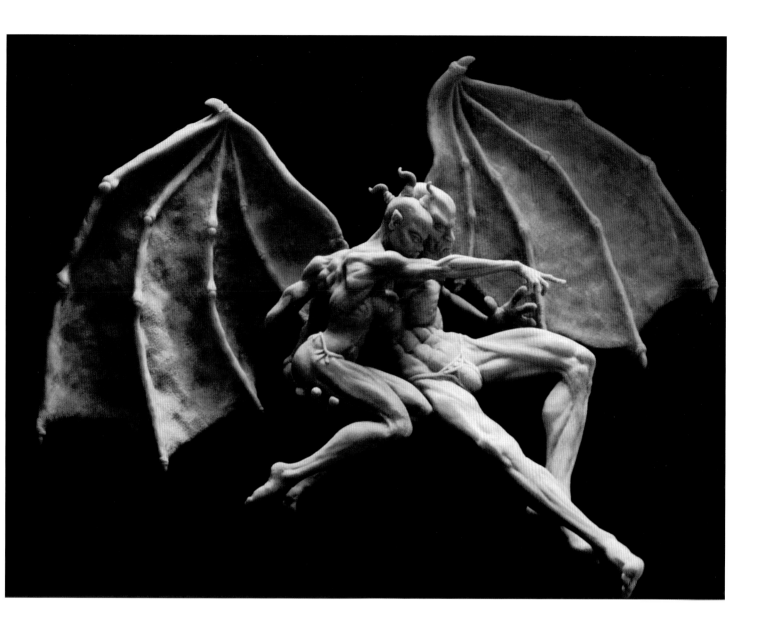

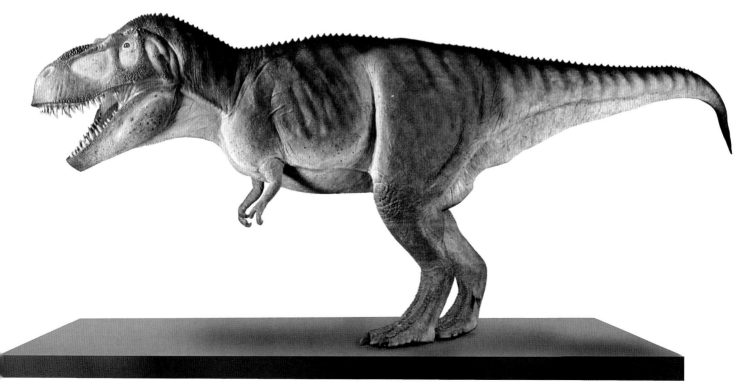

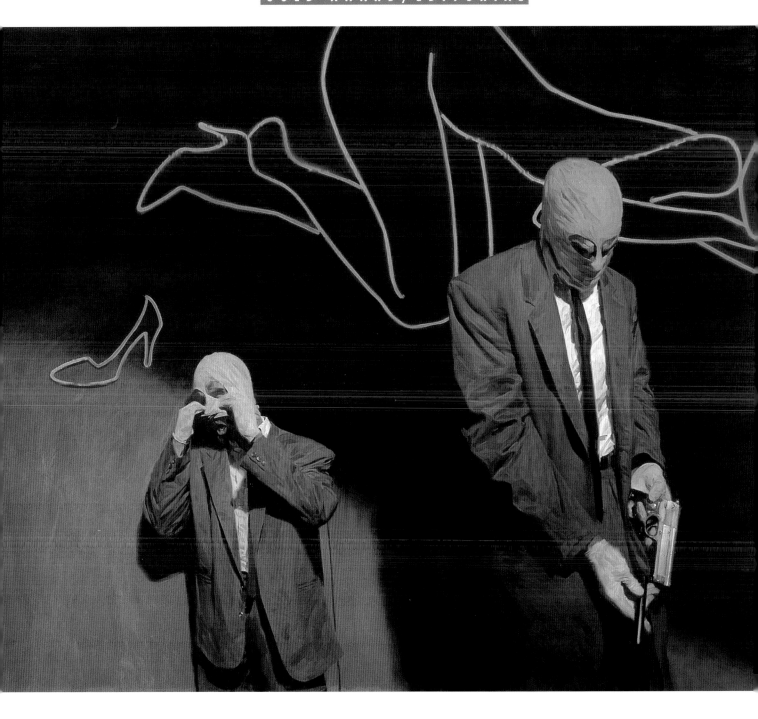

artist: **PHIL HALE**

art director: Tom Staebler designer: Kerig Pope client: Playboy Magazine title: Bloodtest medium: Oil

note: Juror Phil Hale was excluded from the voting for this award.

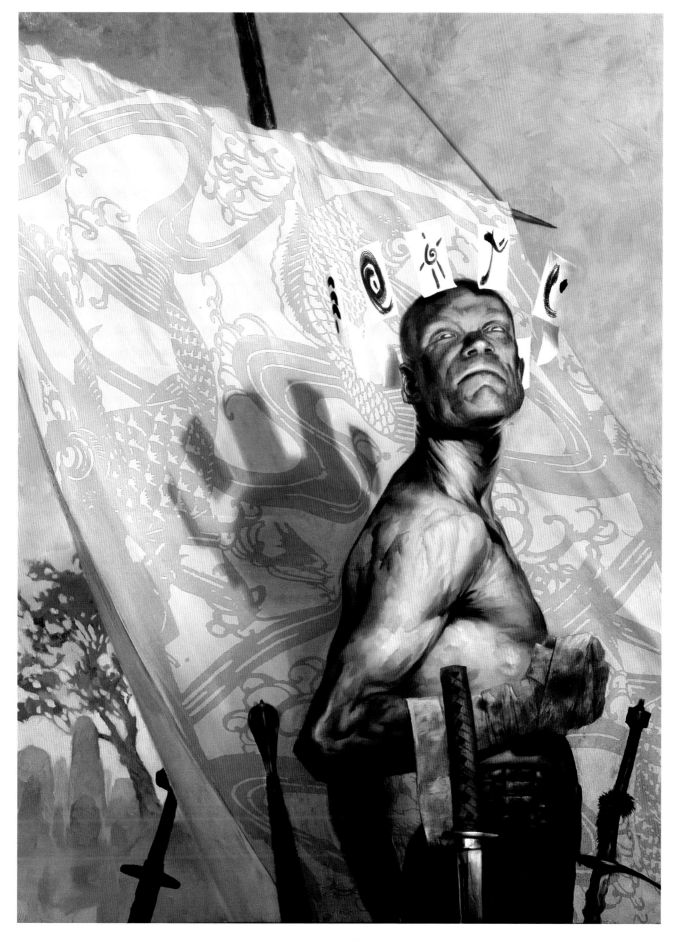

artist: **JON FOSTER**

art director: Peter Whitley designer: Peter Whitley client: Dragon Magazine title: Dragon medium: Oil/digital size: 30"x40"

1
artist: **Pat Andrea**
art director: Tom Staebler
designer: Kerig Pope
client: Playboy Magazine
title: The Letterman

2
artist: **Scott E. Anderson**
art director: Christine Morrison
client: Working Money Magazine
title: Shelter From the Volatility Storm?
medium: Mixed
size: 10"x15"

3
artist: **Anita Kunz**
art director: Fred Woodward/Gail Anderson
client: Rolling Stone
title: J-Lo
medium: Mixed
size: 12"x15"

4
artist: **Anita Kunz**
art director: Françoise Mouly
client: The New Yorker
title: Baby
medium: Mixed
size: 11"x14"

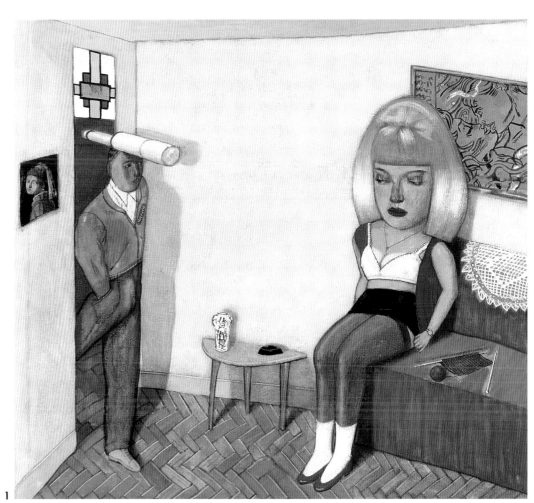

1

2

3

1
artist: **Ray-Mel Cornelius**
art director: Lamberto Alvarez
designer: Lamberto Alvarez
client: Dallas Morning News
title: Downtown Christmas Eve
medium: Acrylic on canvas
size: 12"x20"

7
artist: **Kennon James**
art director: Andrew Migliore
client: Beyond Books
title: Lurker in the Lobby III
medium: Mixed
size: 8¹/₂"x15¹/₂"

3
artist: **Roxana Villa**
art director: Nina Mason
client: Pitzer College
title: 911
medium: Acrylic
size: 9"x15"

4
artist: **Sally Wern Comport**
art director: Nancy Null
client: Harvard Business Review
title: The Job No CEO Should Delegate
medium: Mixed
size: 12"x16"

5
artist: **Stu Suchit**
art director: Stu Suchit
designer: Stu Suchit
client: AS/400
medium: Digital

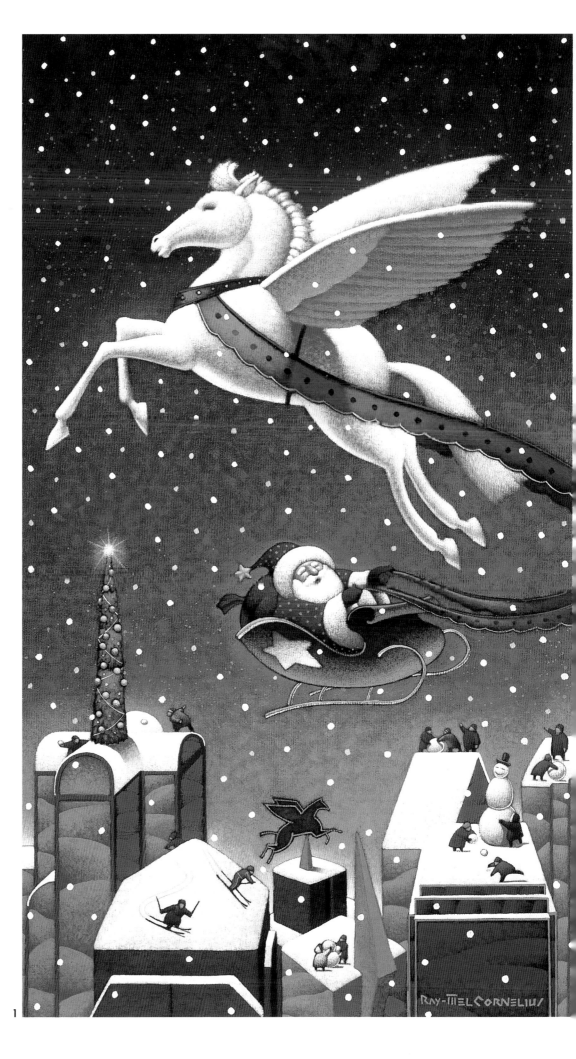

1

3

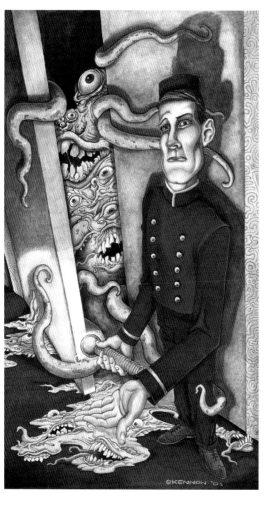

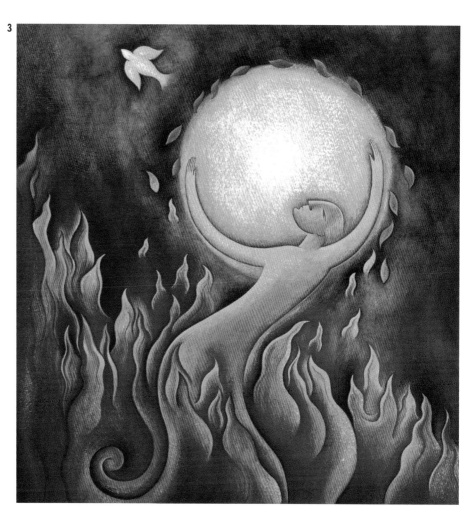

5

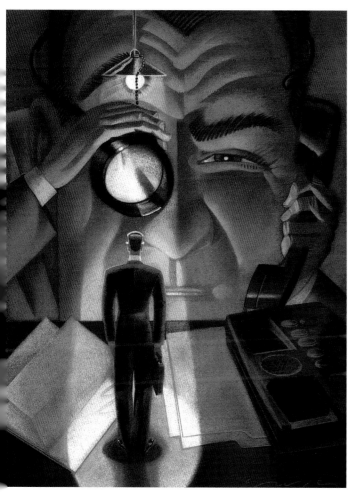

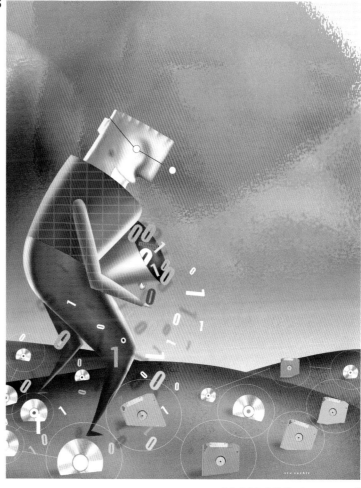

1
artist: **Dave McKean**
art director: Tom Staebler
designer: Kerig Pope
client: Playboy Magazine
title: Aiding & Abetting
medium: Mixed

2
artist: **Istvan Banyai**
art director: Tom Staebler
designer: Kerig Pope
client: Playboy Magazine
title: Supertoys

3
artist: **Rafal Olbinski**
art director: Geraldine Hessler
client: Entertainment Weekly
title: The Year That Was

4
artist: **David Bowers**
art director: Dwayne Cogdill
client: Christian Research Journal
title: Missing Link
medium: Oil
size: 13"x18"

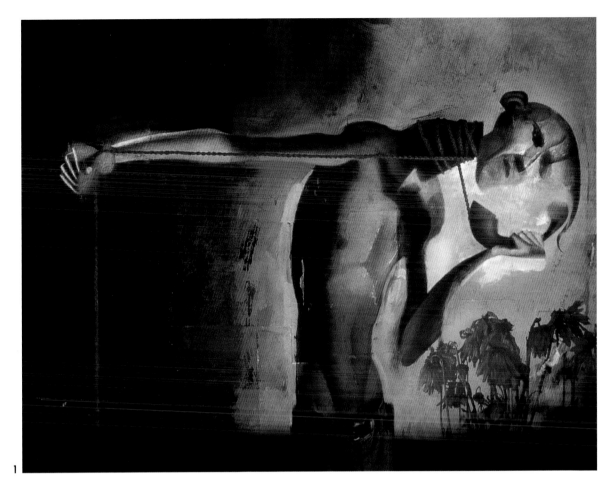

1

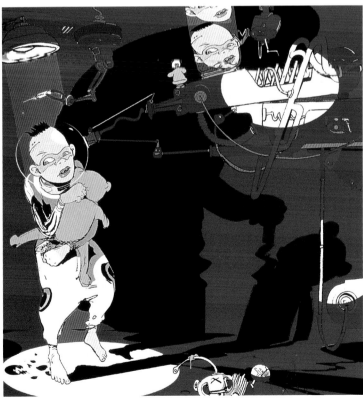

2

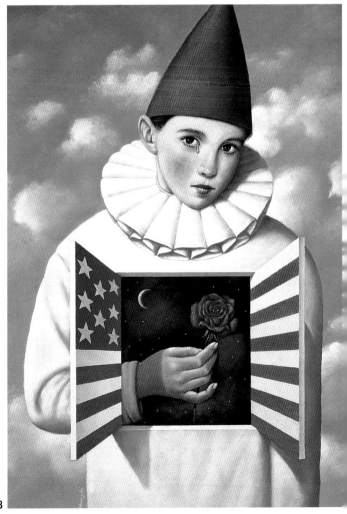

3

4

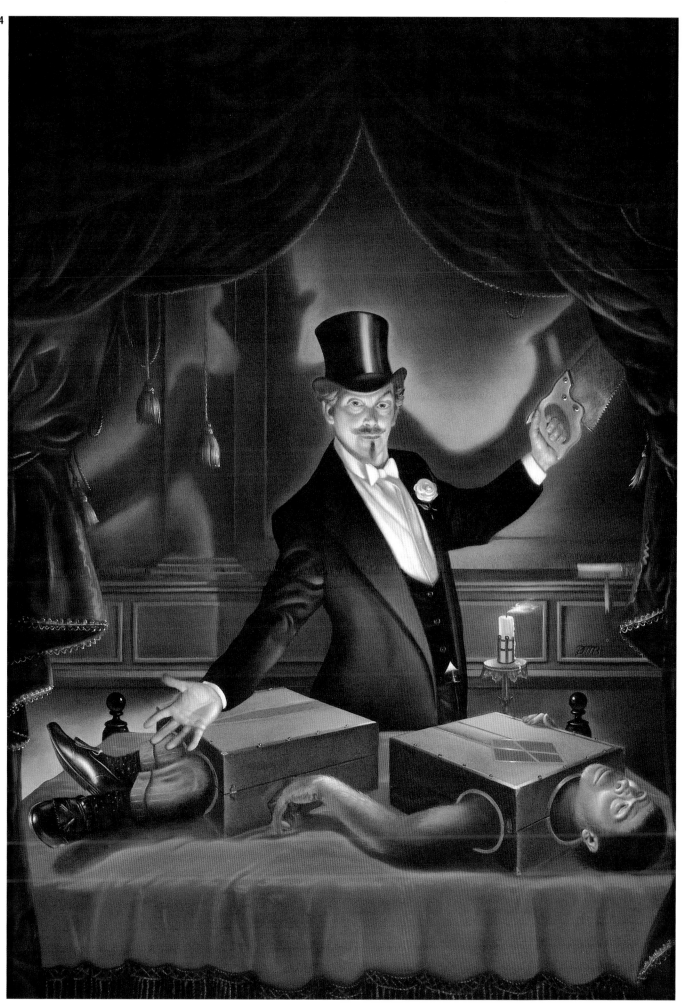

1
artist: **Brom**
art director: Peter Whitley
client: Dragon Magazine
title: Shade of Blue
medium: Oil

2
artist: **Alex Horley-Orlandelli**
art director: Jean L. Scrocco
photographer: Spiderwebart Gallery
client: Heavy Metal Magazine
title: Paladin
medium: Acyrlic
size: 11"x17"

3
artist: **Hubert de Lartigue**
client: Airbrush Art & Action
title: Alizé
medium: Acrylic/inks
size: 50cmx65cm

4
artist: **Yoshihito Tomobe**
art director: Yoshihito Tomobe
client: Vibes Magazine
title: Little Devel
medium: Acrylic
size: 9"x12"

5
artist: **Russell Dickerson**
art director: Jon Hodges
client: Wicked Hollow Magazine
title: Fetal Position
medium: Digital
size: 3¹/2"x5"

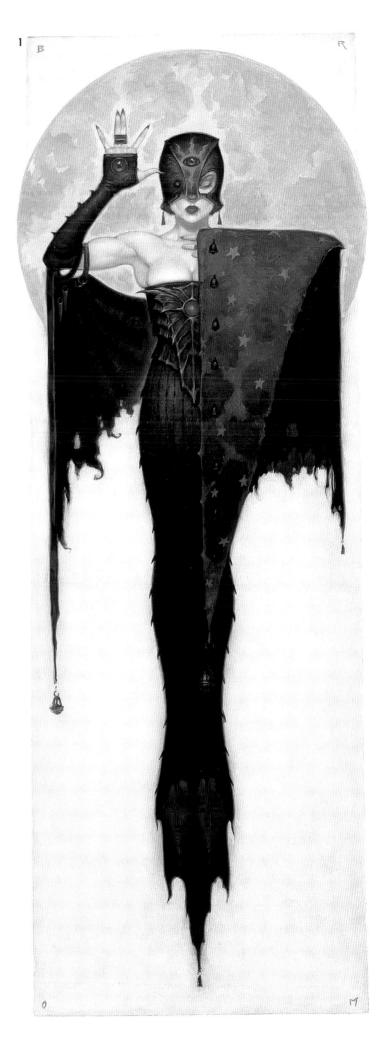

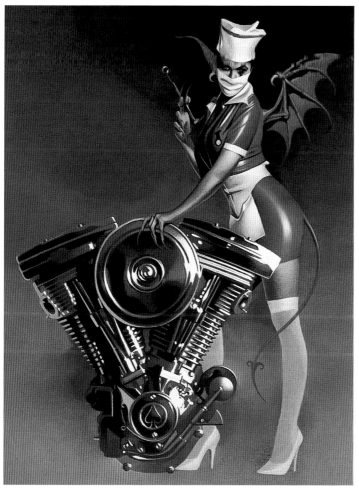

EDITORIAL

1
artist: **Raymond Swanland/Oddworld CG Team**
art director: Cathy Johnson
designer: Raymond Swanland
client: Oddworld Inhabitants
medium: Digital

2
artist: **Bruce Jensen**
art director: Bruce Jenson
client: 60 Minutes II
title: Wall Street Prophets
medium: Digital
size: 9"x6"

3
artist: **Bruce Jensen**
art director: Bruce Jensen
client: 60 Minutes II
title: What Have They Done To Our Food?
medium: Digital
size: 9"x6"

4
artist: **John Zeleznik**
art director: Tom Staebler
designer: Kerig Pope
client: Playboy Magazine
title: Really High Steel

1

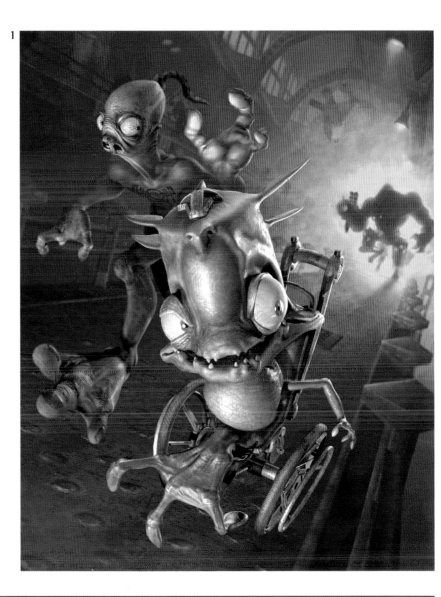

2

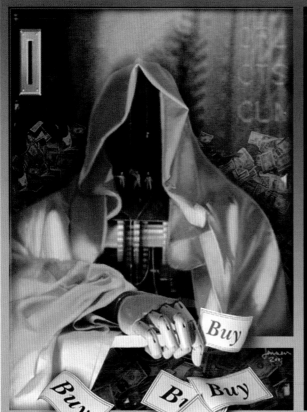

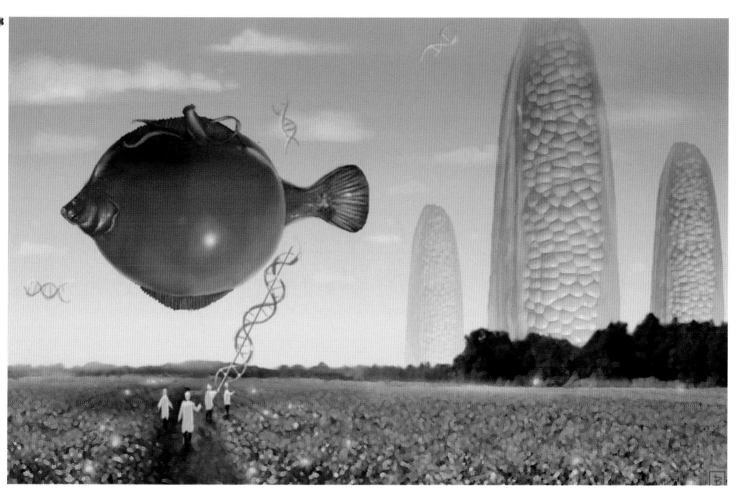

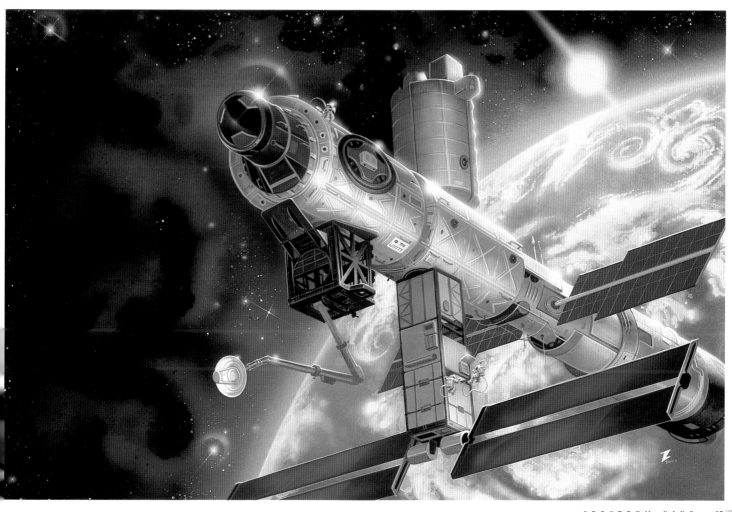

1
artist: **Mark Zug**
art director: Peter Whitley
client: Dragon Magazine
title: Scourge of Light
medium: Oil
size: 14"x18"

2
artist: **Bryn Barnard**
art director: Tony Jacobson
client: Spider Magazine
title: Dragon Mountain
medium: Oil
size: 19"x23"

3
artist: **Mike Weaver**
art director: Christopher Perkins
client: Dungeon/Wizards of the Coast
title: Last Home
medium: Oil
size: 24"x36"

4
artist: **Terese Nielsen**
art director: Lisa Chido
client: Dragon Magazine
title: Sungod
medium: Mixed
size: 9"x12"

1

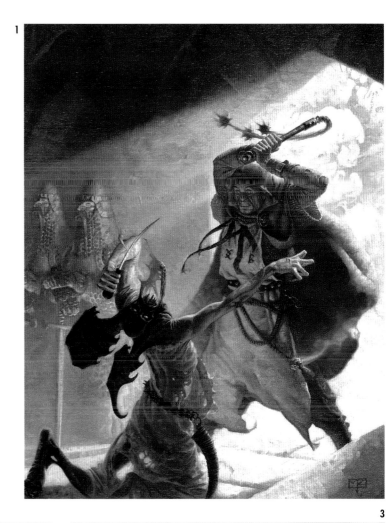

2

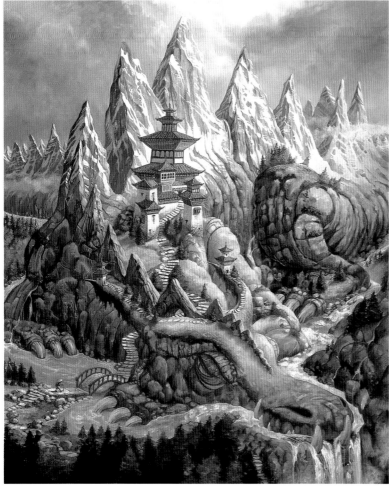

3

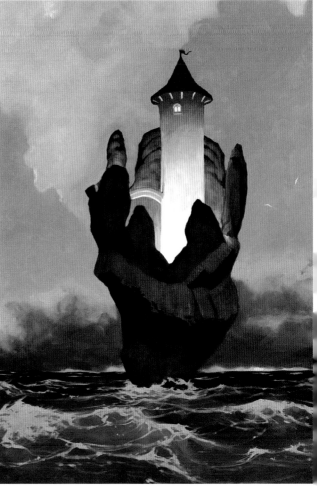

4

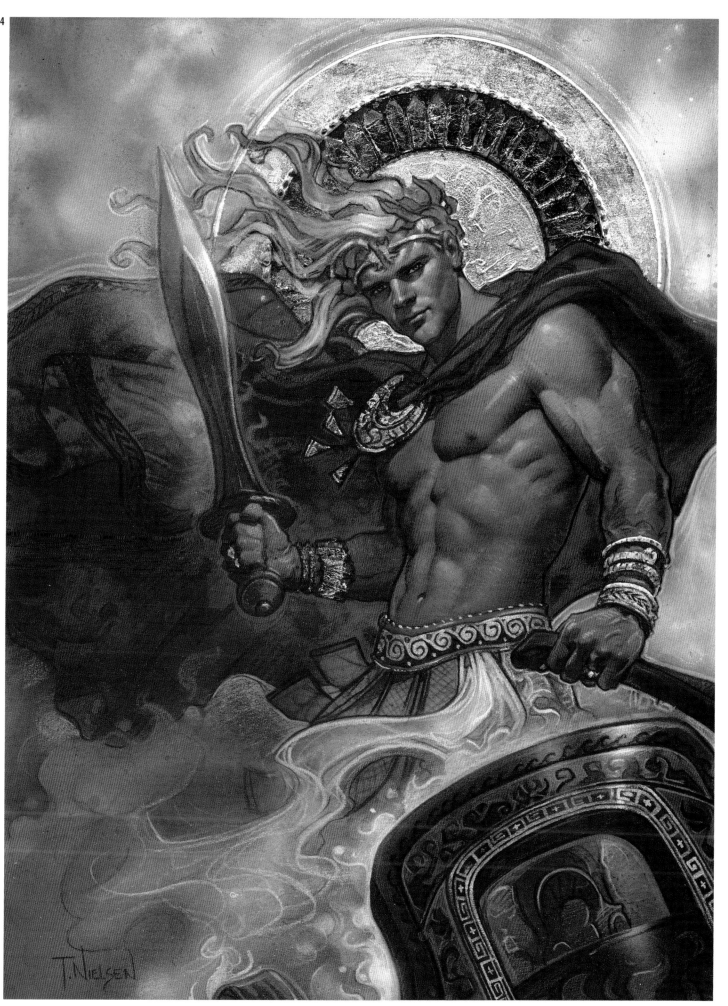

T. Nielsen

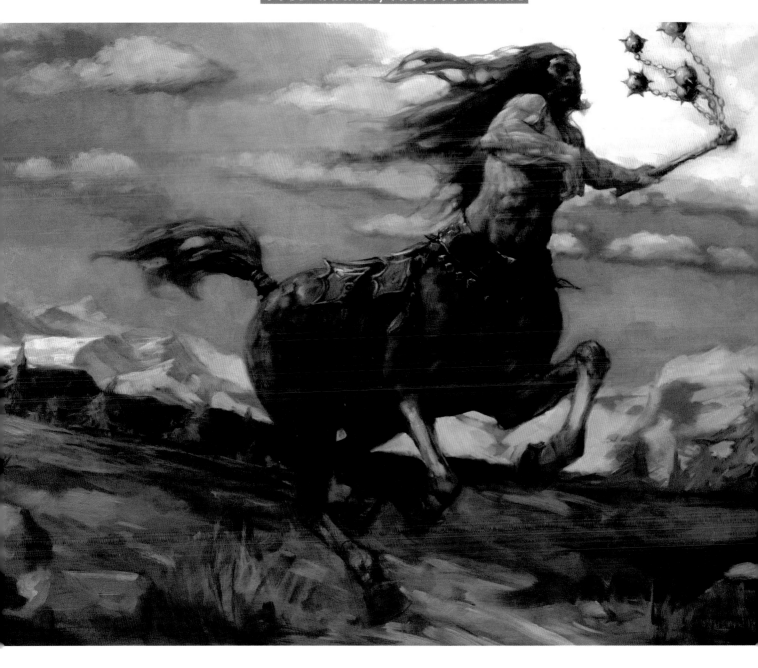

artist: **JUSTIN SWEET**
art director: Dana Knutson client: Wizards of the Coast medium: Oil

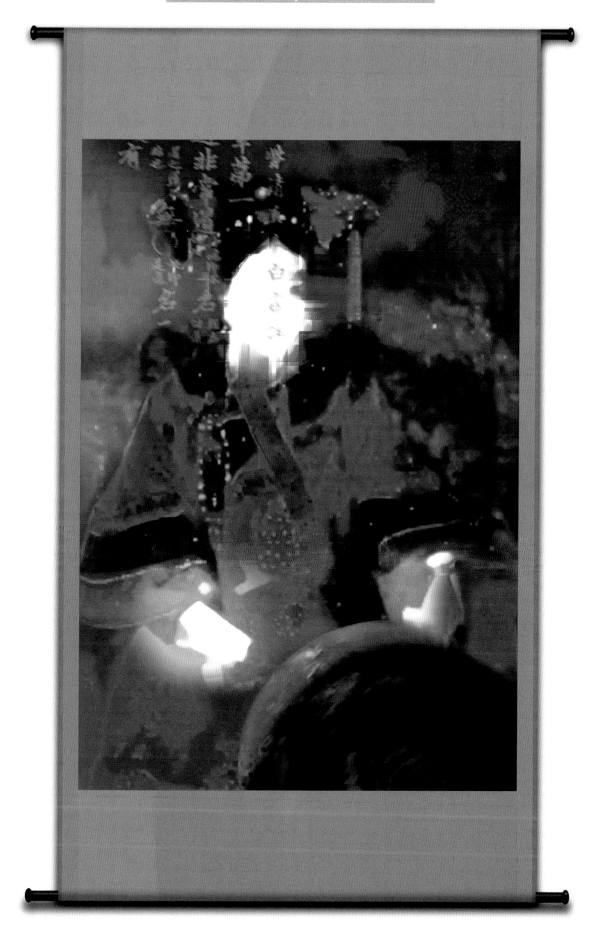

artist: **RICK BERRY**
art director: Rick Berry client: Tufts University title: Penumbra medium: Mixed/digital on silk scroll size: 30"x60"
note: *Juror Rick Berry was excluded from the voting for this award.*

1
artist: **Jason Felix**
client: www.jasonfelix.com
title: Lucifer Demonica
medium: Digital
size: 11"x17"

2
artist: **Scott M. Fischer**
art director: Teresa N. Green
client: Green Fisch Studio
title: Chapter
medium: Oil

3
artist: **Gary Ruddell**
art director: Collin Birdseye
designer: Gary Ruddell
client: Thieves World Cards
title: Dead of Winter
medium: Oil
size: 15"x20"

4
artist: **Daniel R. Horne**
art director: Daniel R. Horne
client: Arcadia Studioz
title: Arcadia
medium: Oil on masonite
size: 20"x26"

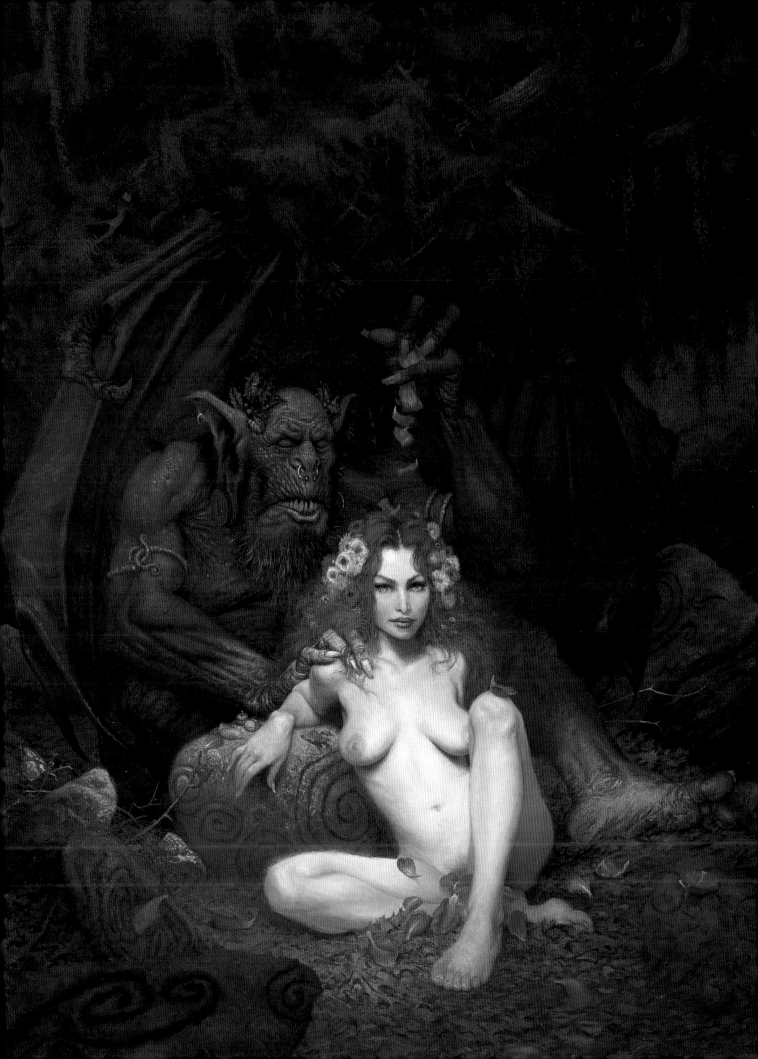

INSTITUTIONAL

1
artist: **LeUyen Pham**
art director: Alexandre Puvilland
designer: LeUyen Pham
title: The One Hundred Eggs
medium: Watercolor
size: 11 1/2"x10 1/2"

2
artist: **Michael Whelan**
designer: Robin Haywood
client: RSVP, Inc.
title: Gold Wing
medium: Acrylics on panel
size: 22"x28"

3
artist: **Larry MacDougall**
art director: Patricia Lewis
client: Underhill Studios
title: Stove Pipe
medium: Watercolor
size: 8 1/2"x11"

4
artist: **Vance Kovacs**
art director: Robert Raper
client: Wizards of the Coast
title: The Silver Marches
medium: Digital

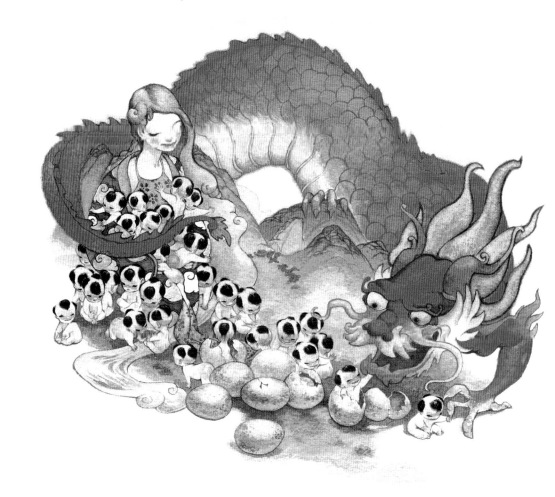

4

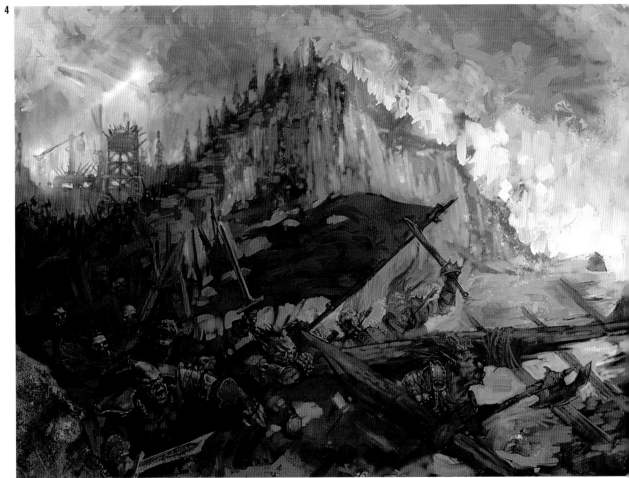

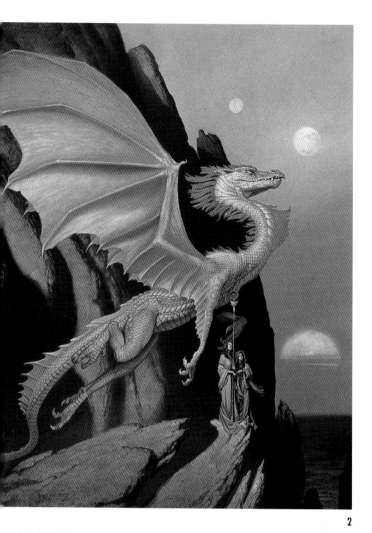

2

3

1
artist: **Rafal Olbinski**
art director: Rafal Olbinski
designer: Rafal Olbinski
client: Kulczyk Holding S.A.
title: March/Marzec
medium: Acrylic
size: 10"x30"

2
artist: **Lee Ballard**
art director: Lee Ballard
designer: Doug Cunningham
client: Impact Gallery
title: Circle
medium: Oil
size: 25"x50"

3
artist: **Ben J La Placa**
art director: Clint Davidson
designer: Ben J La Placa
client: Blue Cube Arts
title: Herd the Call?
medium: Acrylic
size: 24"x33"

4
artist: **Rafal Olbinski**
art director: Rafal Olbinski
designer: Rafal Olbinski
client: Kulczyk Holding S.A.
title: July/Lipiec
medium: Acrylic
size: 10"x30"

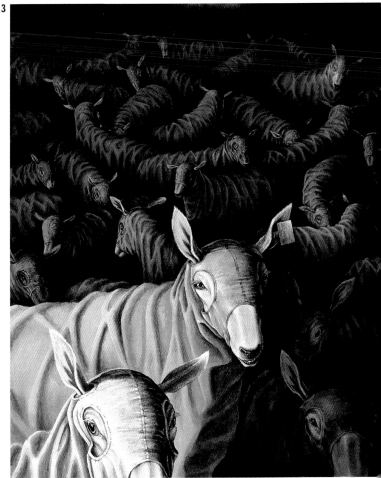

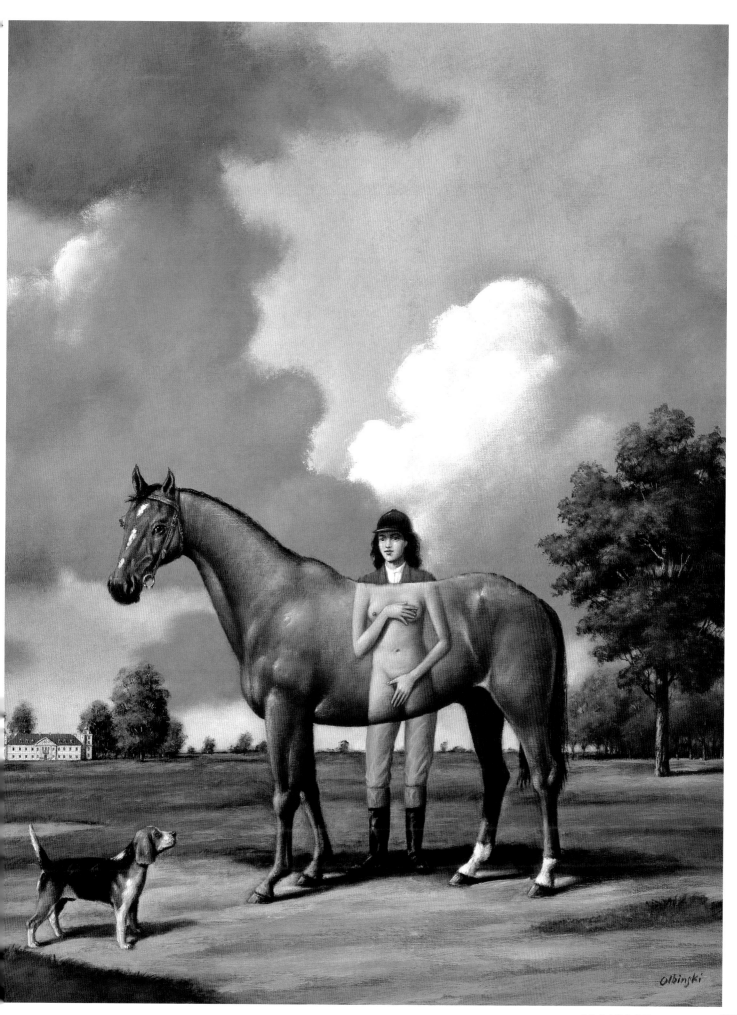

Olbinski

1
artist: **Dave McKean**
designer: Dave McKean
client: Adobe (calendar)
title: They're Out There
medium: Mixed
size: 12"x18"

2
artist: **Joseph Daniel Fiedler**
art director: Mark Murphy
designer: Mark Murphy
client: Murphy Design
title: Trachea Girl
medium: Mixed
size: 4'x4'

3
artist: **Brad Weinman**
art director: Anthony Padilla
designer: Jon Coy
client: Art Institute of Southern California
title: Time To Get Ahead
medium: Oil on wood
size: 7"x10"

4
artist: **Chris Hawkes**
art director: Chris Hawkes
title: Logan
medium: Oil
size: 8"x10"

5
artist: **Greg Spalenka**
art director: Greg Spalenka
title: Princess
medium: Mixed/digital
size: 11"x13"

6
artist: **Russell Harris**
art director: Russell Harris
designer: Russell Harris
title: Liberation
medium: Oil on canvas
size: 10"x10"

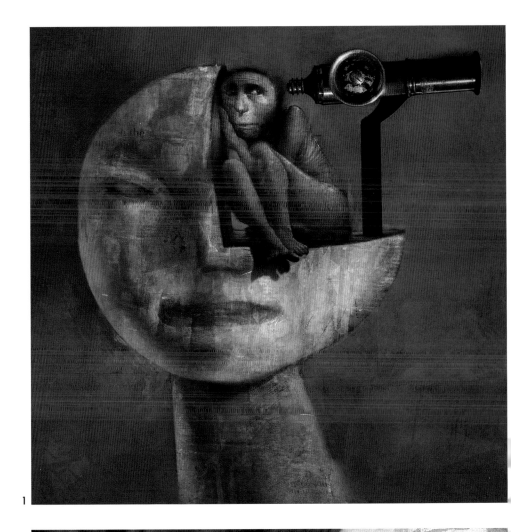

1

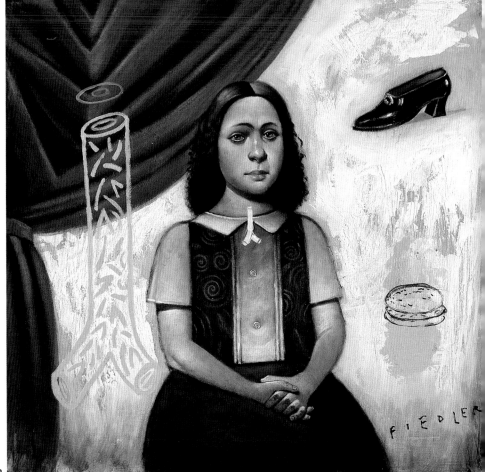

2

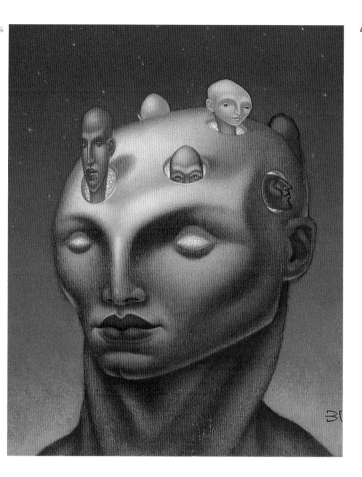

4

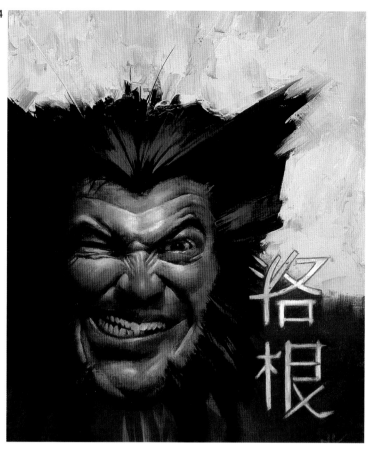

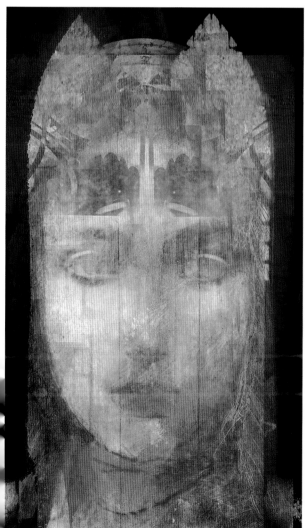

6

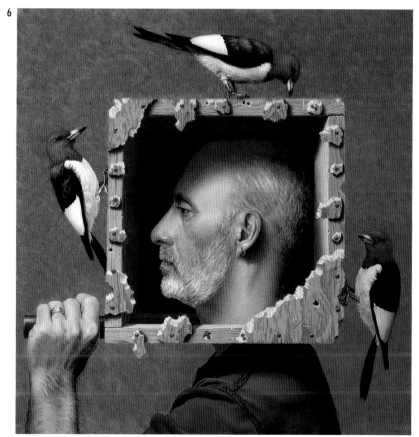

1
artist: **Donato Giancola**
art director: Dana Knutson
client: Wizards of the Coast
title: Cartographer
medium: Oil on paper on masonite
size: 22"x20"

2
artist: **Todd Lockwood**
art director: Dawn Murin
client: Wizards of the Coast
title: The Iron Fortress
medium: Digital
size: 8¹/₂"x11"

3
artist: **Allen Douglas**
title: Guardians of the Emerald Hall
medium: Oil on paper on masonite
size: 16¹/₂"x26"

4
artist: **John Howe**
art director: Robert Hyde
client: Sophisticated Games
title: Orthanc Destroyed
medium: Watercolor
size: 18"x24"

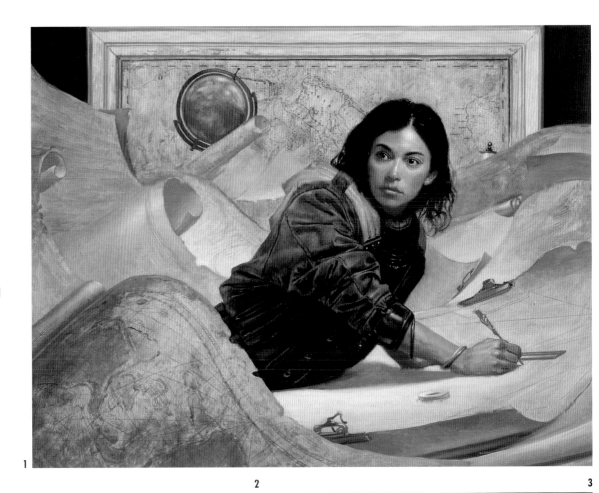

1

2

3

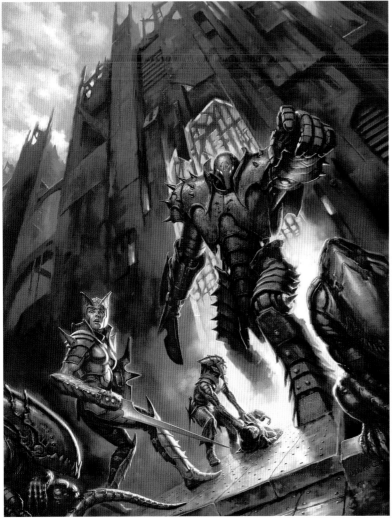

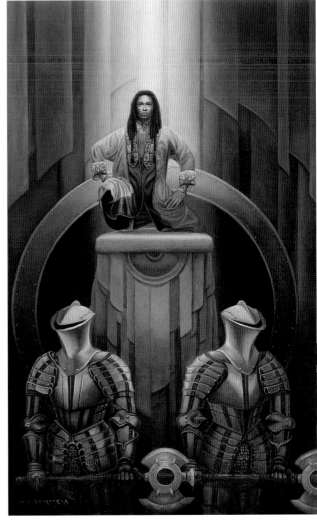

4

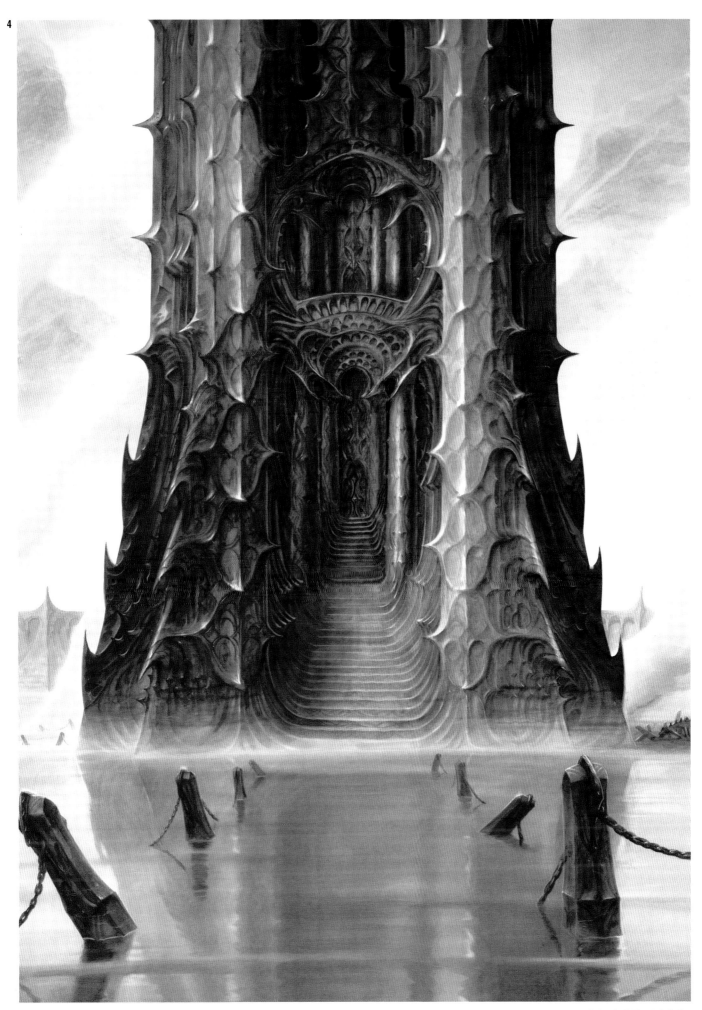

INSTITUTIONAL

1
artist: **Oddworld CG Dept.**
art director: Lorne Lanning
designer: Oddworld Production Design Dept.
client: Oddworld Inhabitants
title: Oddworld: Munch's Oddysee
medium: Digital

2
artist: **Oddworld CG Dept.**
art director: Lorne Lanning
designer: Oddworld Production Design Dept.
client: Oddworld Inhabitants
title: Oddworld: Munch's Oddysee
medium: Digital

3
artist: **Fernando L. Palma**
art director: Fernando L. Palma
designer: Fernando L. Palma
title: Artificial Planet Construction
medium: Digital
size: 27 1/2"x10 1/2"

4
artist: **Stephen Youll**
designer: Stephen Youll
client: Millennium PhilCon
title: An Experiment with Gravity
medium: The medium
size: 29 1/2"x19 1/2"

5
artist: **Mark Tedin**
art director: Kevin Tewart
client: Precedence Entertainment
title: Iron Dragonfly
medium: Acrylic/gouache
size: 14"x11"

1

2

3

4

5

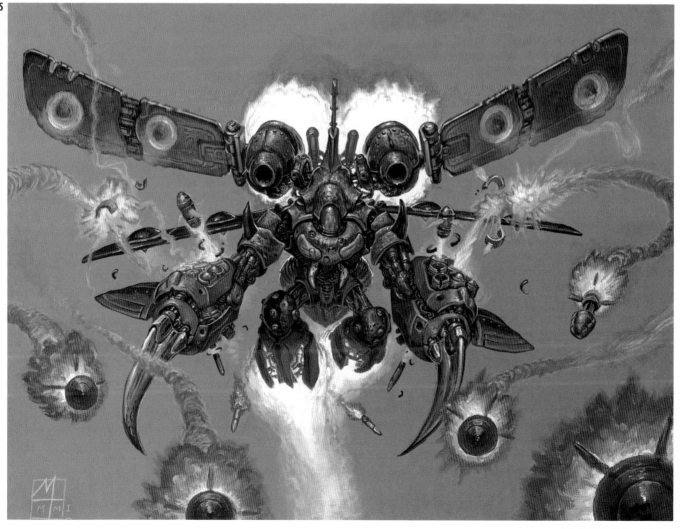

INSTITUTIONAL

1
artist: **John Jude Palencar**
client: CCAD/DAW Books
title: Cultural Center Argentina
medium: Acrylic

2
artist: **Todd Lockwood**
art director: Robert Raper
client: Wizards of the Coast
title: City of the Spider Queen
medium: Digital

3
artist: **Justin Sweet**
art director: Robert Raper
client: Wizards of the Coast
title: Magic of Faerun
medium: Oil

4
artist: **Greg Staples**
art director: Robert Raper
client: Wizards of the Coast
title: Races of Faerun
medium: Mixed

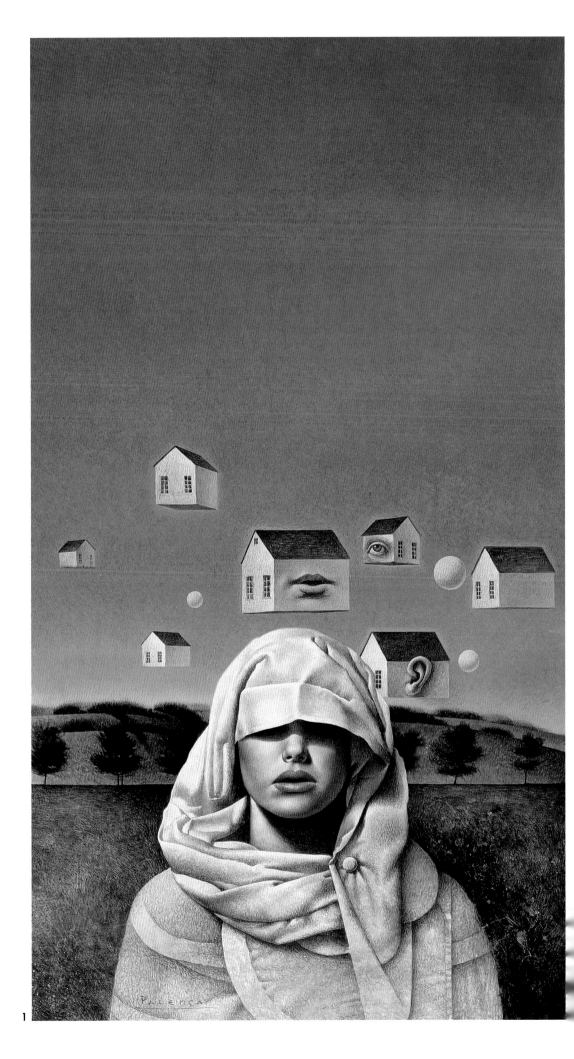

1

2

3

4

1
artist: **Jeff Soto**
art director: Mark Murphy
client: Murphy Designs
title: Tugger
medium: Acrylic
size: 16"x16"

2
artist: **Eric Fortune**
title: The Fight Scene
medium: Acrylic
size: 15 1/2"x12"

3
artist: **Manchu**
client: Livre de Poche
title: The Difference Engine
medium: Acrylic on paper
size: 50cmx65cm

4
artist: **Chris Hawkes**
art director: Chris Hawkes
title: Wildhair
medium: Oil
size: 16"x20"

5
artist: **Zak Jarvis**
art director: Zak Jarvis
title: Ravished
medium: Digital

6
artist: **Patrick Meadows**
art director: Patrick Meadows
client: Dreamweaver Studios
title: Suspension
medium: Acrylics/mixed
size: 20"x30"

1

2

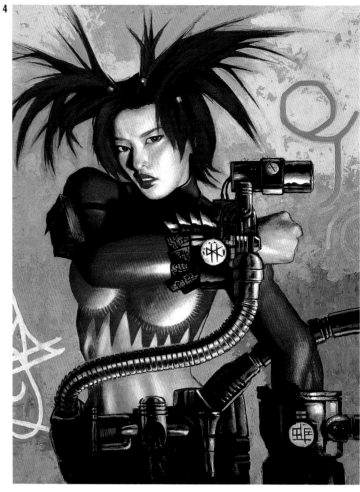

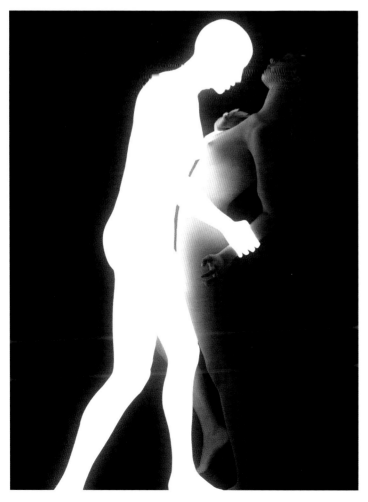

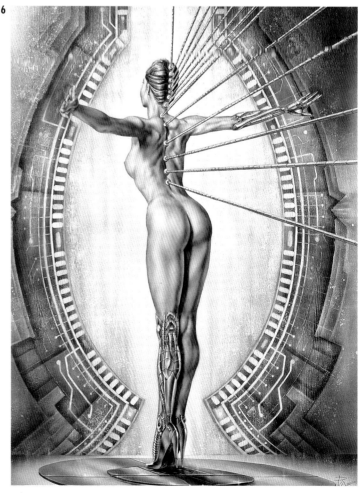

1
artist: **Terese Nielsen**
art director: Dana Knutsen
client: Wizards of the Coast
title: Gaea's Skyfolk
medium: Acrylic/oil
size: 13"x10"

2
artist: **Raymond Swanland**
art director: Raymond Swanland
client: Oddworld Inhabitants
title: Subterranean
medium: Digital

3
artist: **Ron Spears**
art director: Dana Knutson
client: Wizards of the Coast
title: Reflection
medium: Oil
size: 11"x14"

4
artist: **Gale Heimbach**
designer: Gale Heimbach
title: Morgana
medium: Oil
size: 27"x34"

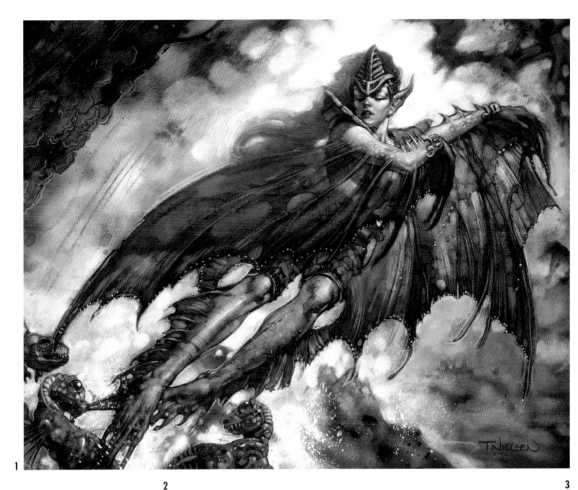

1

2

3

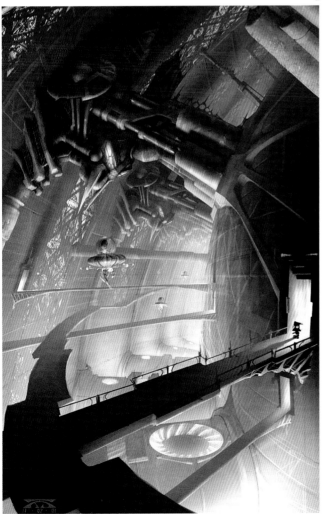

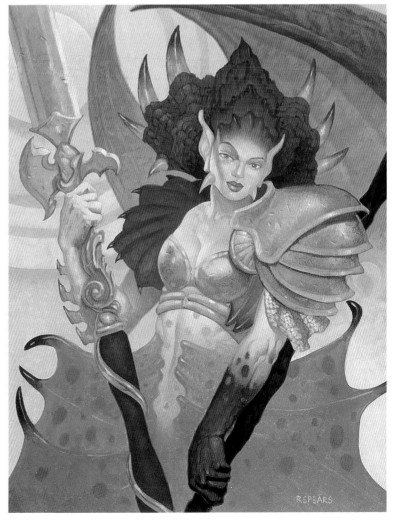

4

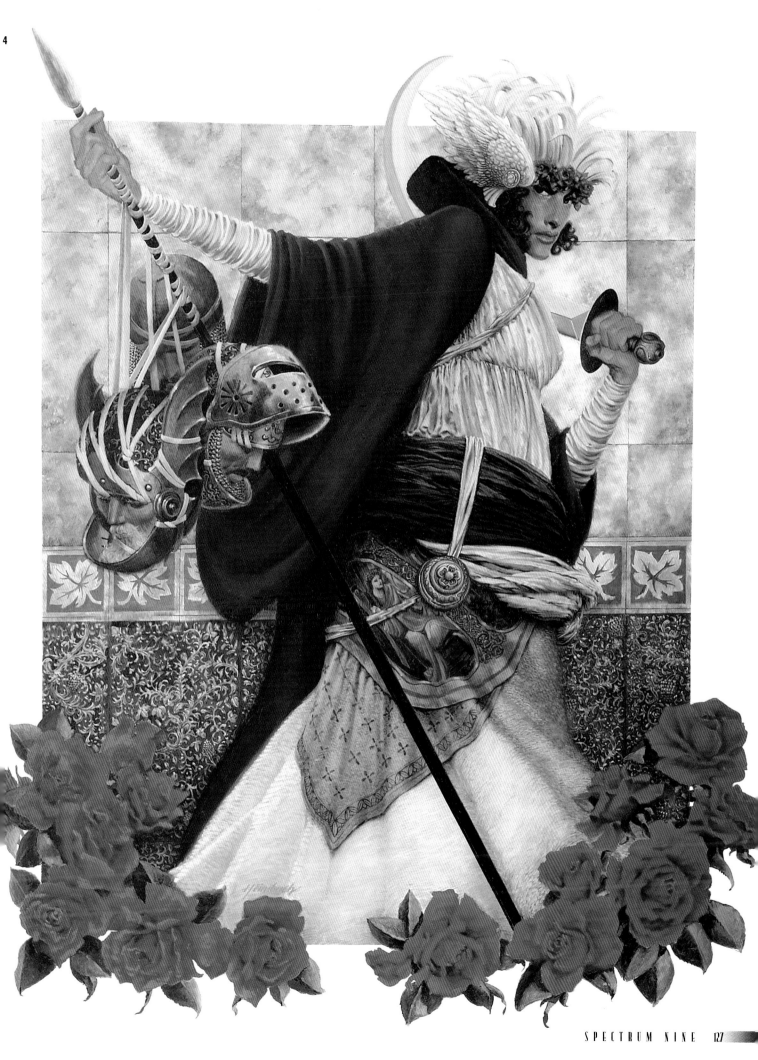

1
artist: **Cambria Christensen/**
Merrilee Liddiard
art director: Merrilee Liddiard
designer: Cambria Christensen
title: Jaded
medium: Acrylic
size: 24"x18"

2
artist: **Will Bullas**
art director: Scott Usher
designer: Will Bullas
client: The Greenwich Workshop, Inc.
title: The Bar Exam...
medium: Watercolor
size: 32"x22"

3–5
artist: **Peter de Séve**
art director: Chris Wedge/
Brian Meius
client: 20th Century Fox
title: *Ice Age* Character Designs
medium: Pencil
size: Various

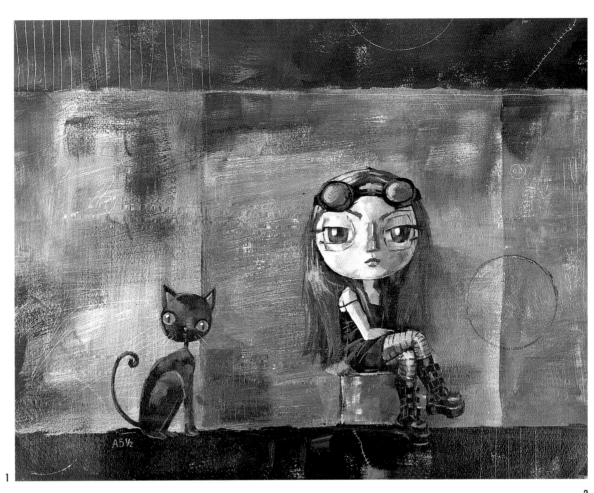

1

2

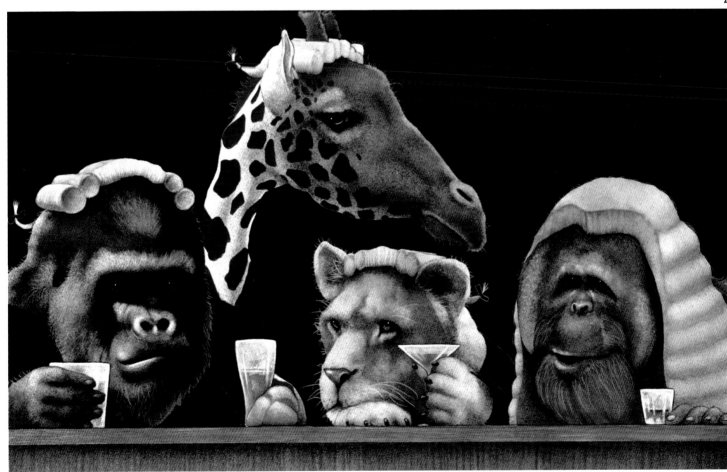

3

4

5

1
artist: **Kari Christensen**
title: Prayer Dragon
medium: Oil
size: 36"x72"

2
artist: **Todd Lockwood**
art director: Matt Adelsperger
client: Wizards of the Coast
title: The 1000 Orcs
medium: Digital

3
artist: **Brom**
art director: Matt Adelsperger
client: Wizards of the Coast
title: Insurrection
medium: Oil

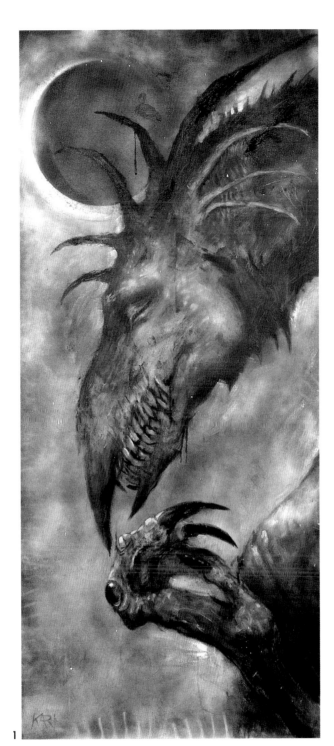

1

2

3

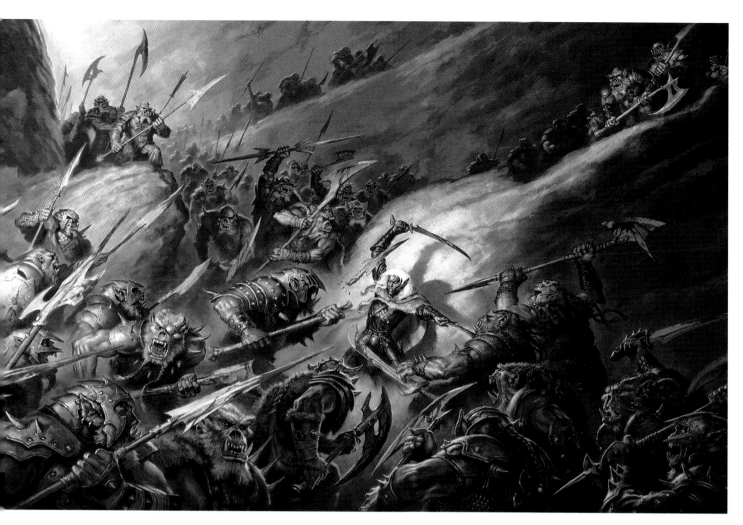

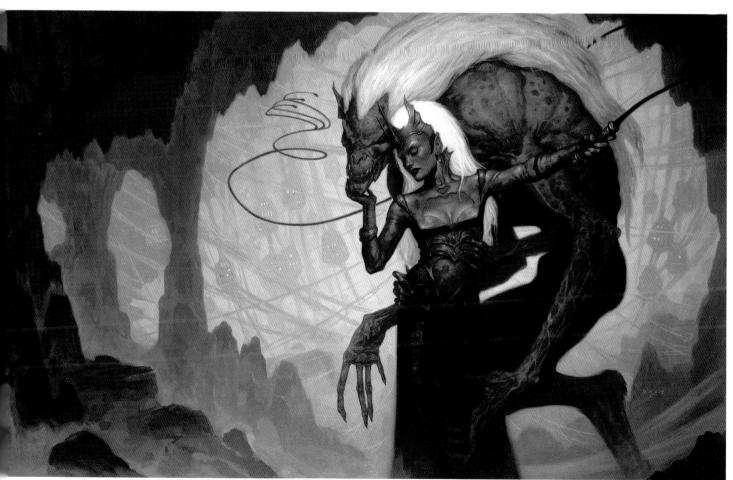

1
artist: **Kathleen O'Connell**
art director: Julie Schaefer
designer: Michelle Cherry-Kemp
client: Herron School of Art/
 Indiana University Purdue
 University Indianapolis
title: The Green Man
medium: Watercolor/color pencil
size: 14"x17"

2
artist: **Joel Spector**
art director: Joel Spector
client: Wizard & Genius
title: Red Winged Angel
medium: Pastels
size: 40"x30"

3
artist: **Michael Whelan**
art director: Mitsutoshi Hosaka
client: Matsuzaki Shoji
title: Skychild's Fall
medium: Oils on panel
size: 22"x22"

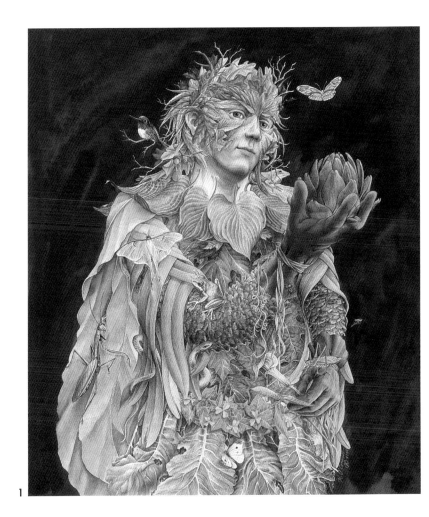

1

2

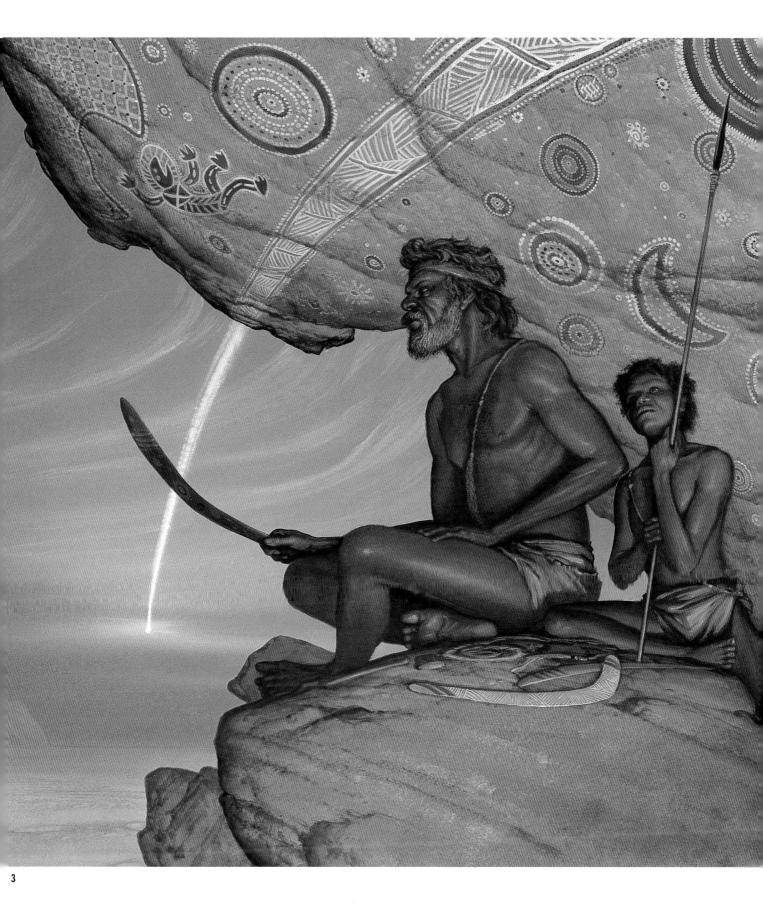

3

1
artist: **Greg Swearingen**
art director: Steffanie Lorig
client: AIGA Seattle
title: Draw Your Own Robot
medium: Mixed
size: 15"x12"

2
artist: **Scott Gustafson**
art director: Scott Usher
designer: Scott Usher
client: The Greenwich Workshop
title: St. Nickolas in His Study
medium: Oil
size: 40"x26"

3
artist: **Lori Koefoed**
art director: Anthony Padilla
designer: Jon Coy
client: Art Institute
 of Southern California
title: Talisman
medium: Oil/digital
size: 24"x36"

1

2

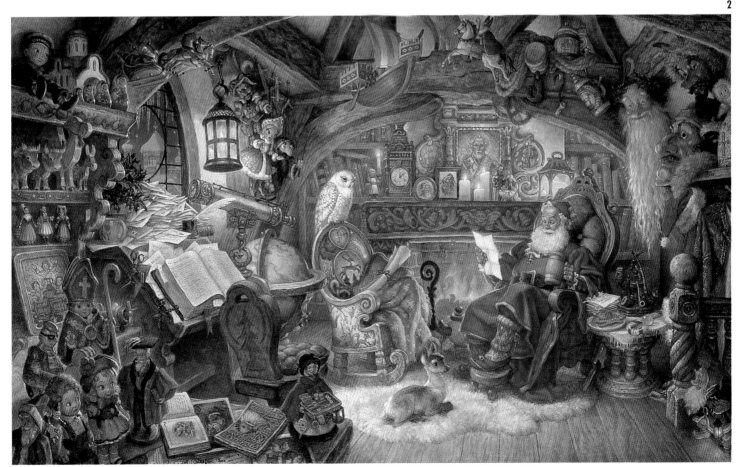

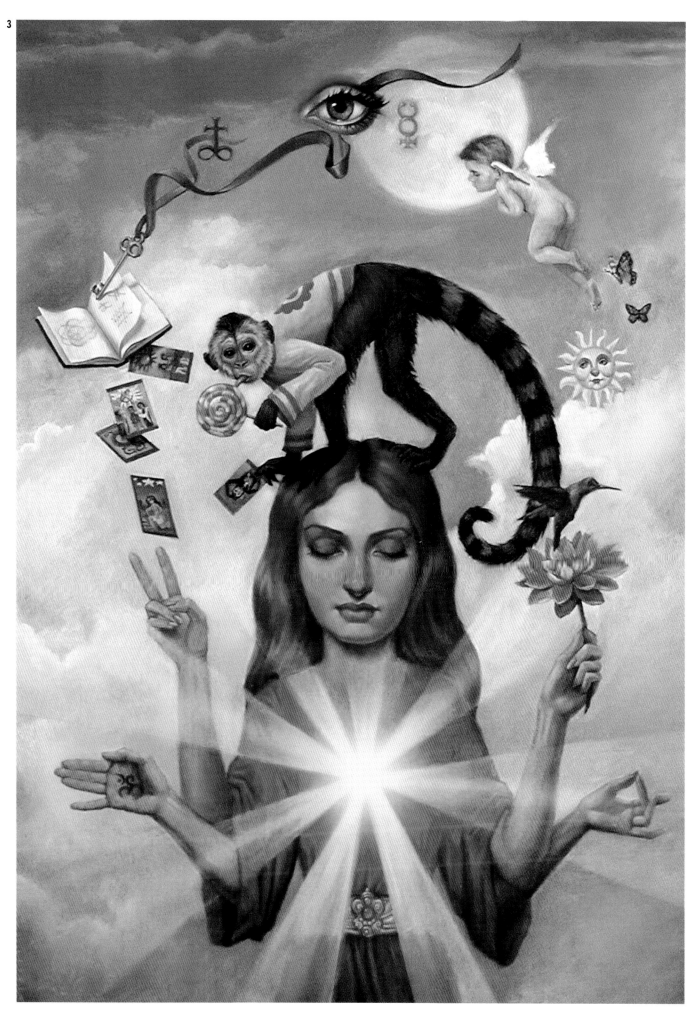

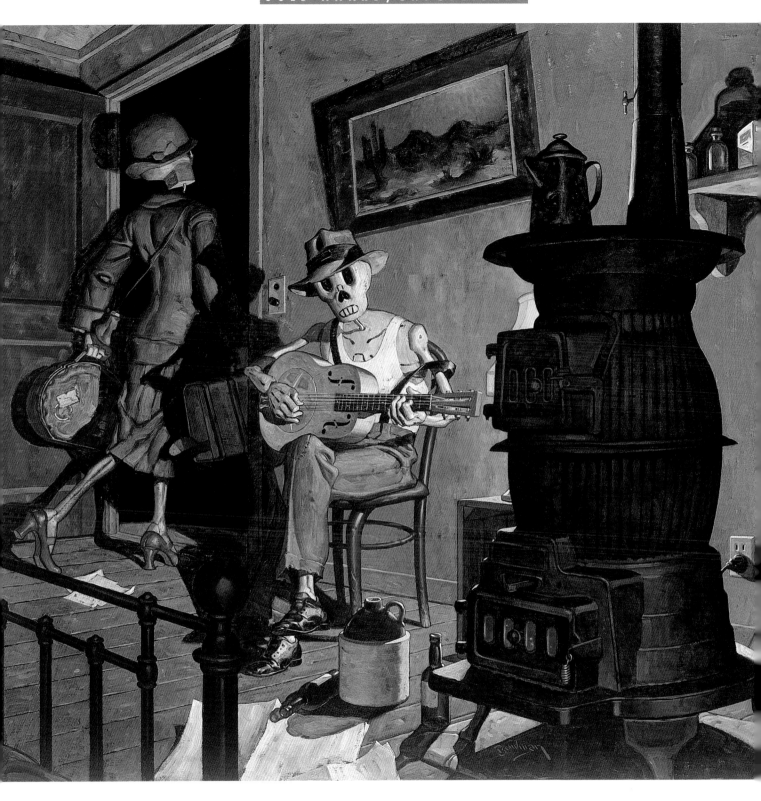

artist: **ERIC BOWMAN**
art director: ERic Bowman title: Baby, Please Don't Go... medium: Oil size: 14"x13"

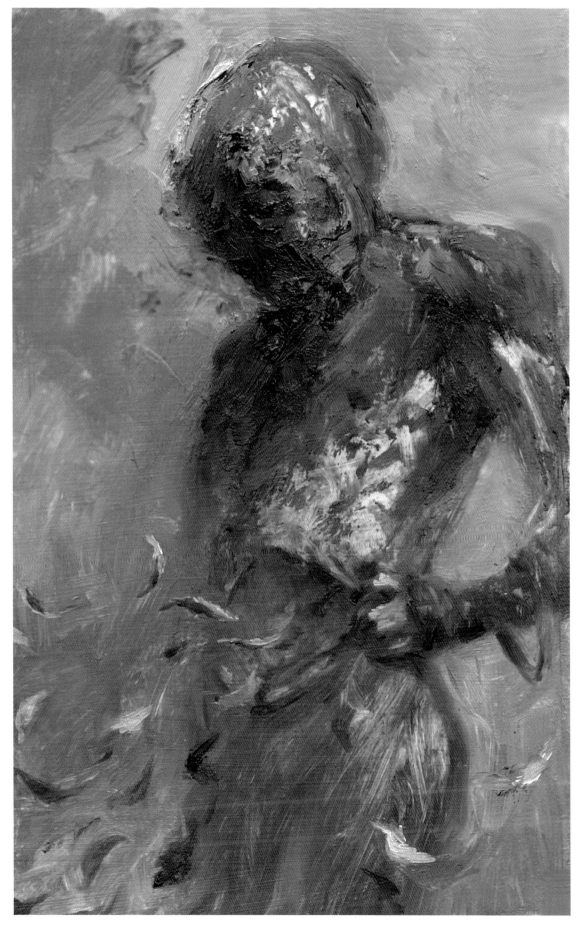

artist: **Nilson**
title: Autumned *medium:* Mixed on board *size:* 13cmx18cm

1
artist: **Joshua W. Kinsey**
title: Migraine
medium: Digital
size: 8"x7 1/2"

2
artist: **Elio Guevara**
title: En tus Ojos
medium: Mixed
size: 18"x24"

3
artist: **Carlos Huante**
art director: Carlos Huante
designer: Carlos Huante
title: The Stand
medium: Mixed

4
artist: **Carlos Huante**
art director: Carlos Huante
designer: Carlos Huante
title: Born Again
medium: Mixed

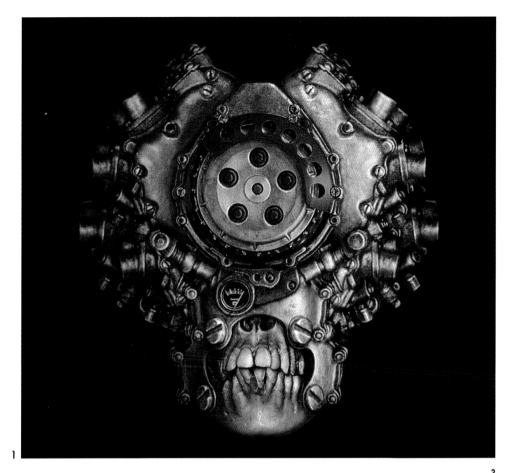

1

2

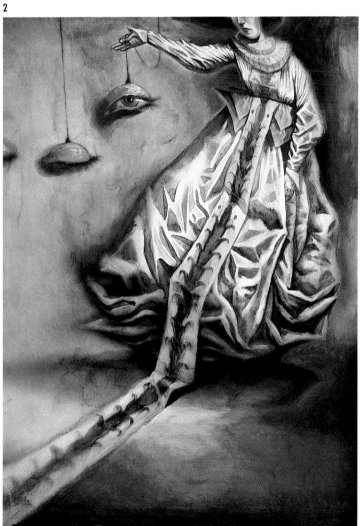

3

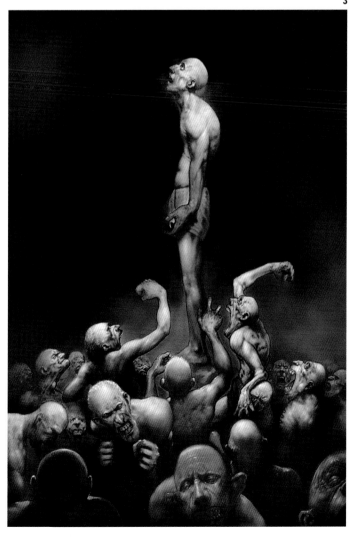

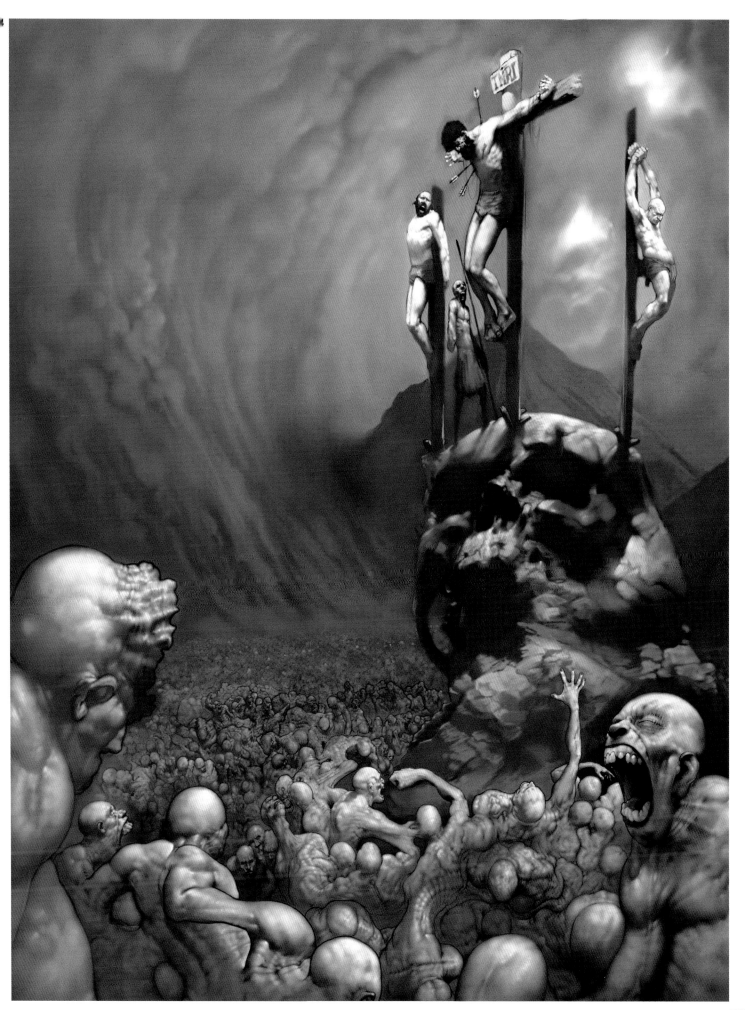

1
artist: **Stephen Hickman**
art director: Stephen Hickman
client: Jane & Howard Frank
title: Nada the Lily
medium: Oil
size: 30"x55"

2
artist: **Vance Kovacs**
art director: Vance Kovacs
client: Black Isle
title: Pieter
medium: Digital

3
artist: **Kip Omolade**
title: Egyptian Graffiti II
medium: Mixed

4
artist: **Jeff Crosby**
art director: Jeff Crosby
client: E Street Gallery
title: Last Chance
medium: Oil on canvas
size: 29"x27"

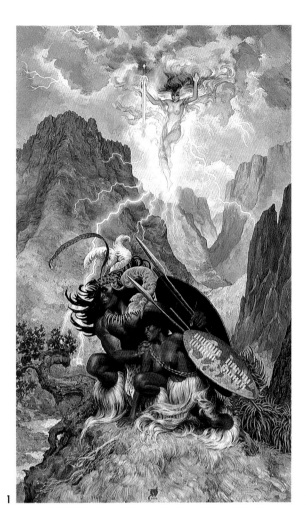

1

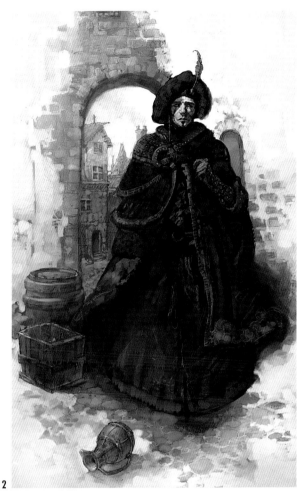

2

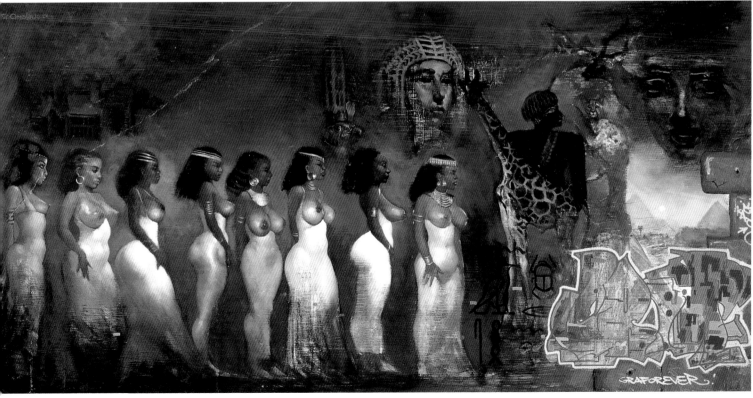

3

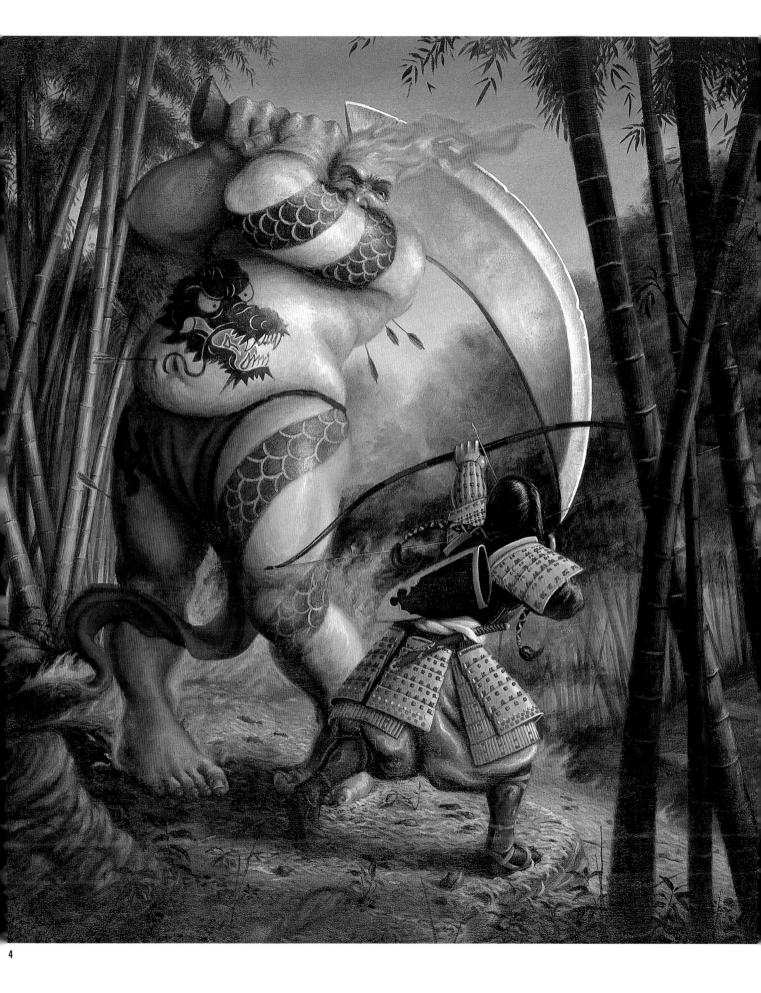

1
artist: **Daren Bader**
character designer: Katsuya Terada
title: The Monkeyking
medium: Oil
size: 18"x24"

2
artist: **Lars Grant-West**
art director: Lars Grant-West
title: Cyberdragon
medium: Oil on masonite
size: 48"x24"

3
artist: **William Stout**
art director: William Stout
designer: William Stout
client: William Stout, Inc.
title: Tyrannosaurus Rex
medium: Watercolor & ink on board
size: 10"x15"

4
artist: **James Gurney**
art director: James Gurney
designer: James Gurney
client: Dinotopia Enterprises
title: Waterfall City: Air Races
medium: Oil on canvas
size: 52"x24"

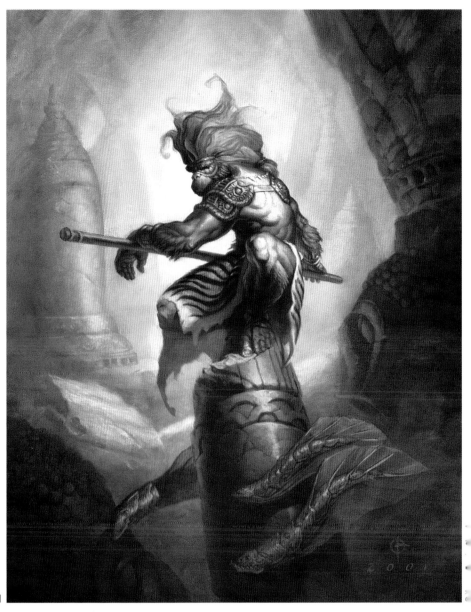

1

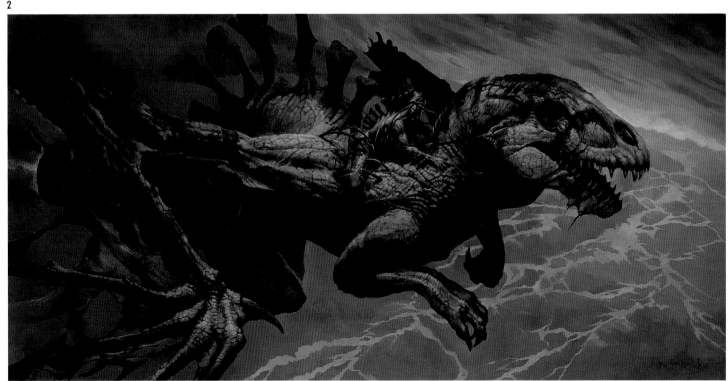

2

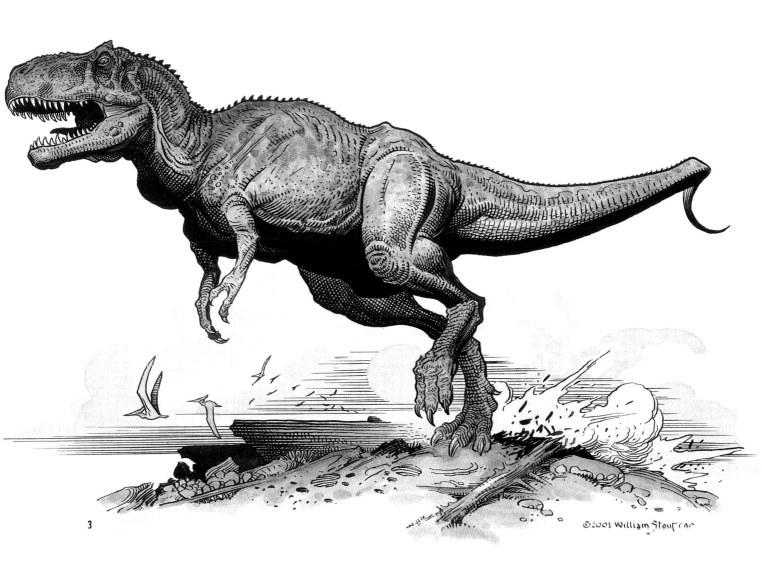

3

©2001 William Stout/rac

4

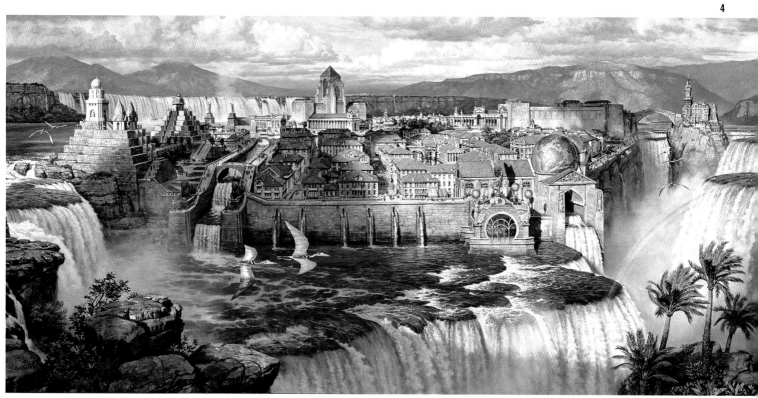

1
artist: **Steven Kenny**
title: The Basin
medium: Oil on canvas
size: 32"x36"

2
artist: **Lori Koefoed**
art director: Lori Koefoed
client: Sarah Bain Gallery
title: The Prophet
medium: Oil
size: 20"x24"

3
artist: **Kip Omolade**
title: Deep Concentration
medium: Oil
size: 18"x24"

4
artist: **Steven Kenny**
title: The Crane
medium: Oil on Panel
size: 24¹/₄"x20¹/₂"

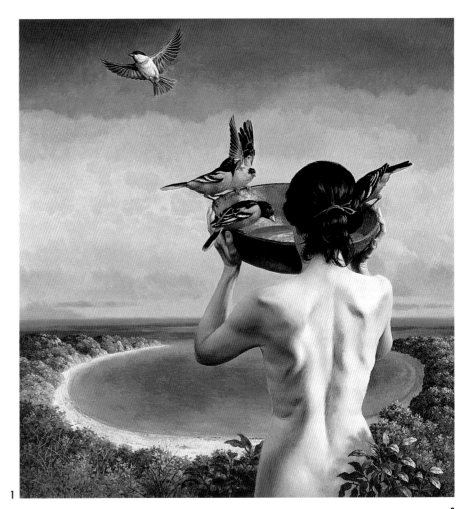

1

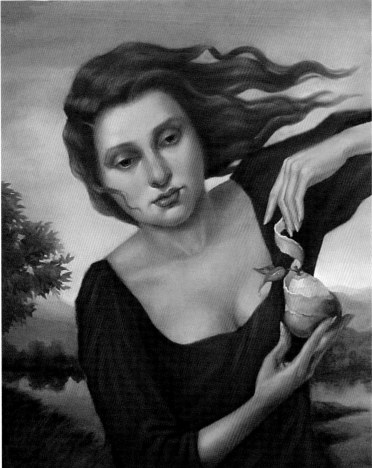

2

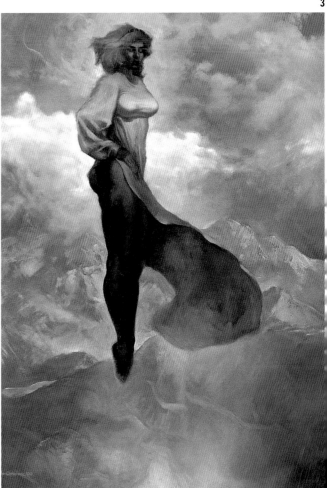

3

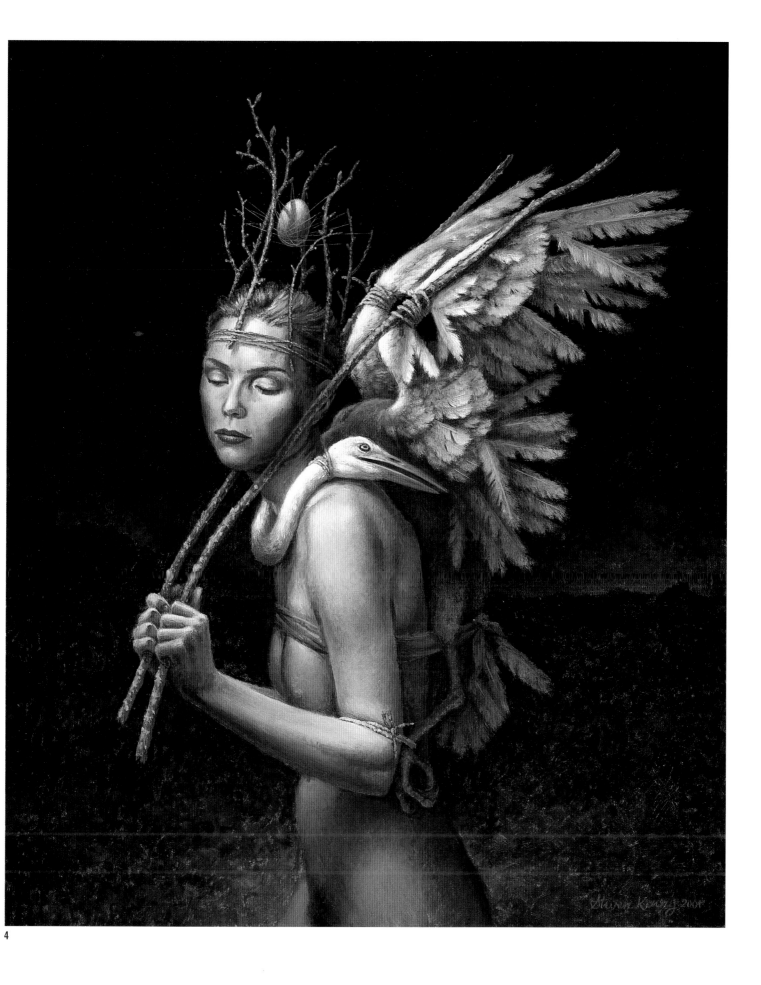

4

1
artist: **Randy Gaul**
title: Dreamscape 1
medium: Digital
size: 36"x24"

2
artist: **Dan Seagrave**
art director: Dan Seagrave
title: Drive By (Temple Series)
medium: Acrylic
size: 36"x24"

3
artist: **Thomas Thiemeyer**
title: Pacifica
medium: Oil on masonite
size: 39"x27"

4
artist: **Randy Gaul**
title: Alzul Stadium
medium: Digital
size: 17"x22"

5
artist: **Sonny Liew**
title: Astro Boy
medium: Oil
size: 18"x24"

6
artist: **Christian Alzmann**
title: Junkyard Dog
medium: Digital

7
artist: **Larry Price**
title: Port of Call
medium: Digital
size: 8¹/2"x11"

1

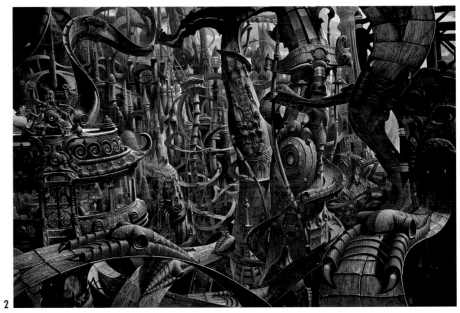

2

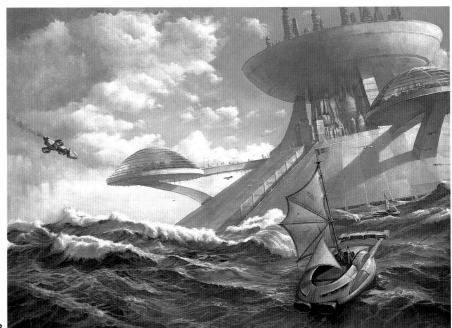

3

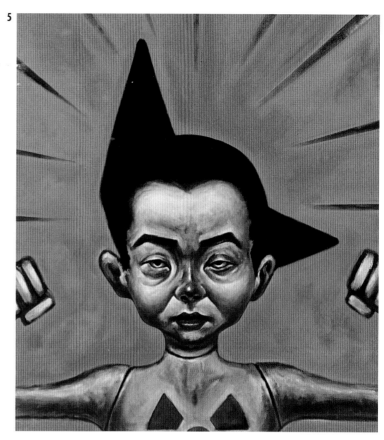

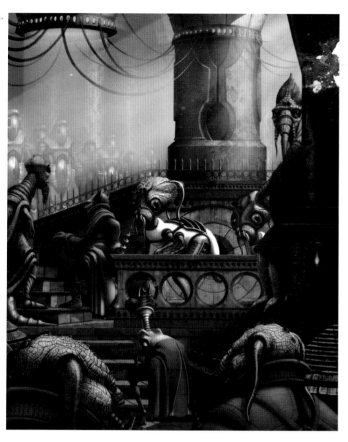

1
artist: **Paul Bonner**
art director: Theodore Bergquist
client: RiotMinds
medium: Watercolor
size: 325mmx460mm

2
artist: **Kirk Reinert**
art director: Lilli Farrel
designer: Kirk Reinert
title: Capricorn
medium: Acrylic
size: 28"x38"

3
artist: **Christophe Vacher**
title: Norova
medium: Oils
size: 30"x40"

4
artist: **Paul Bonner**
art director: Theodore Bergquist
client: RiotMinds
medium: Watercolor
size: 342mmx470mm

1

2

3

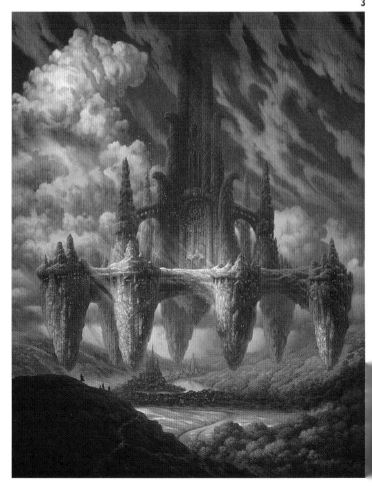

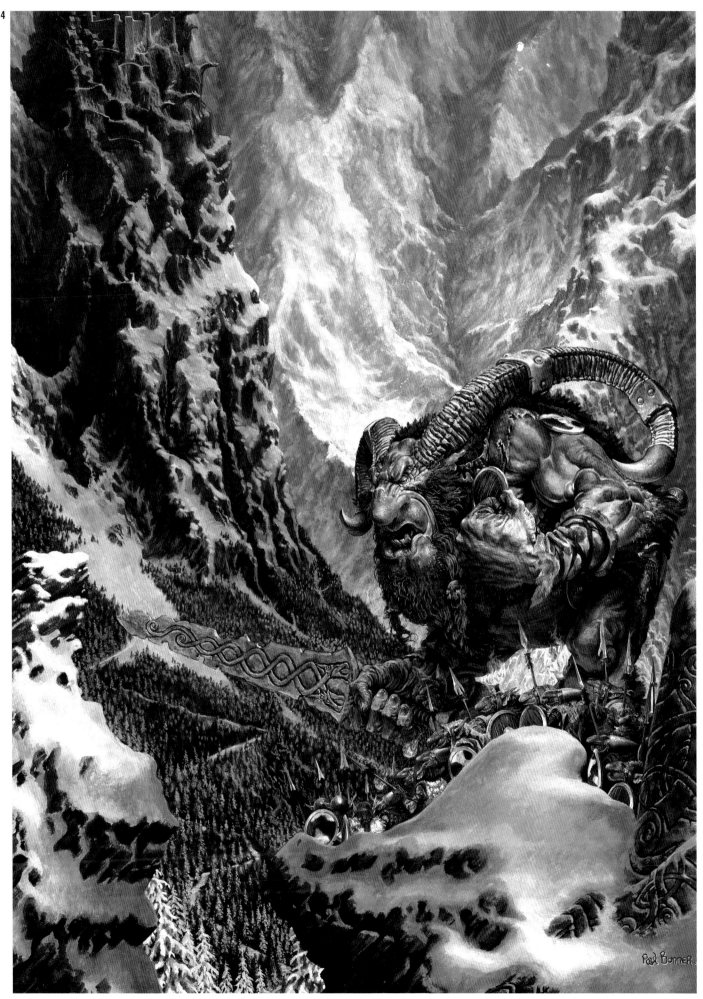

4

Paul Bonner.

Unpublished

1
artist: **Gene Mollica**
client: Student Thesis
title: Fishboy
medium: Mixed/digital
size: 11"x11"

2
artist: **Aaron Jasinski**
art director: Aaron Jasinski
client: Society of Illustrators:
Prevailing Human Spirit Exhibition
title: jaa
medium: Acrylic on canvas
size: 30"x40"

3
artist: **Sivet Christophe**
art director: Sivet Christophe
title: The Return of "Robur" the Conquerant
medium: Oil
size: 29"x36"

4
artist: **Grant Fuhst**
title: Death In New York
medium: Mixed
size: 17³/4"x21"

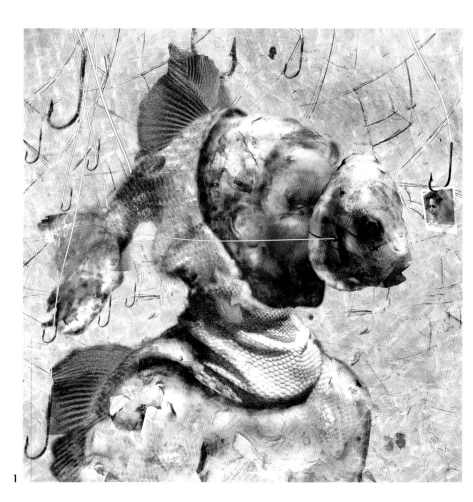

1

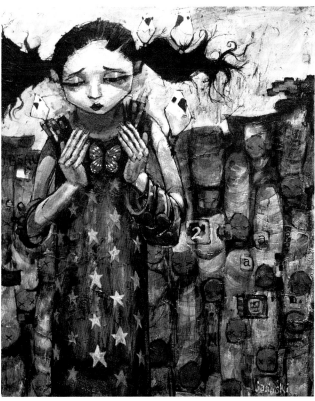

2

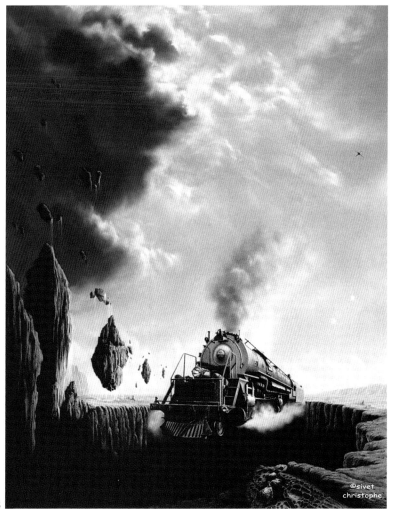

3

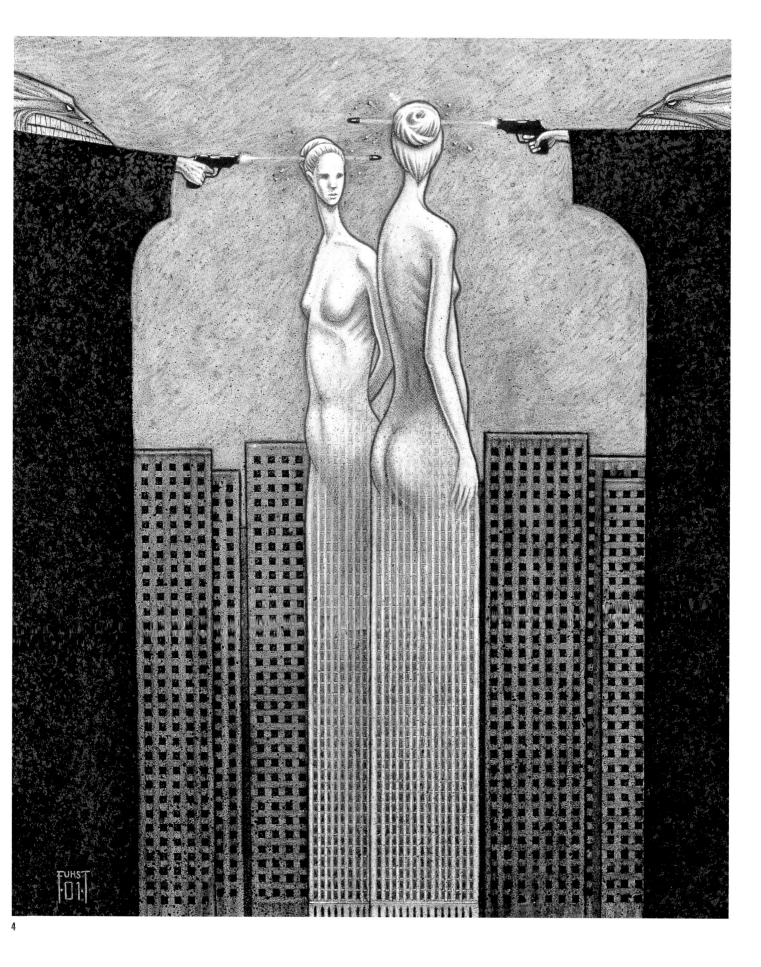

4

Unpublished

1
artist: **Thom Ang**
art director: David Mack
client: David Mack
title: Kabuki
medium: Watercolor/oil
size: 8¼"x11¾"

2
artist: **Tony Mauro/Ken Cha**
title: Kyla
medium: Digital
size: 6"x9"

3
artist: **Joel Spector**
art director: Joel Spector
title: 3 Graces
medium: Pastels
size: 14½"x21"

4
artist: **Omar Rayyan**
title: The Frog Courtisan of Venice
medium: Watercolor
size: 8"x11½"

5
artist: **Christophe Vacher**
title: The Long Sleep
medium: Oils
size: 15"x30"

6
artist: **Chad Michael Ward**
art director: Chad Michael Ward
designer: Chad Michael Ward
title: Black Rust–Angel Bot
medium: Mixed
size: 11"x17"

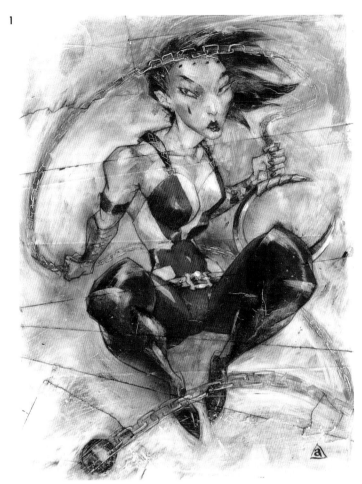

2

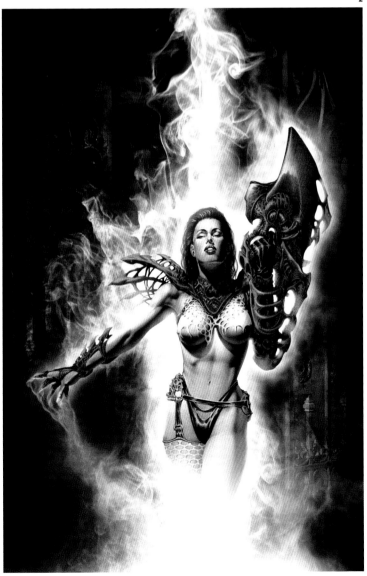

3

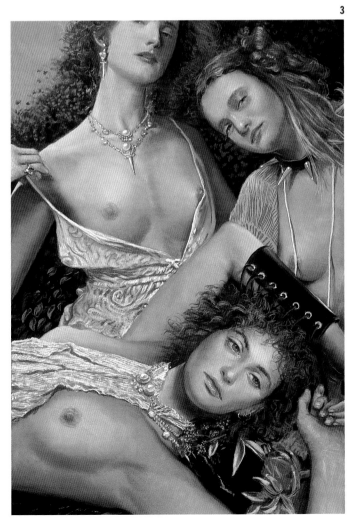

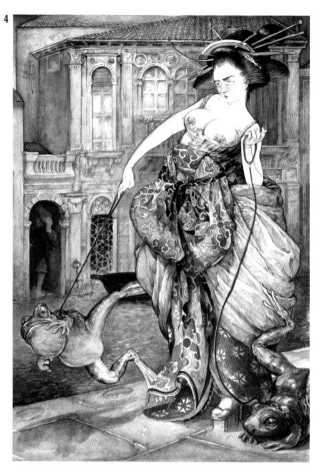

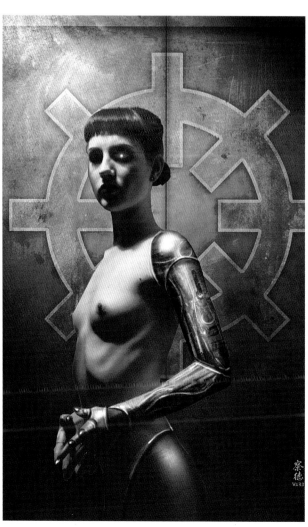

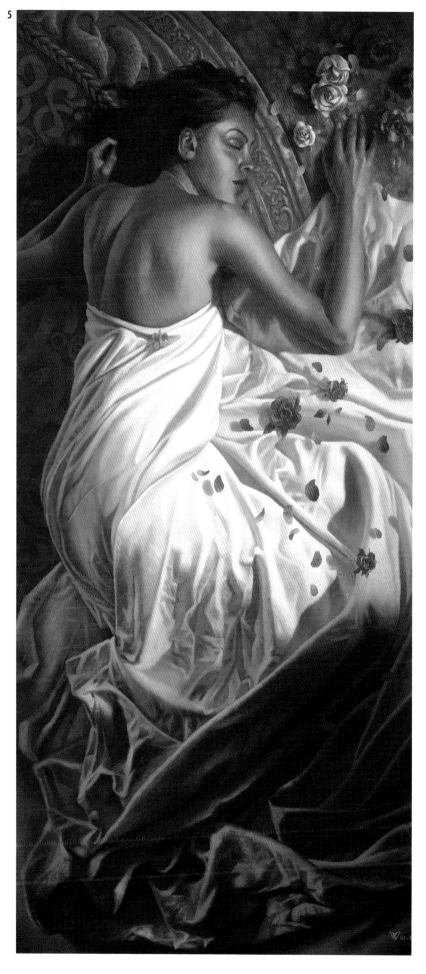

1
artist: **Aaron McBride**
title: Sagania
medium: Digital
size: 10¹/2"x11"

2
artist: **Charles Vess**
art director: Charles Vess
designer: Charles Vess
client: Endicott Studio for the Mythic Arts
title: Masquerade
medium: Colored inks
size: 12"x17"

3
artist: **Don Powers**
title: Vainomoinen
medium: Egg tempera
size: 14"x18"

4
artist: **Aaron McBride**
title: Springheeled Jack
medium: Digital
size: 11"x17"

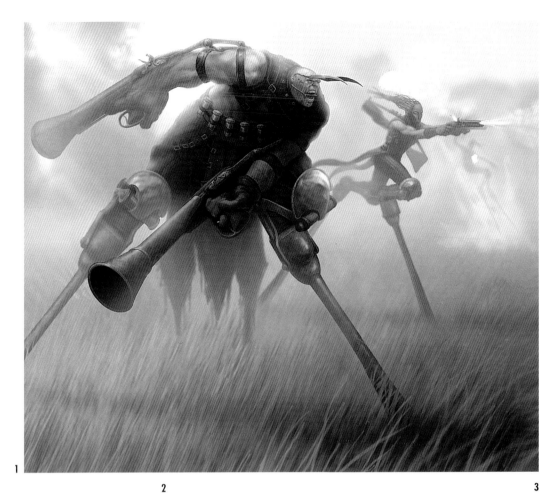

1

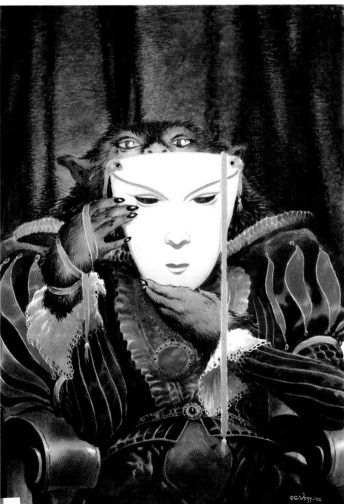

2 3

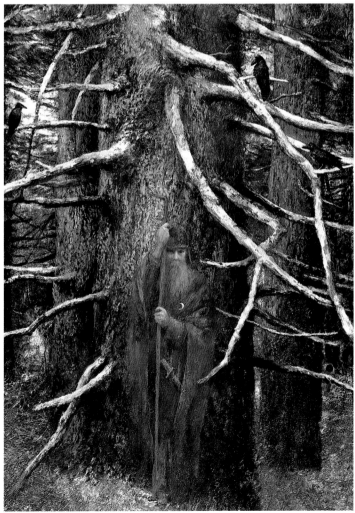

4

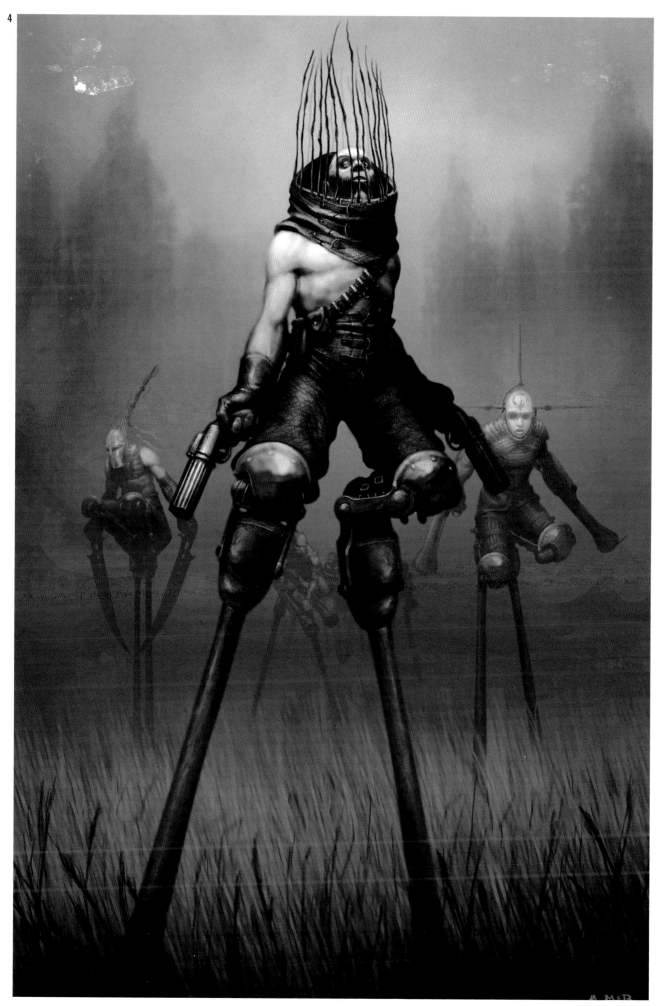

1
artist: **Ben Blatt**
art director: Ben Blatt
title: Guerra
medium: Watercolor/gouache
size: 20"x16"

2
artist: **Steve Montiglio**
title: Mysteria Deliria
medium: Mixed/digital
size: 44"x32"

3
artist: **George Klauba**
client: Ann Nathan Gallery
title: The Lily and the Thistle
medium: Acrylic on panel
size: 15¼"x21"

4
artist: **Nilson**
title: TroboNautee's
 Subsonic Daydream
medium: Oils on board
size: 30cmx40cm

5
artist: **Wayshak**
title: Medicated
size: 34"x29"

6
artist: **Amanda Wachob**
title: Delia Silvernail
medium: Oil on canvas
size: 11"x18"

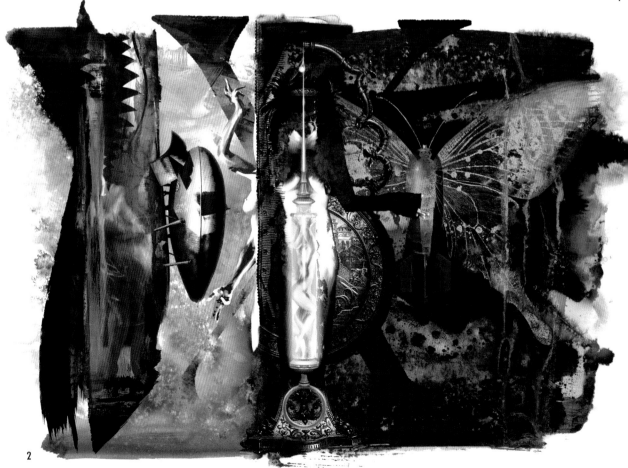

1

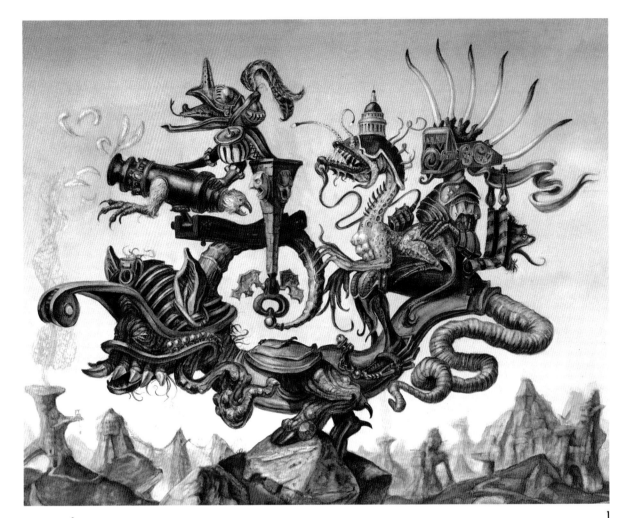

2

3

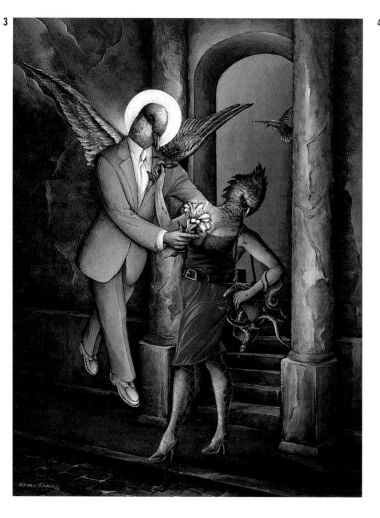

4

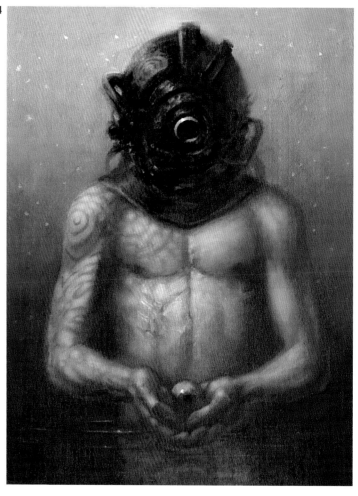

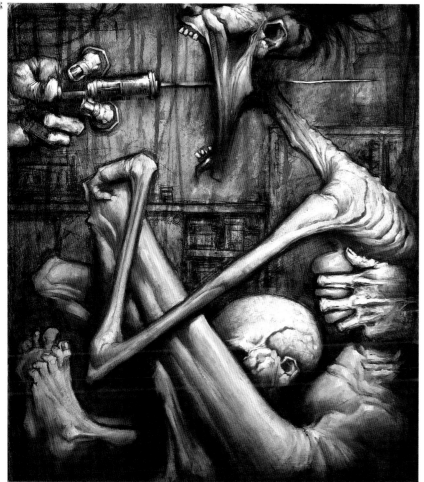

6

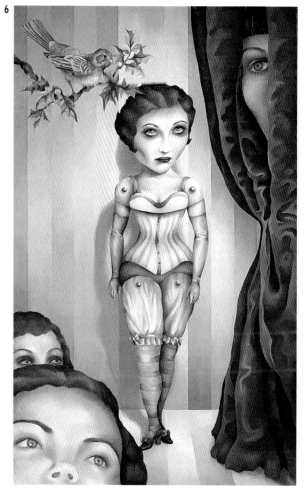

1
artist: **Jeff Faerber**
art director: Jeff Faerber
title: People Chase
medium: Mixed
size: 18"x18"

2
artist: **Brian Despain**
title: Ten Stone Tea
medium: Digital
size: 6"x8"

3
artist: **Gabriela Dellosso**
title: Victorian Bubble Blower
medium: Mixed & gold leaf
size: 26"x42"

4
artist: **Merrilee Liddiard**
title: Batgirl's Ballet
medium: Acrylic
size: 16"x20"

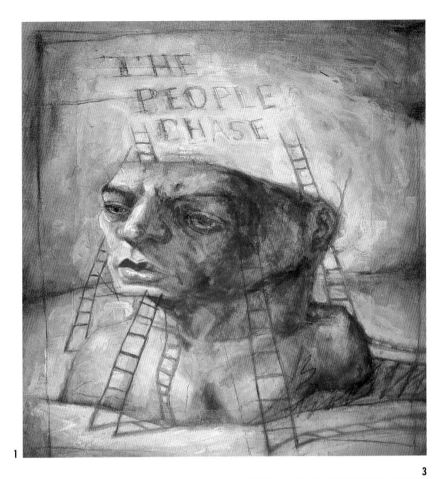

1

2

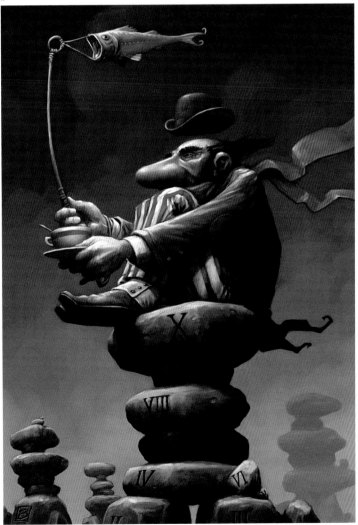

3

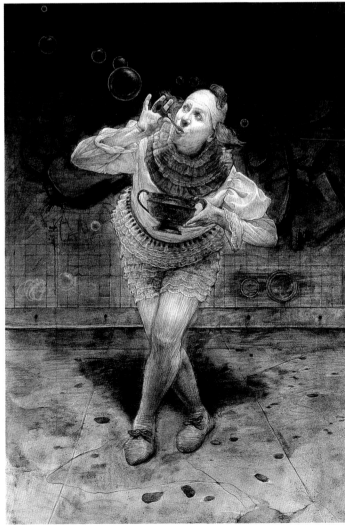

4

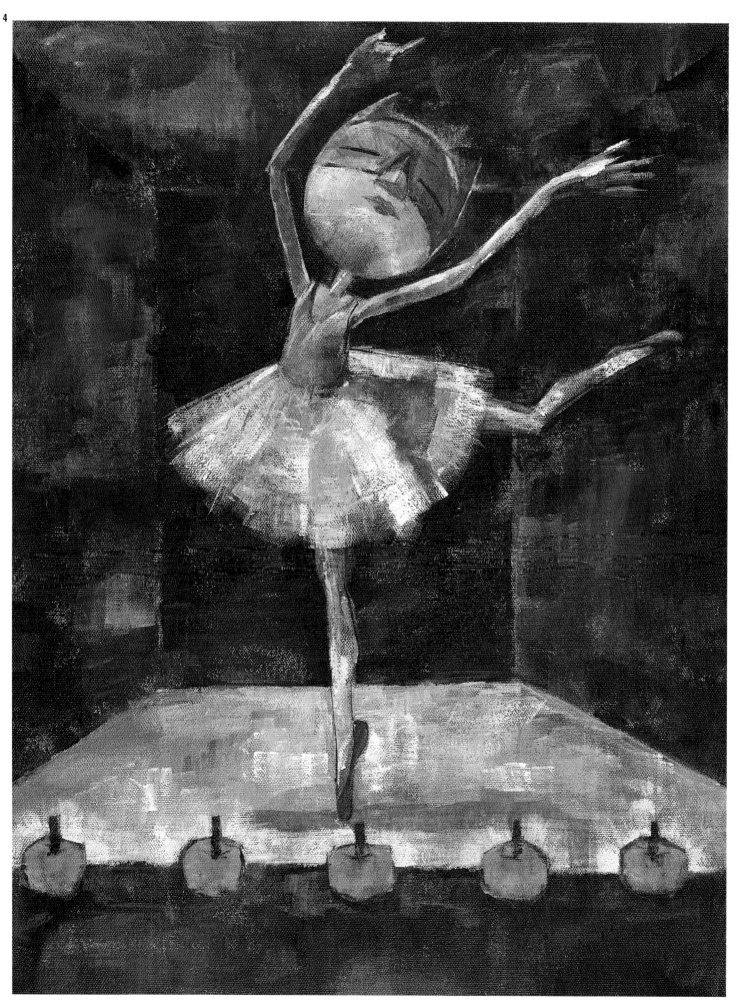

1
artist: **Kino**
art director: Kino
photographer: Paul Hopkins
title: Life
medium: Mixed
size: 48"x5'5"

2
artist: **Peter Clarke**
title: Stolen!
medium: Acrylic
size: 30"x24"

3
artist: **Anita Kunz**
title: Mother
medium: Mixed
size: 15"x10"

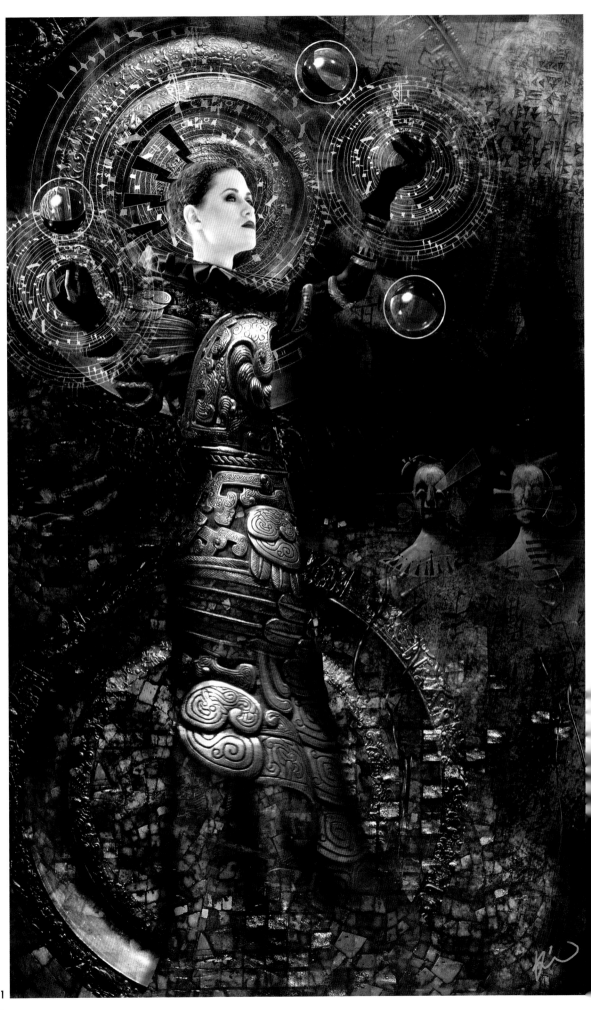

1

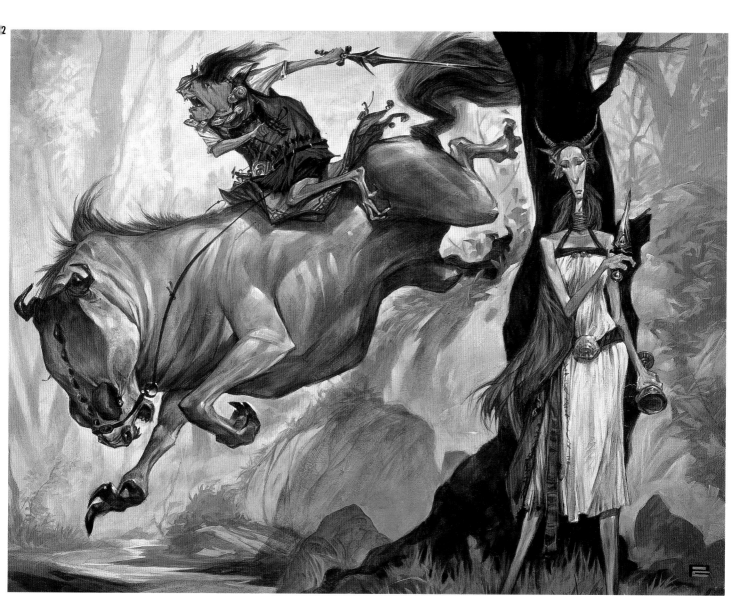

1
artist: **Christian McGrath**
title: The Hive
medium: Digital
size: 8"x7"

2
artist: **Sandy Collora**
art director: Sandy Collora
title: Griseus (Guardians of Atlantis)
medium: Acrylic
size: 15"x10"

3
artist: **John Dickenson**
title: Upup
medium: Graphite/digital
size: 21"x7"

4
artist: **Petar Meseldzija**
client: Ron & Linda Snoeks
title: The Source
medium: Oil
size: 31¹/₂"x43¹/₄"

5
artist: **Kyle Anderson**
title: After the Battle
medium: Digital

6
artist: **Richard Hescox**
art director: Richard Hescox
title: The Storm
medium: Oil
size: 36"x24"

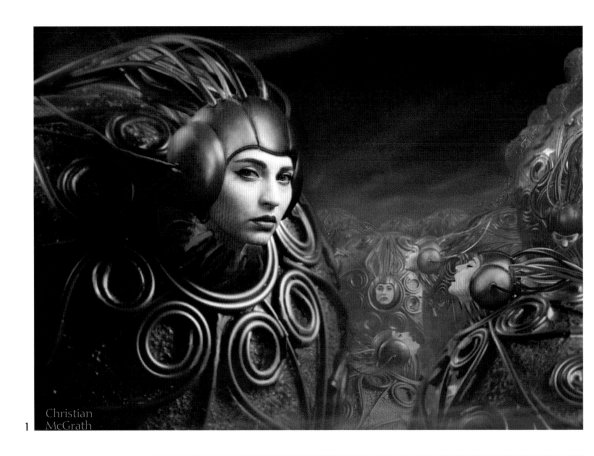

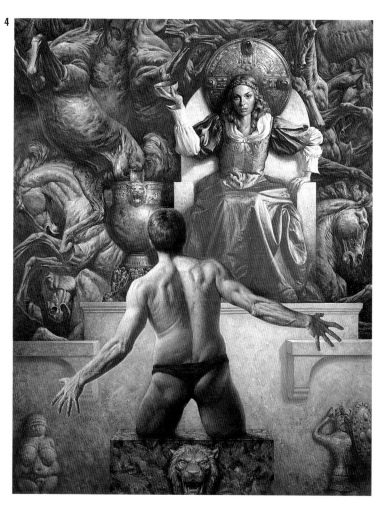

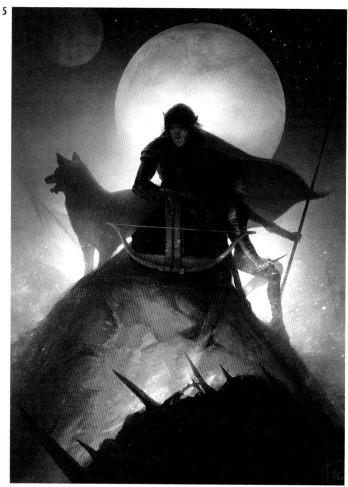

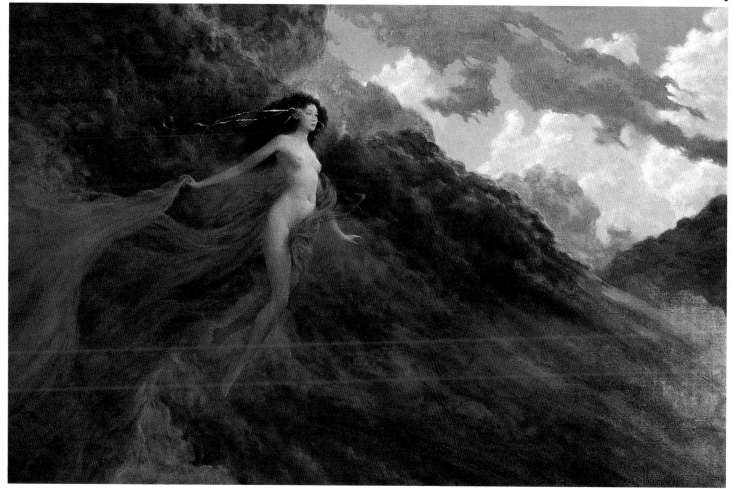

1
artist: **Sonny Liew**
title: Gojiro! Gojiro!
medium: Oil
size: 20″x30″

2
artist: **Scott Hutchison**
title: From Here to There
medium: Oil on panel
size: 48″x24″

3
artist: **John C. Berkey**
art director: John C. Berkey
title: Everything Spins
medium: Casein/acrylic
size: 28″x18″

4
artist: **John C. Berkey**
art director: John C. Berkey
title: Another Quiet Day in the Country
medium: Casein/acrylic
size: 26¹/2″x18¹/4″

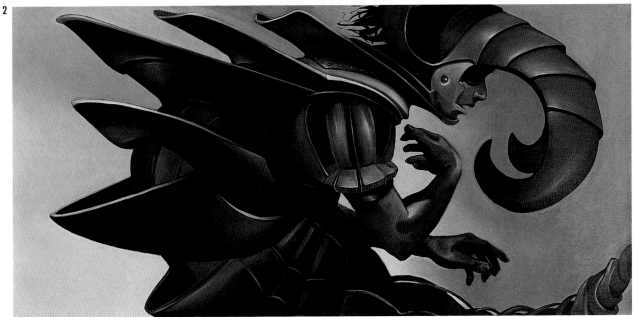

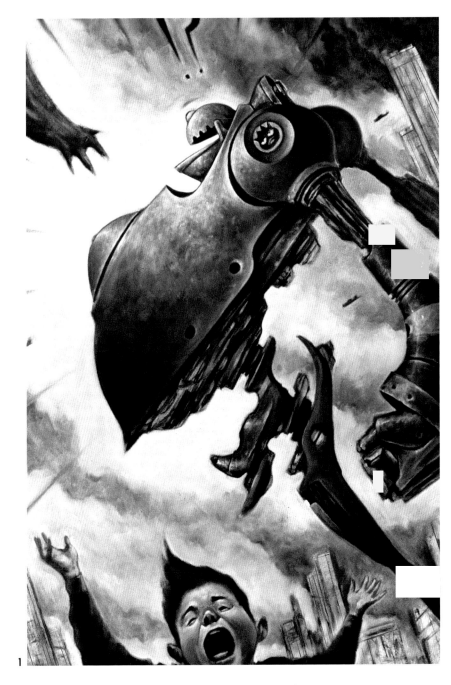

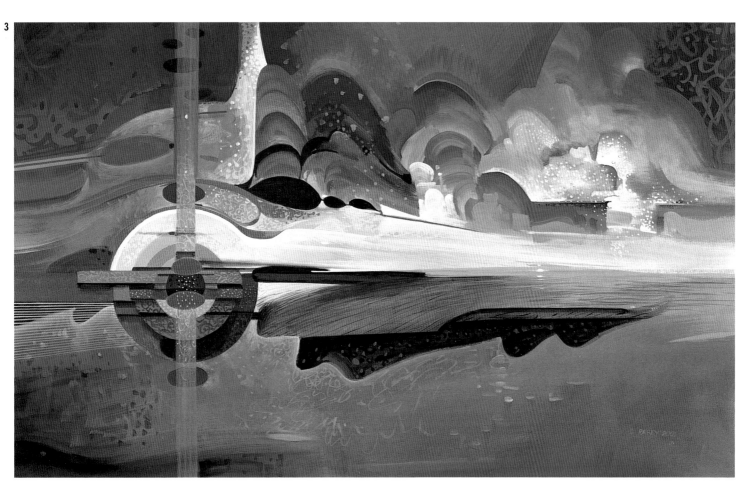

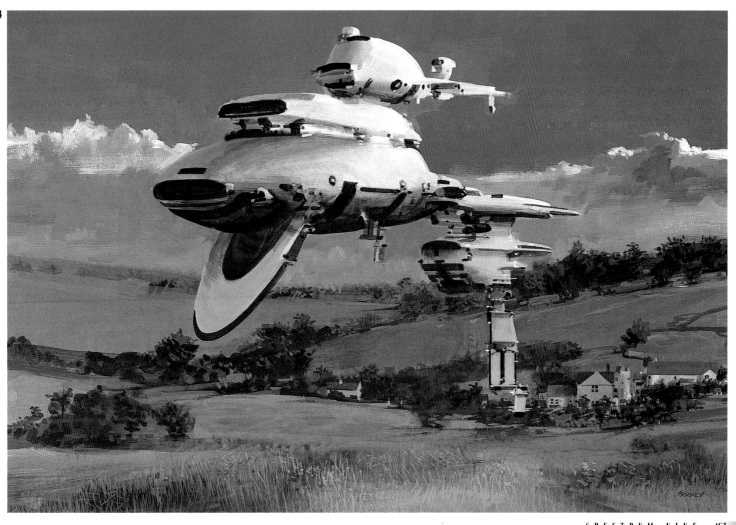

UNPUBLISHED

1
artist: **Jason Nobriga**
title: Mr. Icarus
medium: Oil on board
size: 13"x13"

2
artist: **Carol Heyer**
title: Something Fishy
medium: Acrylic
size: 24"x18"

3
artist: **Joe Lacey**
client: Joe Lacey & Todd Greb
title: Cozmo's Amazing Rocket Adventure
medium: Oil
size: 16"x20"

4
artist: **Peter Clarke**
title: All I Ask
medium: Acrylic
size: 17"x24"

5
artist: **Tanner Goldbeck**
title: Fred & Jerry
medium: Oil
size: 36"x23"

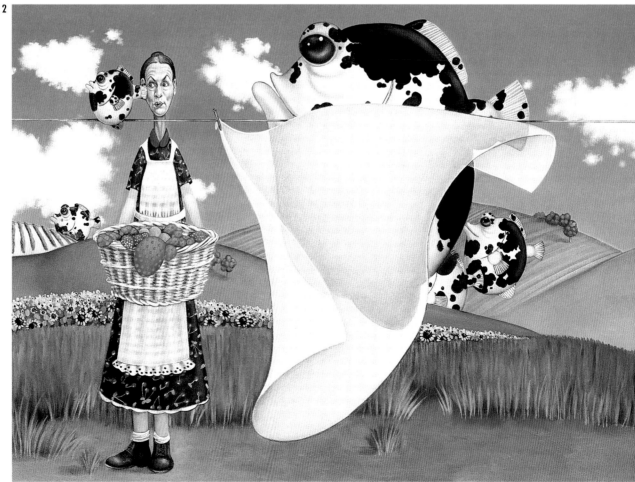

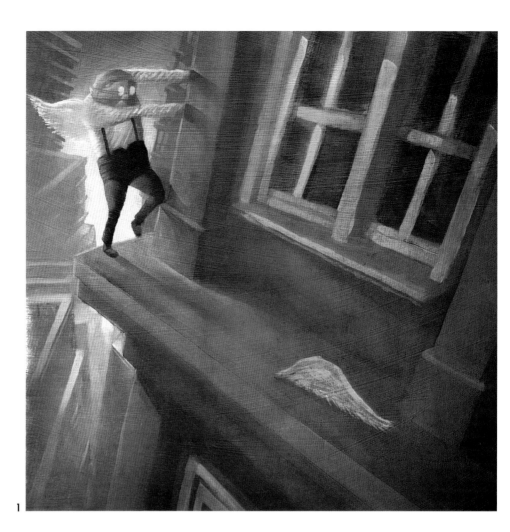

3
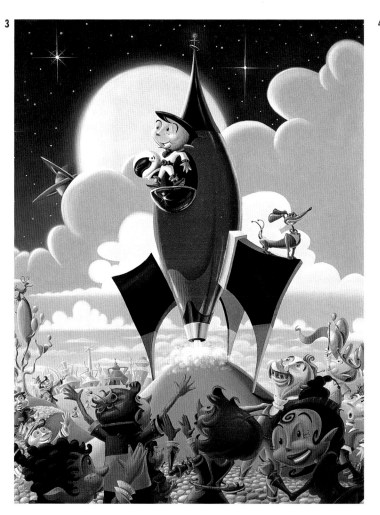

4
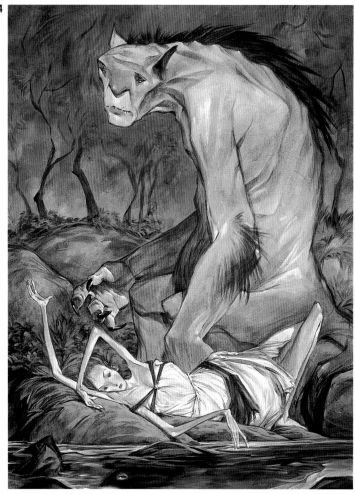

5
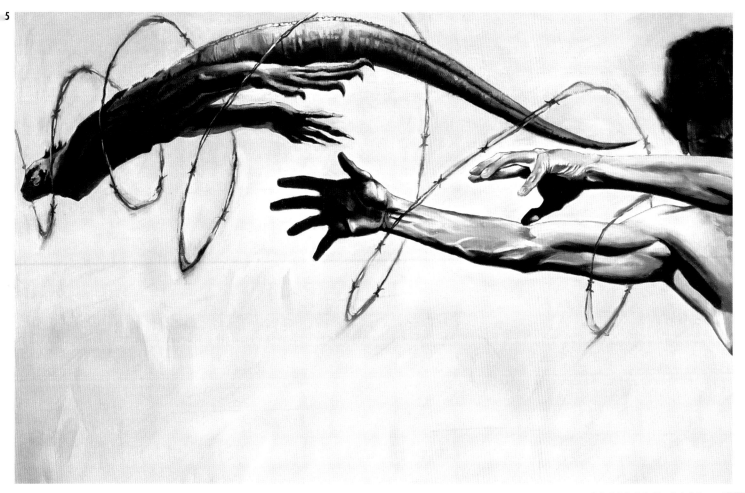

1
artist: **Raymond Swanland**
title: Mimic
medium: Digital
size: 12"x21"

2
artist: **Ken Laager**
title: Where Goblins Dwell
medium: Oil on canvas
size: 24"x30"

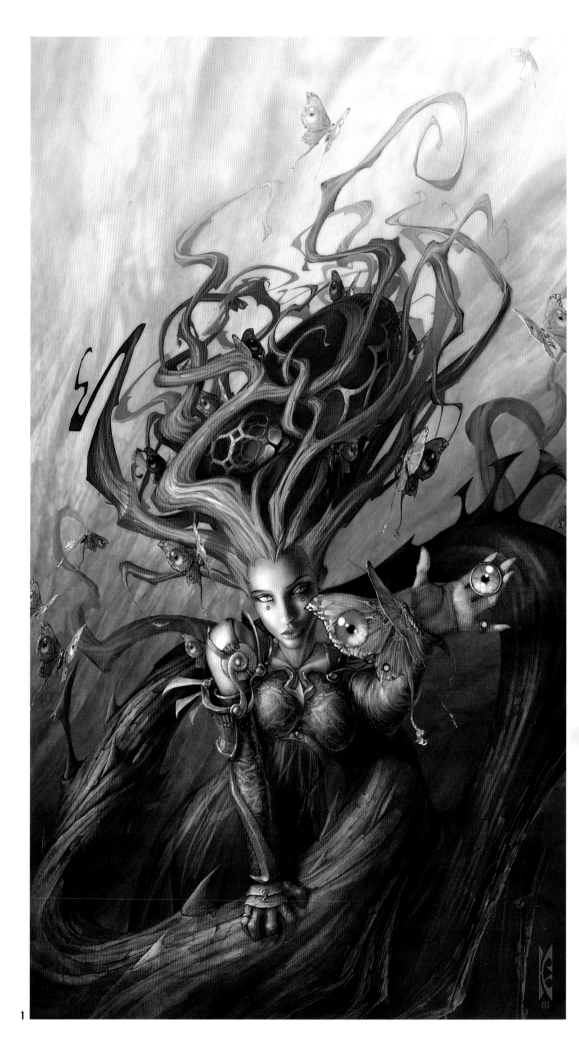

1

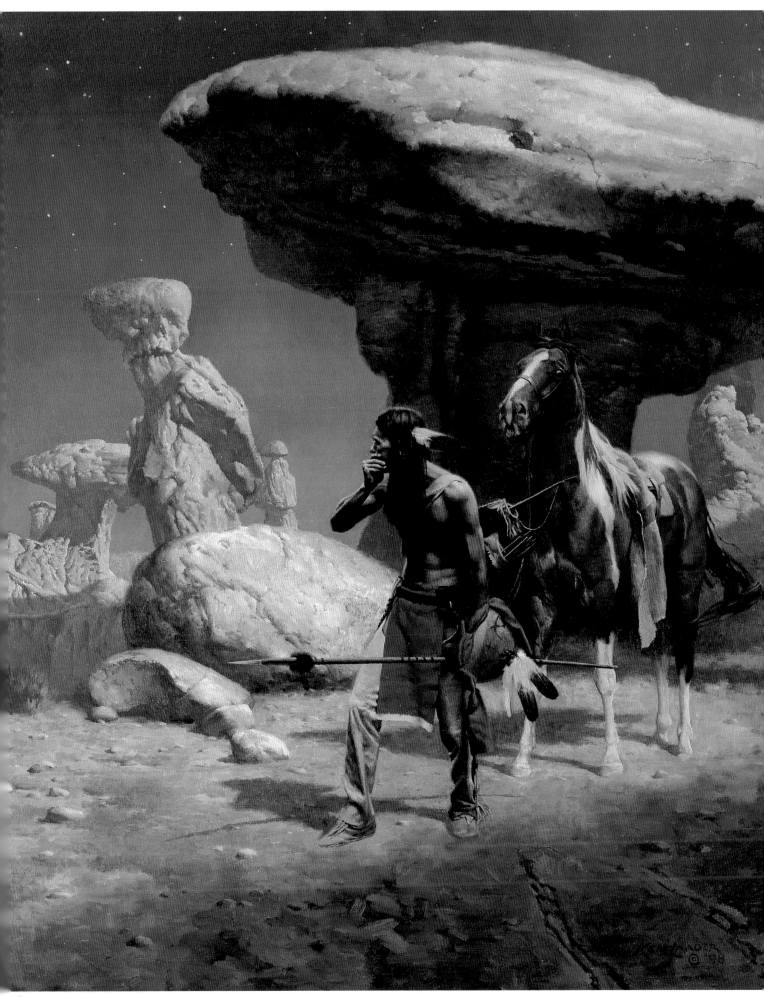

1
artist: **Jeffrey Jones**
title: Tarzan in the Land of the Wild
medium: Oil on canvas
size: 24"x32"

2
artist: **Donato Giancola**
client: Howard & Jane Frank
title: Eric Bright-Eyes
medium: Oil on paper on panel
size: 67"x34"

3
artist: **Michael Whelan**
title: Lumen 6.2
medium: Oil
size: 48"x42"

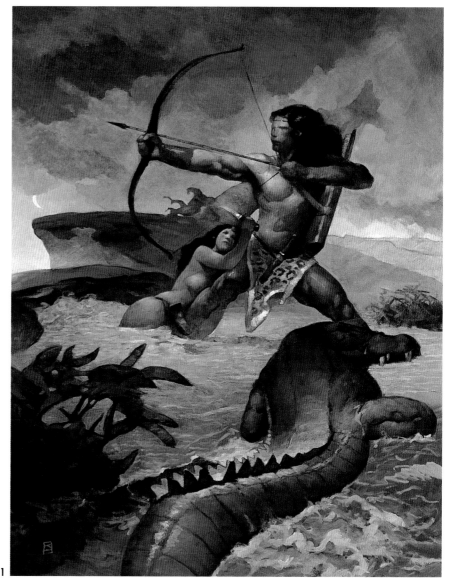

1

2

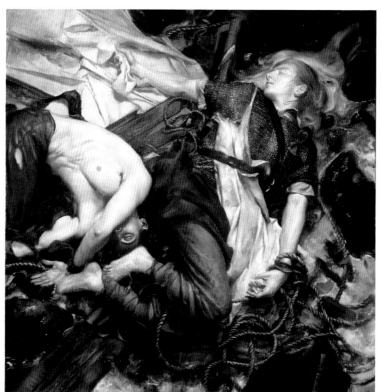

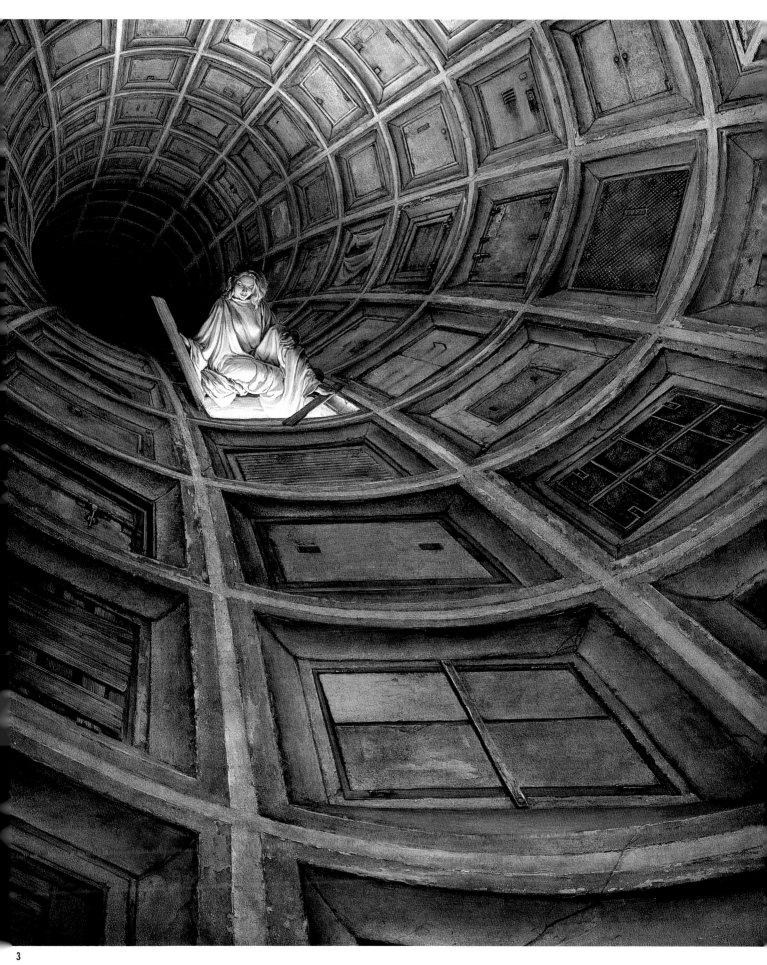

3

A

Christian Alzmann 149
251 Channing Way #3
San Rafael, CA 94903
415-507-1605
calzmann@earthlink.net

Kyle Anderson 165
315 Cloudview Dr.
Austin, TX 78745
kyle@kyleanderson.com

Scott E. Anderson 96
805-962-7160
www.scottandersonart.com
scott@scottandersonart.com

Pat Andrea 96

Thom Ang 154
c/o Allen Spiegel Fine Arts
221 Lobos Avenue
Pacific Grove, CA 93950
831-372-4672
thomang@earthlink.net

Patrick Arrasmith 34, 61
309 6th St./#3
Brooklyn, NY 11215
718-499-4101
www.patrickarrasmith.com

B

Daren Bader 144
daren@angelstudios.com
www.darenbader.com

Lee Ballard 114
514 Galland St.
Petaluma, CA 94952
707-775-4723
lee@nillo.com

Istvan Banyai 100

Bryn Barnard 106
417 Point Caution
Friday Harbor, WA 98250
360-378-6355
artists@rockisland.com

Dennis Beckstrom 91
8297 Petunia Way
Buena Park, CA 90620
714-562-8824
jekyllhyde@adelphia.com

Beet 38
Bpmobile Hanger G2 Bassin a flot n1
Quai Armand Lalande
33300 Bordeaux–France
www.beetart.com

Wes Benscoter 19
www.wesbenscoter.com

John C. Berkey 167
5940 Christmas Lake Road
Excelsior, MN 55331
952-474-3042

Rick Berry 68, 78, 109
93 Warren St,
Arlington, MA 02174
781-648-6375
www.braid.com

Ben Blatt 158
727 So. 17th St./Apt. #2
Philadelphia, PA 19146
215-772-0279
www.altpick.com/benblatt

Paul Bonner 131, 150, 151
Tegnestuen F3. St Kongensgade
1264 Copenhagen K,
Denmark 1264 KBH K
+ 33 120031
bonner@mail.dk

David Bowers 37, 42, 101
206 Arrowhead Lane
Eight-Four, PA 15330
724-942-3274
dmbowers@cobweb.net

Eric Bowman 53, 138
7405 SW 154th Place
Beaverton, OR 97007
503-644-1016
ebowman@aracnet.com

Timothy Bradstreet 74, 77
1001 Lemon Ave.
El Cajon, Ca 92020
619-590-2447
timbradstreet@timbradstreet.com

Brom 20, 102, 132
www.bromart.com

Tim Holter Bruckner 82, 85, 88
256 125th Street
Amery, WI 54001
715-268-7291
artfarm@amerytel.net

Will Bullas 128, 130
1325 Indiana St. #208
San Francisco, CA 94107
831-659-1045
cvn01@aol.com

Jim Burns 60
c/o Alan Lynch
11 Kings Ridge Road
Long Valley, NJ 07853
908-813-8718
alartists@aol.com

C

Ciruelo Cabral 43
P.O. Box 57
08870 Sitges, Barcelona, Spain
+34 93-894-6761
ciruelo@dac-editions.com

Frank Cho 52, 55
7719 Chatfield Lane
Ellicott City, MD 21042
410-796-7044
fccho@erols.com

Cambria Christensen 128
146 S. 400E
Provo, UT 84606
801-818-3898
cambriac@hotmail.com

Kari Christensen 132
146 South 400 East
Provo, UT 84606
monsterbox@hotmail.com

Sivet Christophe 152
17 Impasse Louis Aragon
Servian, France 34290
+33 046-737-0884
sivetchris@aol.com

Z-Ko Chuang 35
530 Larkin St. #307
San Francisco, CA 94102
415-225-1691
www.z-ko.com

Peter Clarke 163, 169
401-952-2571
ptrclarke@aol.com
peterclarkestudios.com

Sandy Collora 89, 164
20800 Beach Blvd. #100
Huntington Beach, CA 92648
sandy@collorastudios.com

Sally Wern Comport 99
208 Providence Rd.
Annapolis, MD 21401
410-349-8669
westudio@crosslink.net

Ray-Mel Cornelius 98
1526 Elmwood Blvd.
Dallas, TX 75224
214-946-9405
www.raymelcornelius.com

Gordon Crabb 59
c/o Alan Lynch
11 Kings Ridge Road
Long Valley, NJ 07853
908-813-8718
alartists@aol.com

Kinuko Y. Craft 55, 58
83 Litchfield Road
Norfolk, CT 06058
860-542-5018
kinuko@kycraft.com

Jean-Louis Crinon 89, 92
P.O. Box 34413
San Francisco, CA 94134-0413
gargoyle.dn@worldnet.att.net
www.angelfire.com/va/pfort/crinon
.html

Jeff Crosby 56, 143
585 Isham St. #2G
New York, NY 10034
212-304-0203
jeffcrosby@aol.com

D

Stephen Daniele 16
9427 171st Ave. NE
Redmond, WA 98052
425-882-2162
www.stephendaniele.com

Simon Davis 78, 80
12 Guild Rd, Aston Cantlow
Solihull, West Midlands B95 6JA UK
+44 013-864-8760
simsal20@aol.com

Hubert de Lartigue 103
97 rue Auber 94400
Vitry-Sur-Seine, France
+0033 14-726-2502
hdl@club-internet.fr

Peter de Séve 129
25 Park Place
Brooklyn, NY 11217
718-398-8099
deseve@earthlink.net

Gabriela Dellosso 160
499 Fulton Court
West NY, NJ 07093
201-319-8940
mdbert@aol.com

Brian Despain 160
111 Thorndike Street Apt. 1
Cambridge, MA 02141
617-491-8390
badbrain@imphead.com

Joseph DeVito 85
115 Shady Hill Drive
Chalfont, PA 18914
215-822-3002
jdevito4@earthlink.net

Matt Dicke 74
212-475-0440
www.mattdicke.com

John Dickenson 164
460 Cypress Drive #7
Laguna Beach, CA 92651
949-464-1955
www.gumworks.com

Russell Dickerson 103
639 Chestnut #83
Windsor, CO 80550
970-686-6264
audentioro@darkstormcreative.com

Vincent Di Fate 40
12 Ritter Drive
Wappingers Falls, NY 12590
914-297-6842

Leo and Diane Dillon 49
221 Kane Street
Brooklyn, NY 11231
718-624-0023

Tony DiTerlizzi 35
183 Chestnut Street
Amherst, MA 01002
www.diterlizzi.com

Allen Douglas 118
535 Countryside Lane
Webster, NY 14580
585-671-6351
adouglasstudio@aol.com

E

Eikasia 36
9, rue Kleber
Maisons-Alfort, France 94700
+33 (0)1-48-99-1320
eikazia@hotmail.com

James M. Elliott 88
27007 Midland Road
Bay Village, OH 44140
440-871-2018
zillionconcepts@aol.com

Tristan Elwell 45
197 Main Street
Cold Spring, NY 10516
845-265-5207
elwell@bestweb.net

F

Jeff Faerber 160
881 Washinton Ave. #6C
Brooklyn, NY 11225
718-398-0278
jeff@jefffaerber.com

Jason Felix 110
227 Judah Street
San Francisco, CA 94122
415-665-9674
jasonfelix@msn.com

Joseph Daniel Fiedler 116
154 Vista Del Valle
Ranchos de Taos, NM 87557
505-737-5498
fiedler@scaryjoey.com

Emily Fiegenschuh 84
19 Valley Rd. #11
Drexel Hill, PA 19026
nameksei@aol.com

Scott M. Fischer 110
846 Rt. 203/Box 32
Spencertown, NY 12165
518-392-7034

Eric Fortune 124
517 E. Tompkins St.
Columbus, OH 43202
614-262-8418
efortune357@hotmail.com

Jon Foster 46, 50, 70, 71, 95
118 Everett Ave.
Providence, RI 02906
401-277-0880
jon@jonfoster.com

Grant Fuhst 153
1822 S. Dahl Lane
Syracuse, UT 84075
801-773-0112
gfuhst@hotmail.com

G

Fred Gambino 60
c/o Alison Eldred
89 Muswell Hill Rd.
London, UK SE18 3PB
+ 20 8316 0367

Randy Gaul 148, 149
5 Glen Drive
Fairfax, CA 94930
415-455-9239
rgaul84202@aol.com

Donato Giancola 118, 172, bacover
397 Pacific Street
Brooklyn, NY 11217
718-797-2438
donato@donatoart.com

Gary Gianni 30, 31
2540 W. Pensacola
Chicago, IL 60618
773-267-4345
ggianni@enteract.com

Gnemo 130

Tanner Goldbeck 169
2508 Castillo Ave. #3
Santa Barbara, CA 93105
805-563-5711
racecar@silcom.com

Christian Gossett 69
11042 Camarillo St. #9
North Hollywood, CA 91602
818-754-0802
theredstar-hq@hotmail.com

Kim Graham 85
1225 SW 112th St.
Seattle, WA 98146
206-241-5952

Lars Grant-West 144
24 Tucker Hollow Rd.
N. Scituate, RI 02857
401-647-7348

Cheryl Griesbach & 48
Stanley Martucci
34 Twinlight Terrace
Highlands, NJ 07732
732-291-5945

Scott Grimando 39
6 Fifth Avenue
Westbury, NY 11590
516-876-9148
www.grimstudios.com

Gris Grimly 63
12105 Pacific Ave #6
Los Angeles, CA 90066
310-391-6289
grisgrimly@madcreator.com

Elio Guevara 140
606 Vinings Crest.
Smyrna, GA 30080
770-435-2174
www.elioguevara.com

James Gurney 145
P.O. Box 693
Rhinebeck, NY 12572
845-876-7746
www.dinotopia.com

Scott Gustafson 136
4045 N. Kostner
Chicago, IL 60641
773-725-8338
gustafsn@enteract.com

H
Scott W. Hahn 88
5732 22nd St. W.
Bradenton, FL 34207
941-751-5461
scott.hahn@bankofamerica.com

Phil Hale 26, 40, 94
25A Vyner St.
London, UK EZ 9DG
+44 207-241-2105

Nils Hamm [Nilson] 139, 159
Flügelstrasse 13
40227 Düsseldorf, Germany
nilshamm@hotmail.com

Russell Harris 117
9333 S. Paxton Ave.
Chicago, IL 60617
773-933-9028

Mark Harrison 32
111 Havelock Rd.
Brighton, E. Sussex, UK BN1 6GN
011-44-1273-555-952
ms.harrison@virgin.net

Naoto Hattori 21
naotohattori@aol.com
www.wwwcomcom.com

Chris Hawkes 117, 125
1289 E. Canyon Pk. Rd.
Bountiful, UT 84010
801-295-5727
chawkes@darkhorsemail.net

Daniel L. Hawkins 89, 92
30017 Post Oak Road
Tollhouse, CA 93667
559-855-4975
danhawkins25@hotmail.com

Gale Heimbach 127
20 Washington St.
Douglassville, PA 19518-9772
610-582-8026
grh@earthlink.net

Richard Hescox 165
P.O. Box 338
Hobart, WA 98025
425-413-6036
triffid@attbi.com

Carol Heyer 168
925 E. Avenida de los Arboles
Thousand Oaks, CA 91360
805-492-3683
www.carolheyer.com

Stephen Hickman 142
10 Elm St.
Red Hook, NY 12571
845-758-3930
shickman@stephenhickman.com

David Ho 36
3586 Dickenson Common
Fremont, CA 94538
510-656-2468
ho@davidho.com

Alex Horley-Orlandelli 103
c/o Spiderwebart
5 Waterloo Road
Hopatcong, NJ 07843
973-770-8189
spiderwebart@worldnet.att.net

Daniel R. Horne cover, 30, 87, 111
900 Edgemoor Road
Cherry Hill, NJ 08034
856-779-8334
www.danielhorne.com

Brian Horton 75
23411 Summerfield #42i
Aliso Viejo, CA 92656
949-362-3170
bri-suc@pacbell.net

John Howe 119
c/o Alan Lynch
11 Kings Ridge Road
Long Valley, NJ 07853
908-813-8718
alartists@aol.com

Carlos Huante 140, 141
1104 Michigan Dr.
Santa Rosa, CA 95405
415-448-3377
kletos1@yahoo.com

Scott Hutchison 166
5827 Washington Blvd. #45
Arlington, VA 22205
703 546-6701
scotthutchison@scotthutchison.com

I
Frazer Irving 75
frazer@frazerirving.com

Richard Isanove 72, 73
risanove@aol.com

J
Kennon James 99
3714 SE 33rd Place
Portland, OR 97202
503-232-4116
www.kennonjames.com

Zak Jarvis 78, 125
2241 Via Bianca
Oceanside, CA 92054
760-439-6053
zak@voidmonster.com

Aaron Jasinski 152
810 153rd Ave NE #B201
Bellevue, WA 98007
425-444-0848
aaron@aaronjasinski.com

Bruce Jensen 33, 104, 105
3939 47th Street
Sunnyside, NY 11104
718-937-1887
www.brucejensen.com

Jeffrey Jones 172
P.O. Box 166
Bearsville, NY 12409
jonesart@ulster.net

Joe Jusko 16, 75
35 Highland Road, #4404
Pittsburgh, PA 15102
412-833-7528

K
Steven Kenny 146, 147
130 Fodderstack Road
Washington, VA 22747
540-675-2355
stevenkenn@earthlink.net

Tom Kidd 50, 51
59 Cross Brook Rd.
New Milford, CT 06776
860-355-1781
tkidd@snet.net

Josh W. Kinsey 140
209-524-3171
http//users.thevision.net/jwkinsey

George Klauba 159
5247 N. Bernard
Chicago, IL 60625
773-583-3808

Lori Koefoed 137, 146
913 Old Topanga Cnyon
Topanga, CA 310-455-2220
lori@lorikoefoed.com

Vance Kovacs 112, 142
477 N. Shaffer Street
Orange, CA 92866
714-288-1383
horchata@earthlink.net

Dick Krepel 29
869 Warnell Drive
Richmond Hill, GA 31324
912-727-3368
rkrepel@coastalnow.net

Adam Kubert 73

Anita Kunz 96, 97, 163
218 Ontario St.
Toronto, Ontario, Canada M5A 2V5
416-364-3846
akunz@globalserve.net

L
Ken Laager 171
304 North Elm St.
Lititz, PA 17543
kenlaager@aol.com

Joe Lacey 169
6115 Vista Terrace
Orefield, PA 18069
610-336-4460
www.joelacey.com

Greg Land 69

Ben J. LaPlaca 114
515 Melrose Ave.
Columbus, OH 43202
614-204-8405

Jody A. Lee 42
P.O. Box 231
White Plains, NY 10605
jodylee@jodylee.net
www.jodylee.net

Paul Lee 75

Joe Lester 92
P.O. Box 942
Bensenville, IL 60106
jlester2000@yahoo.com

Merrilee A. Liddiard 128, 161
366 E. 100 S. #B
Provo, UT 84606
merrileeliddiard@hotmail.com

Sonny Liew 149, 166
78 Stedman Street
Brookline, MA 02446
617-232-7868

Gary A. Lippincott 30, 131
131 Greenville Road
Spencer, MA 01562
508-885-9592
www.garylippincott.com

Sandra Lira 93
P.O. Box 7332
Kensington, CT 06037
lira@sculptor.net
www.sculptor.net

Todd Lockwood 118, 123, 132
www.toddlockwood.com

Jerry Lofaro 24
58 Gulf Road
Henniker, NH 03242
603-428-6135

M
Larry MacDougall 113
137 Broker Drive
Hamilton, Ontario
Canada L8T 2B9
905-388-6514
underhill@sympatico.ca

Barsom Manashian 86, 91
914 W. Belmont Ave. #3
Chicago, IL 60657
773-281-9689
simian@execps.com

Gregory Manchess 25, 48
13358 SW Gallop Court
Beaverton, OR 97008
503-590-5447
gtmanchess@aol.com

Manchu 125
6 Allee des Erables
Tours, France 37000
+33 024-737-1603
philippe.bouchet7@wanadoo.fr

Stephan Martiniere 32
10500 Missouri Bar Rd.
Nevada City, CA 95959
530-478-0911
martiniere@neteze.com

Tony Mauro 154
1379-1/2 Vienna Way
Venice, CA 90291
310-314-3669
tmauro@loop.com

Aaron McBride 156. 157
2420 Steiner St. #11
San Francisco, CA 94115
415-448-3752
amcb@ilm.com

Christian McGrath 164
3526 Wayne Ave.
Bronx, NY 10467
646-229-1402
cmcgrath72@aol.com

Dave McKean 64, 67, 80, 100, 116
c/o Allen Spiegel Fine Arts
221 Lobos Avenue
Pacific Grove, CA 93950
831-372-4672
asfa@redshift.com

Steve McNiven 69

Patrick Meadows 125
c/o Ben Biber
P.O. Box 6749
Asheville, NC 28816
828-252-3477

Gene Mellica 152
1269 Prospect Ave.
Brooklyn, NY 11218
718-686-6764
genemollica@earthlink.net

Petar Meseldžija 65, 165
Kogerwatering 49
1541 XB Koog A/D Zaan
The Netherlands
+31-75-670-8649

Ian Miller 44
c/o Jane Frank
P.O. Box 814
McLean, VA 22101
703-847-4251
www.wow-art.com

Christopher Moeller 75, 76
210 Parkside Avenue
Pittsburgh, PA 15228
412-531-3629
moellerc@adelphia.net

Steve Montiglio 158
1837 North La Brea Avenue #8
Los Angeles, CA 90046
323-573-7316
steve@montiglio.com

Clayburn Moore 84, 85
3038 SE Loop 820
Ft. Worth, TX 76140
817-568-2620

Chris Moore 60
Black Moss Barn
Black Moss Road, Blacko
NR Nelson, Lancashire
England BB9 6LE

N

Vince Natale 24, 36
36 John St.
West Hurley, NY 12491
845-679-0354
vnatale@bestweb.net

Greg Newbold 45
3724 S. 2700 E
Salt Lake City, UT 84109
801-274-2407
gregnewbold@mail.com

Terese Nielsen 55, 107, 126
6049 Kauffman Avenue
Temple City, CA 91780
tanielsen7@earthlink.net
www.tnielsen.com

Jason Nobriga 168
www.jasonnobriga.com

Lawrence Northey 83, 86
9580 Kirkmond Crescent
Richmond, British Columbia
Canada V7E 1M8
604-275-9594
chromedreams@hotmail.com

O

Kathleen O'Connell 134
5360 Singleton St.
Indianapolis, IN 46227
317-791-9628

William O'Connor 56
452 W 8th St.
Plainfield, NJ 07060
908-822-0658

Oddworld Inhabitants 120

Rafal Olbinski 100, 114, 115
142 E. 35th Street
New York, NY 10016
212-532-4328

Kip Omolade 142, 146
284 Easter Parkway #2L
Brooklyn, NY 11225
718-789-7790
kipomolade@aol.com

Glen Orbik 18
818-785-7904
glenandlaurel@earthlink.net

P

John Jude Palencar 46, 47, 64, 122
508 Floral Valley W
Howard, OH 43028
740-392-4271
jjp33@core.com

Fernando L. Palma 120
2 Clancy Lane/Kinglake West 3757
Melbourne, Victoria, AUS
futurestudios@hotmail.com

LeUyen Pham 112
4210 26th St.
San Francisco, CA 94131
leuyenp@sbcglobal.net

John Picacio 29
334 E Craig Pl.
San Antonio, TX 78212
210-731-9348

Don Powers 156
217 Edgewood Dr.
Thomasville, GA 31792
229-226-1948
dtpowers@rose.net

Larry Price 149
146 Joanne Lane
DeKalb, IL 60115
815-758-3347
www.larrypriceart.com

Q

Joe Quesada 72

R

Ravenwood 62
c/o Sell, Inc.
333 N. Michigan Avenue #800
Chicago, IL 60601

Omar Rayyan 39, 155
P.O. Box 958
West Tisbury, MA 02575
508-693-5909
omar@studiorayyan.com

Mark Rehkopf 93
633 Colby Dr. Unit 9B
Waterloo, ONT, Canada N2V1B4
519-884-4260
markart@golden.net

Kirk Reinert 150
42 Longview Rd.
Clinton Corners, NY 12514
845-266-2397

Luis Royo 54, 59
c/o Alan Lynch
11 Kings Ridge Road
Long Valley, NJ 07853
908-813-8718
alartists@aol.com

Gary Ruddell 110
875 Las Ovejas
San Rafael, CA 94903
415-479-1016

Steve Rude 72
P.O. Box 660583
Arcadia, CA 91066
steverude@steverude.com

Robh Ruppel 32
1639 Broadview
Glendale, CA 91208
818-249-9341

S

Marc Sasso 39
68 Plymouth Road
White Plains, NY 10603
914-949-1949
www.marcsasso.com

Dan Seagrave 148
6 Station Lane, Farnsfield
Newark, Notts NG228LA England
+44 01623-883469
dan@danseagrave.com

Dave Seeley 29
102 South St. 4
Boston, MA 02111
617-423-3195
seeley@daveseeley.com

Jordu Schell 91
c/o Michael Edenfield
17904 23rd Lane SE #E102
Seattle, WA 98155
206-685-3325

Kino Scialabba 162
5633 Colfax Ave. #314
N. Hollywood, CA 91601
818-623-0848
kino@pacbell.net

Douglas Smith 18, 44
34 Erie Ave.
Newton, MA 02461
617-558-3256

Travis Smith 22
1358 Clove St.
El Cajon, CA 92021
seempieces@mindspring.com
www.seempieces.com

Lisa Snellings 86
c/o Jane Frank
P.O. Box 814
McLean, VA 22101
703-847-4251
www.wow-art.com

Mike Sosnowski 91
2045 Holly Dr. #D
Hollywood, CA 90068
323-467-0190
sozstudios@aol.com

Jeff Soto 124
727 Kelly Lane
Riverside, CA 92501
909-328-8776
www.jeffsoto.com

Greg Spalenka 15, 48, 117
c/o Allen Spiegel Fine Arts
221 Lobos Avenue
Pacific Grove, CA 93950
831-372-4672
asfa@redshift.com

Ron Spears 126
16676 N 106th Way
Scottsdale, AZ 85259
480-419-1501
ronspears@sprynet.com

Joel Spector 134, 154
3 Maplewood Drive
New Milford, CT 06776
860-355-5942
joelspect@aol.com

Greg Staples 123

Matt Stawicki 58
2503 Cratchett Road
Wilmington, DE 19808
302-993-0683
www.mattstawicki.com

Cory Strader 18
125 Chiswick Rd. #408
Brighton, MA 02135
617-787-9745

William Stout 53, 145
1468 Loma Vista Street
Pasadena, CA 91104
626-798-6490
wmstout@bbs-la.com

Stu Suchit 99
117 Jayne Avenue
Port Jefferson, NY 11777
631-928-8775
stusuchit@aol.com

Jon Sullivan 59
18 Highview, 75 Eglinton Hill
Plumstead, London, UK SE18 3PB
+44 0208-316-0367

Raymond Swanland 23, 104, 126, 170
1157 Buchon St.
San Luis Obispo, CA 93401
805-542-9785
rswanland@charter.net

Greg Swearingen 136
1955 NW Hoyt #65
Portland, OR 97209
503-449-8998
gregswearingen@yahoo.com

Justin Sweet 56, 81, 108, 123
1009 Henrietta Circle
Placentia, CA 92870
714-528-1028
jsweet01@adelphia.net

T

Shaun Tan 27, 34
51 Coode Street, Maylands, Perth,
Western Australia 6051
shauntan@cygnus.uwa.edu.au

Jean Pierre Targete 57
7020 NW 179th Street #206
Miami, FL 33015
305-827-7862
jptarget@aol.com

Mark Tedin 121
2008 Federal Ave. E
Seattle, WA 98102
206-328-3814
tedinmark@mindspring.com

Thomas Thiemeyer 148
Stuttgart, Germany 70193
0711-636-3211
thomasthiemeyer@t-online.de

Yoshihito Tomobe 103
105 826 Shimo-Sakunobe, Takatu-Ku
Kawasaki, Japan 213-0033
044-877-0560
tomobe@pi.highway.ne.jp

V

Christopher Vacher 150, 155
10240 Camarillo Street #206
Toluca Lake, CA 91602
www.vacher.com

John Van Fleet 45, 79
c/o Allen Spiegel Fine Arts
221 Lobos Avenue
Pacific Grove, CA 93950
831-372-4672
asfa@redshift.com

Charles Vess 80, 156
152 E. Main Street
Abingdon, VA 24210
540-623-0796
greenmanpress@naxs.com

Roxana Villa 99
P.O. Box 884
Woodland Hills, CA 91365
818-992-0490
rox@roxanavilla.com

W

Amanda Wachob 159
23 Ridge St.
Kingston, NY 12401
845-334-9276
amandawachob@hotmail.com

Chad Michael Ward 155
245 W. Loraine St. #118
Glendale, CA 91202

Anthony S. Waters 16
P.O. Box 369
Kirkland, WA 98083-0369
425-803-0898
www.thinktankstudios.com

Jonathan Wayshak 159
1000 Powell Street #73
San Francisco, CA 94108
415-576-9343
wayshak@scrapbookmanifesto.com

Mike Weaver 106
1018 Atherton Lane
Woodstock, GA 30189
mike@ifxe.com
www.ifxe.com

Brad Weinman 117
5268 Lindley Avenue
Encino, CA 91316
818-342-9984
bweinman@mindspring.com

Steven W. West 90
9621-54th Avenue S.
Seattle, WA 98118
206-723-6801
stevenwwest@earthlink.net

Michael Whelan 42, 113, 135, 173
P.O. Box 88
Brookfield, CT 06804
203-792-8089
whelanart@aol.com

Kent Williams 28
c/o Allen Spiegel Fine Arts
221 Lobos Avenue
Pacific Grove, CA 93950
831-372-4672
asfa@redshift.com

Matt Wilson 53, 62
4506 Linden Ave. N
Seattle, WA 98103
206-547-7724
bigargus@attbi.com

Ashley Wood 14. 24, 41, 66
ash@ashleywood.com
www.ashleywood.com

Y

Paul Youll 40
c/o Alan Lynch
11 Kings Ridge Road
Long Valley, NJ 07853
908-813-8718
alartists@aol.com

Stephen Youll 121
296 Pegasus
Road Piscataway, NJ 08854
732-985-0086

Z

John Zeleznik 39, 105
25876 The Old Road/PMB #315
Stevenson Ranch, CA 91381
661-799-9987
hunterz5@earthlink.net

Mark Zug 17, 54, 106
50 North Pine Street #304
Marietta, PA 17547
717-426-1672
mxug@aol.com

Painting by Joseph DeVito

Artists, art directors, and publishers interested in receiving entry information for the next Spectrum competition should send their name and address to:

Spectrum Design, P.O. Box 4422, Overland Park, KS 66204

Call For Entries posters (which contain complete rules, list of fees, and forms for participation) are mailed out in October each year.